REVERSING INTO THE FUTURE

NEW WAVE GRAPHICS 1977–1990

First published in the United Kingdom in 2021 by

Pavilion
43 Great Ormond Street
London
WC1N 3HZ

ISBN 978-1-911663-95-9

A CIP catalogue record for this book is available from the British Library.

10 9 8 7 6 5 4 3 2 1

Reproduction by Rival Colour Ltd, UK

Printed and bound by IMAK Ofset, Turkey

www.pavilionbooks.com

Readers should note that record label credits in the captions refer to the specific item illustrated, even though design and photographic elements were sometimes generated elsewhere (for example, commissioned by an overseas affiliate of the record label or third party label which licensed the record being promoted in the poster).

ACKNOWLEDGEMENTS

From contract to submission of the final draft, it took just fifty-three days to complete *Reversing Into The Future* — surely a record for an illustrated book of this size. This accomplishment was only possible because we worked from the design structure created by Barbara Doherty and Mal Peachey for *Too Fast To Live*. Mal also did a yeoman job as my agent — he is patient and tenacious! Thanks also to Barbara for reprising her role here, for her tirelessness and infinite patience (saint would be an understatement). Without our project manager and editor (and my fast friend) Charlie Mounter, the book would never been delivered on time. She has done a phenomenal job. I would also like to thank Mark Sinker for his expert advice.

Izzy Holton, Lucy Smith and Nicky Collings from Pavilion could not have been more helpful, and I give my gratitude to Helen Lewis and David Graham for reconsidering the book at the eleventh hour and securing approval to proceed with *Reversing Into The Future* literally two days into the New Year (true new wave believers).

I also must thank all of the text contributors to the book: Andrew Blauvelt, Phil Brophy, Malcolm Garrett, Peter Groff, Chip Kidd, Chris Morton, Rick Poynor and Matt Worley. Their extended captions and essays constitute the scholarly foundation of the book (I just provided the pretty pictures). I hope that the book will raise awareness of Chris' immense talent. Peter was generous with his time, providing a very reassuring layer of quality control for the US new wave spreads. Malcolm's assistance with image selection and supply, as well as captions, was greatly appreciated. Chip and Malcolm also exceeded my highest expectations with their cover designs.

Work began on this book during the early days of the COVID-19 scourge, and for the first few months of 2020 my first cousins and siblings in the UK, US and Israel met almost weekly on Zoom. Seeing everyone regularly raised my spirits and kept me (relatively) sane during this difficult time, and I would like to thank them all: Celia (and her husband and my friend Edward), George, Gilly, Jane, Jennifer, John, Nigel, Noah and Yoram. I couldn't ask for a more supportive family. Thank you, lovely Debra, for keeping your Irish temper in check during this ordeal.

Lastly, I would like to mention my cousin, and protean author, Pete Silverton. The Byzantine path which led to the publication of both *Too Fast To Live* and *Reversing Into The Future* began nearly ten years ago, with a conversation we had while strolling through Camden Town. I met Pete over forty years ago, when he was courting my cousin Jennifer. I was just eighteen, consumed by punk rock music, and I peppered him incessantly with questions about The Clash and Sex Pistols (both Glen Matlock and Joe Strummer were mates of his). In those early days of 1979, I have no doubt that I irritated him intensely. Mercifully for me, of course he had to be on his best behaviour (by Pete standards!). Over the decades, Pete merged into our family, and has been an invaluable sounding board regarding my collection, publishing, and life in general. I consider Pete to be a brother, and dedicate this book to him.

Andrew Krivine, 2021

REVERSING INTO THE FUTURE

NEW WAVE GRAPHICS 1977–1990

ANDREW KRIVINE

PAVILION

CONTENTS

A handful of images related to artists from outside the UK and North America have also been included in the UK BANDS sections.

PICTURES CAME AND BROKE YOUR HEART

Chip Kidd

The first real, legitimate rock concert I was allowed to go to was in the fall of 1980, at the Philadelphia Spectrum. I was fifteen years old and the act was… Yes. That's not a mental glitch, the group was actually Yes. Yes, THAT Yes, but with a difference.

The album *Drama* had just come out. My geeky friends and I were all over it, but we were also keenly aware that there had been a major shake-up within the group: Jon Anderson was out as the vocalist, and ditto Rick Wakeman as keyboardist (sacrilege!). This was major. Replacing them were two people we had never heard of, named Trevor Horn and Geoff Downes. As much has we loved the old Yes classic albums *Fragile* and *Close to the Edge* (and boy, did we), we also had to admit that the new *Drama* collection was pretty great. 'Tempus Fugit' and 'Into The Lens' were two songs that absolutely captivated us — the music was somehow even more intense and thoughtful and immediate, and Horn and Downes were listed as co-writers. And Roger Dean was back as the cover artist, with black cats cavorting over a typically surrealistic quasi-Arctic landscape! That helped to anchor the whole thing.

Horn sounded pretty much like Anderson, and Downes clearly commanded the keys. But they had a past that we knew nothing about. Yet.

As my friends and I sat up in the cheap seats for the show at the Spectrum (it was very much an arena, which accommodated thousands, now sadly gone), we immersed ourselves at a distance as the group was going through their hits with the new personnel, and then eventually the *Drama* stuff (yay!). But during a medley of the current material, Horn and Downes casually launched into a number apparently called 'Video Killed the Radio Star'. It was tuneful and jumpy, and NOT a Yes song.

A small part of the crowd went crazy. Small. The rest of us sort of bopped along and scratched our heads and tried to figure it out.

Then finally, as an encore, they played 'Roundabout', and all was well again.

Afterwards, our minds buzzing, our parents somehow found us and picked us up in our woody station wagon in the crowded parking lot. We went home elated.

Little did we know that we had actually also just seen Buggles. More on that in a moment.

At the time, I knew I wanted to do something creative for a living when I grew up, I just wasn't sure what. Certainly, making album covers would have been fantastic, but there was no clear path to that as an actual vocation — you might as well say that you wanted to be an astronaut.

In the meantime, the pop music I paid attention to was changing, and my tastes were changing with it. Part of this had to do with peer pressure — the cool kids at school were suddenly talking about The Clash, Devo and something called Gang of Four. And then MTV happened. And the first music video they played was… 'Video Killed the Radio Star' by… Buggles. Now in heavy rotation. Holy shit: WE SAW THEM.

Soon I was combing the import album section at the Listening Booth record store in the Berkshire Mall in West Reading PA. Eventually I found it: *The Age of Plastic*. These were definitely the same guys, though they looked totally different on the cover, like deconstructed cartoon characters. And among the other imports I found a lot more: Devo, the B-52's, Elvis Costello,

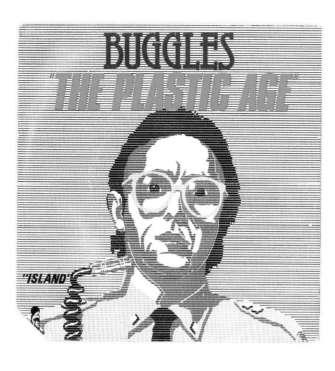

BUGGLES: 'The Plastic Age' 45 (Island Records, 1980).

Duran Duran, Siouxsie and the Banshees. There was something about these album covers that seemed both old and yet totally contemporary at the same time: it was like someone took design ideas from the 1950s and remade them to look like... NOW. It was the 1980s, man! Everything was brand new! I didn't really have a grasp of the concept of irony at the time, but that's what I was seeing: images and visual sensibilities that were created twenty- and thirty-some years ago to provide a sense of comfort and ease to the middle classes — but now they were being recontextualized to do exactly the opposite. What was this?

Whatever it was, it was not punk. Punk was scary and alienating and chaotic and the sleeves all looked like ransom notes cobbled together by a crazy person (not that that didn't look cool — it did), and it all ended with the messy death of Sid Vicious and Nancy Spungeon. This was an evolution from that, musically and visually. The music press soon declared it: this was new wave. It was more sophisticated — angular and yet undeniably (and more often rapturously) melodic. I remember once when my mom overheard the strains of Elvis Costello's 'Alison' wafting from my bedroom, she commented: 'Oh, that's such a pretty song.' Luckily, she wasn't listening to the words.

Suddenly Yes and its attending overwrought phantasmagoria seemed utterly ridiculous, like the aural equivalent

YES: (above) *90125* LP (ATCO, 1983); **Garry Mouat (Assorted iMaGes)** design. The eleventh studio album from Yes was their most commercially successful. The album was named after its US catalogue number. (below) 'Owner of a Lonely Heart' 45 (ATCO, 1983); **Garry Mouat/Malcolm Garrett (Assorted iMaGes)** design. The 12" single was intended to be seen as a digital wireframe version of the *90125* album image, which it preceded. Both were created using Robocom software on an Apple IIe computer.

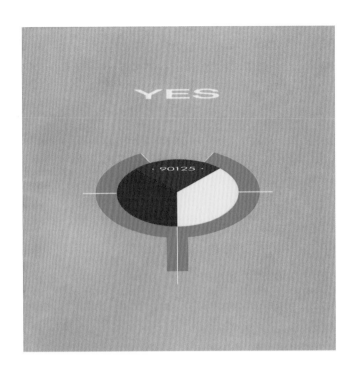

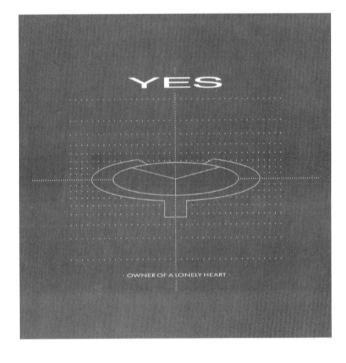

of a gingerbread Victorian mansion when you were presented with a sleek cliffside neutra-wedge. The music of the new wave followed suit, especially the cover songs. Once I heard Devo's staccato, percussively insane version of 'Satisfaction', I could never go back. If The Rolling Stones thought they were being subversive with it in the 1960s, they would probably also have thought that it was utterly crazy to play this song on national TV while wearing flowerpots on their heads and clad in banana-hued hazmat suits. Yet that is precisely what Devo did, twenty years later on *Saturday Night Live*, and totally got away with it. This was the way it was all going.

Irony of ironies, four years later Yes itself would eventually cave musically to the new sensibility, with its next album, *90125*, which yielded the only #1 single on the US charts in the group's twenty-plus-year career. The song was 'Owner of a Lonely Heart', and it sounded more or less like... Buggles. Not only that, but the cover art was one of the first ever created on an Apple computer, by someone named Garry Mouat at Assorted Images. Its clean lines and shards of flat bright colour on a cool matte silver metallic background presented the idea of a world in which Roger Dean never existed. And I wanted to move there.

By that time I was in college, intensely studying graphic design, and soon became

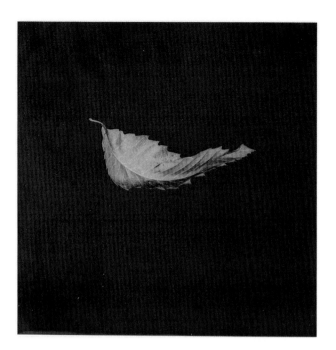

NEW ORDER: 'True Faith' 12" 45 (Factory, 1987); **Peter Saville Associates** design, **Trevor Key** and **Peter Saville** dichromat image.

aware of the work of designer Peter Saville and his astonishing album covers for the Factory Records label, based in the impossibly exotic-sounding locale of Manchester, England. More important, I had heard the music first, thanks to my university's student-run radio station.

So I wondered: who was this New Order, who created songs that at first sounded like bad disco and yet somehow within a few bars morphed and built and swirled into wildly gorgeous orchestral soundscapes? All this while the lyrics were arched, detached, and observing the songs seemingly from elsewhere?

And what about Saville's sleeves for New Order (and before them Joy Division), which mimicked the relationship of the lyrics to the music even more so. The imagery, however beautiful — a falling leaf, the diagram of a pulsar from a distant star, the opalescent sheen reflecting off a sheet of scrap metal — had no apparent direct connection to any of the song titles or subject matter. It just WAS, and it was brilliant, because formally it was beautiful, but more to the point it forced the viewers/listeners to piece together their own narratives based on what they were seeing and hearing. You could argue that this approach was the direct opposite, say, of *Sgt. Pepper*, which pretty much commanded that you stare at it the entire time you were listening to the record.

Saville and New Order seemed to be saying 'Yes, the sleeve's nice to look at. Now toss it aside and listen to the music.' As a fan I always found it maddening that they never, ever printed the lyrics or much else beyond legal information on the label or cover. Liner notes? Keep dreaming! But the music was so good I grudgingly respected that. I suppose that was the point.

Upon college graduation, I beelined it for New York City in the fall of 1986 to try to get a job in graphic design. Luckily enough, I soon did, at the Alfred A. Knopf book publishing imprint, arguably the most prestigious in the country. It wasn't really the job I was looking for — designing book covers — but at the newly minted age of twenty-two I knew I had to give it a shot. I would have rather been designing record albums somewhere, but that would have been like trying to be an astronaut, and Peter Saville had already planted his spectacular flag on the moon. He had unexpectedly devised a way to reinvent a format that we all thought had been played out. He made me care about it again.

The bar had been raised. Somehow, I would have to try and figure out how to do something like that for books...

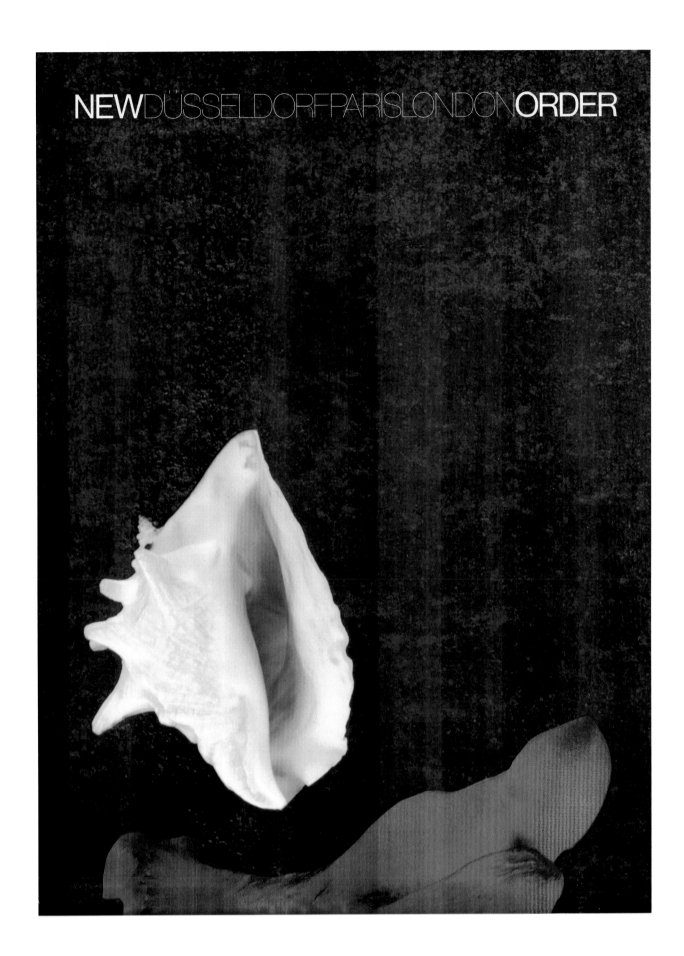

PICTURES CAME AND BROKE YOUR HEART

NEW ORDER: Tour poster (Factory, 1987); **Peter Saville Associates** design, **Trevor Key** and **Peter Saville** dichromat image.

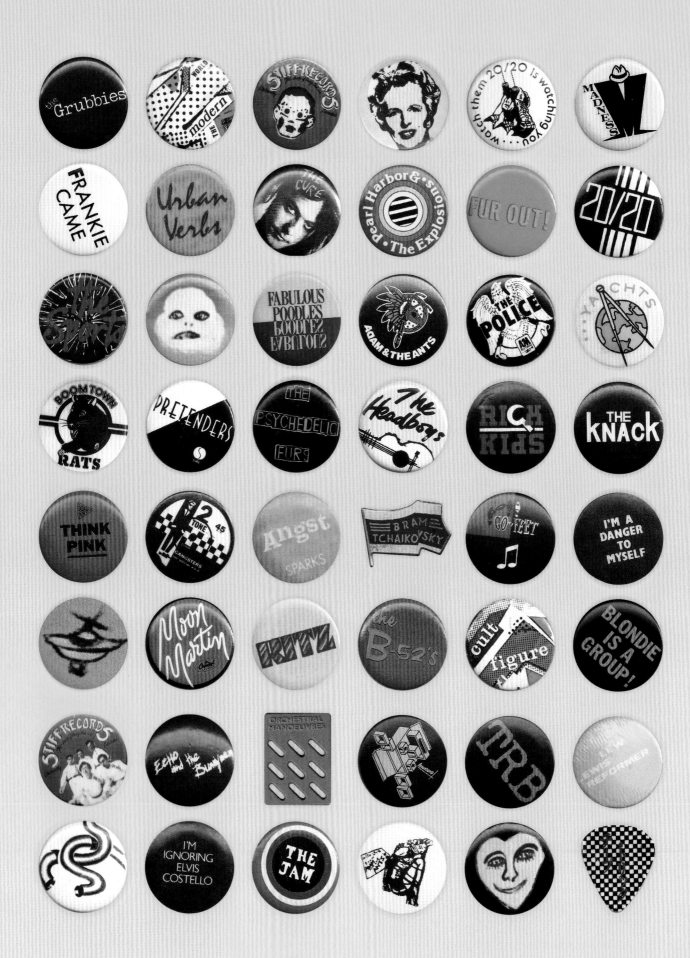

SURFING THE NOUVELLE VAGUE

When I started working on my previous book, *Too Fast To Live*, I intended to include an expansive section on new wave. The first draft (circa 2015) in fact contained over a thousand pages spread across three volumes, with new wave a large component of the third volume. Basically, I was working unchecked by any adult with publishing experience, and was swept into a long, winding wormhole! The mind-blowing final layout was clearly never going to be released by any sane publisher. This was where my agent, Mal Peachey, entered the scene, and introduced me to Pavilion Books. As we began to rebuild the book from scratch, it soon became apparent that it would be impossible to include a section on new wave which could do justice to the subject.

At the time I was a bit disappointed, as I had hoped to create the definitive graphic design book on punk, new wave and post-punk. It soon became clear to me that this was actually a stroke of good luck. I was approached by several collectors (many with duplicate titles) who were happy to sell posters to a fellow traveller who they knew really cared. In the nine months since *Too Fast To Live* was released, scores of new wave-related gems have joined the collection. *Reversing Into The Future* has been a huge beneficiary of this bounty — I hope it is well worth the wait.

New wave is a really elusive musical category, as can be seen in the conflicting perspectives fervently expressed by my esteemed essay contributors — further clouded by the application of the same term to other artistic endeavours, including French cinema, free jazz and science fiction. To many the term connotes a diluted, more tuneful, commercially acceptable version of punk, while some see it as a precursor to power pop, which also occasionally incorporated elements of ska, reggae and synth-pop for good measure. However, we also know that both Mark Perry (publisher of the seminal UK fanzine, *Sniffin' Glue*) and Malcolm McLaren (the Sex Pistols' manager) initially applied the term 'new wave' to the early cohort of punk bands (The Clash, The Damned, Sex Pistols, etc.). Given their histories and almost concurrent emergence, it is not easy to disentangle early new wave from punk. At their cores, they share a common DNA, with genetic markers infused with energy, humour and exuberance.

To date, in the world of rock-music posters, new wave has been regarded by graphic designers and poster collectors with disdain and condescension. It has been the unwanted ginger stepchild of the rock-poster medium. I fervently hope that *Reversing Into The Future* will spur a reappraisal of both the music and the graphics.

Andrew Krivine

WHAT DOES 'NEW WAVE' MEAN? [1]

Pete Groff

I have excellent news for the world. There is no such thing as 'new wave'. It does not exist. … There never was any such thing as new wave. It was the polite thing to say when you are trying to explain you are not into the boring old rock and roll, but you don't dare to say punk because you were afraid to get kicked out of the fucking party and they wouldn't give you coke anymore. There's new music, there's new underground sound, there's noise, there's punk, there's power pop, there's ska, there's rockabilly, but new wave doesn't mean shit.

So spoke Claude Bessy (aka 'Kickboy Face'), in Penelope Spheeris' immortal documentary of the LA punk scene, *The Decline of Western Civilization* (1981). Bessy himself was the editor of *Slash* — one of the earliest and best underground punk zines in America — so his perspective was of course unapologetically, even enthusiastically, partisan. But his assessment neatly sums up the way new wave has come to be seen by those in the know. On the one hand, it was a bland euphemism for punk — worse, a watered-down, vapid and shamelessly commodified imitation of punk. On the other hand, by the early 1980s the genre had became so broad, inclusive and nebulous that it was effectively meaningless (see the fate of 'alternative' and 'indie' in subsequent decades). Indeed, nowadays one can find expertly curated compilations of virtually every musical genre no matter how obscure or picayune, but to date there are no serious contemporary retrospectives of new wave. And pivotal groups that used routinely to be characterized as new wave have mostly been resituated into more respectable categories: punk, proto-punk, post-punk,

power pop, art rock. In short, punk's deflationary take on new wave has won out.

Yet it seems to me this account is too neat and tidy and self-serving. I'd like to propose that new wave was in fact much more interesting and important than that, and that by buying into punk's sometimes overly simplistic oppositions (purity *v.* impurity, authenticity *v.* phoniness, integrity *v.* venality) we close ourselves off from the power of a musical moment that was in many ways just as liberating and inspiring as that of punk — perhaps in some ways

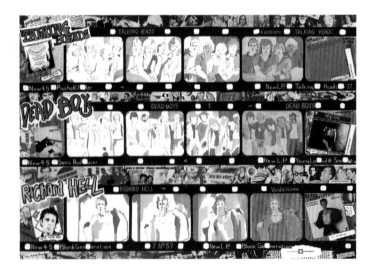

ABOVE: UK label launch poster with serialized images of Richard Hell, the Dead Boys and Talking Heads (Sire Records, 1977).

[1] This essay focuses only on American new wave; for a discussion of British new wave, see Matt Worley's excellent essay in this volume. There is, surprisingly, a paucity of serious writing on the topic of new wave music in general, although a number of studies have begun to emerge in the last decade. The best overall study in my view is still Theo Cateforis, *Are We Not New Wave? Modern Pop at the Turn of the 1980s* (Ann Arbor: University of Michigan Press, 2011), to which this essay is very much indebted.

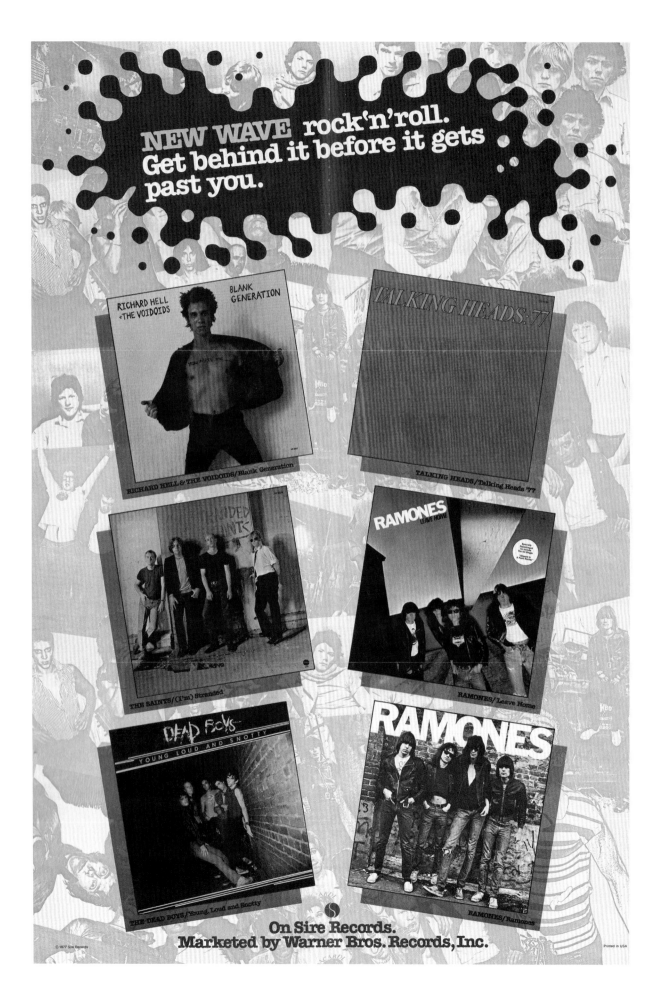

even *more* so. And so here I will try to take a few steps towards doing justice to new wave and perhaps even rehabilitating it as a meaningful and praiseworthy genre. I'll begin with a quick overview of the emergence and history of the term, because (as with so many things) what it came to signify was not what it always meant.

The expression 'new wave' is a bit like the term 'modern': it starts off as something rather formal and empty, without any specific categorial standards, but then gradually coalesces into something more substantive. As is often pointed out, the first noteworthy use of the phrase comes from the iconoclastic *Nouvelle Vague* of French cinema in the late 1950s and 1960s. It was then intermittently trotted out to describe a heterogeneous mishmash of bands in the mid- to late 1960s (e.g. The Supremes, The Rolling Stones, John's Children, Love, even Country Joe and the Fish!). By 1973, though, the phrase starts to take on a more specific meaning, with critics like Dave Marsh and Nick Kent using it retroactively to describe the Velvet Underground, The Young Rascals and Leslie West's The Vagrants, and then applying it to New York proto-punk acts like New York Dolls and Wayne County — but also bands like Blue Öyster Cult and Kiss. New wave at this point seems to signify an ethos as much as an aesthetic: leaner, meaner, sometimes more rudimentary or ragged bands that eschew the idealism of the 1960s or the self-indulgent technical wizardry of prog rock, and instead tap into the amateurish and transgressive spirit of early rock and roll. By early 1975, the Dolls, having been briefly resuscitated by Malcolm McLaren but on the cusp of dissolution, are being marketed by him as the 'new wave' of rock and roll. Within months the Dolls will fall apart and McLaren will return to Britain to put Sex Pistols together, branding them as 'new wave' too; the term will be picked up and used to describe the first generation of British punk bands — right alongside 'punk' itself. Meanwhile, back in the

States, 'new wave' and 'punk' (a label which has its own tangled and contested semantic history) are being used interchangeably to describe a gaggle of exciting new bands clustered around CBGB and Max's Kansas City: the Patti Smith Group, Television, Ramones, Blondie, Talking Heads, etc. By 1976, new wave and punk are virtually synonymous.

By the end of 1977, however, a shift is underway. Put simply, punk 'sells out', but doesn't sell. That is to say, by this time a good many first-wave punk bands have been signed by major labels who are anxious to commodify the next big thing, but the next big thing proves indigestible to the mainstream. Accordingly, the record industry recalibrates. On the one hand, there is a shift in marketing strategy. Most notably, Sire Records (who had with great prescience snatched up Ramones, Flamin' Groovies, Talking Heads, Dead Boys, Richard Hell and the Voidoids, and many other seminal punk/new wave acts) starts promoting their catalogue with a new slogan: 'Don't Call it Punk.' The word 'punk', Seymour Stein explains, is as offensive as 'race' and 'hillbilly' were when they were used to describe 'rhythm and blues' and 'country and western' thirty years before. 'New wave' is the preferred term of choice now. In this respect, Bessy was right: it's 'the polite thing to say when you are trying to explain you are not into the boring old rock and roll, but you don't dare to say punk.' At the same time, labels increasingly begin seeking out bands that have that punkish *frisson* — the energy, the irreverent attitude, the jarring visual aesthetic — but are perhaps less confrontational, less dangerous, more friendly, more accessible and more easily marketable to a broader audience.

By 1978, punk itself is at a crossroads. Theo Cateforis helpfully describes it as splintering into three general movements: one faction sees punk as having outlived its purpose and decides to embrace growth and experimentation, extirpating the residually conservative, 'rockist'

elements of punk and experimenting with new genres, formats and technologies. Here we have the post-punk moment represented by bands like PiL, Siouxsie and the Banshees, Magazine, Joy Division, The Slits, etc. The second faction doubles down on the original promise of punk, vowing to make it real this time — harder, faster, louder, sometimes more populist, sometimes more political, sometimes more organically rooted in youth culture and in any case more confrontational. This is the 'second wave' of punk, manifesting itself variously as 'street punk', Oi!, hardcore and anarcho-punk. The third faction dials it back, sublimates the anger and aggression of punk, retains its energy, intelligence and humour, makes some prudent concessions to accessibility (lighter — or at least more subtly dark — themes, cleaner, tighter arrangements, melody, hooks, danceability) and becomes new wave. They seem to be the perfect solution to punk dyspepsia.

Now it's tempting to assume that new wave bands were, right from the get-go, simply a function of the corporate demand for bowdlerized punk. But that's unduly cynical, I think, and puts the cart before the horse. Consider again Cateforis' three-fold fragmentation model: it's an elegant description of the situation in Britain, but it doesn't map onto the US quite as well. Because even though there was a second wave of punk in the US (hardcore) and a much-ballyhooed new wave moment as well, there never really was a 'post-punk' movement as such. Or maybe the problem is just that in the States, the boundaries between punk, proto-punk, post-punk and new wave were always fuzzy. Note that many of the American bands retrospectively categorized as post-

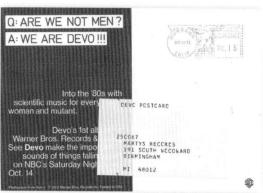

punk were in fact arty *proto*-punk (e.g. Television, Talking Heads, Suicide, Pere Ubu, Devo, The Residents). Some of them were of course momentarily branded as punk before it was really codified, and some walked out the other end of punk as new wave. Considered this way, I think it's fair to say that bands like Talking Heads and Devo were in the mid-1970s *simply making the music they wanted to make* in a decidedly independent and DIY spirit — music that at the time was strange, new, exciting and not particularly palatable to mainstream tastes. It's not like they *wanted* to be the Stooges or Dead Boys or Teenage Jesus and the Jerks but somehow lacked the backbone. In its earliest forms at least, then, new wave shouldn't be seen as a cynical concession to external pressures, but rather as an autonomous and spontaneous expression of creative desire. It's worth adding that many of the other so-called American post-punk bands that really *did* come after punk chronologically (some of which are discussed below) shared the same general ethos and aesthetic as those

seminal new wave bands. In short, despite our anachronistic cravings to separate the 'pure' from the 'impure', there was no cardinal difference there.

What then was the ethos and aesthetic of new wave? I'm going to cast the net pretty narrowly here, and focus only on American artists between 1978 and 82. New wave of course continues beyond that, but in the wake of MTV, the Fairlight synthesizer and New Romanticism, it begins to take on a rather different character and becomes bit of a grab-bag. So in order to come up with a more distinct portrait I'll just focus on a small core of artists. Let's think of Devo, Talking Heads and Blondie as the three archetypal American new wave bands. Devo is in some ways *the definitive* band, for both snobs and novices. They're the earliest of the three (formed in 1973, but with roots reaching back to the late-sixties counterculture) and hailing from Akron, OH, they epitomize the uniquely American weirdness emanating from the Midwest's decaying industrial centres in the mid-1970s. But more importantly, they offer probably the densest cluster of readily identifiable new wave signifiers: the unapologetically intelligent, vulnerable and even neurotic nerdiness (a decisive rejection of 'cool' hyper-sexualized rocker machismo), the anxious, staccato, yelped vocals, nervous, twitchy, herky-jerky rhythms and abrupt, unnatural, robotic movements (a self-parodic performance of 'whiteness' or, more broadly, the frailties of human desire bound up by the mechanical regularity of the modern world), highly processed and manipulated instruments (electric drums, hot-rodded hybrid guitars, keyboards and even synthesizers, a rarity in punk), plus a wildly imaginative but

DEVO: (below) Large lenticular badge, *c.* 1980; (opposite) Colour postcard promoting *Saturday Night Live* appearance (Warner Bros. Records, October 1978); **Kate Myers** photograph.

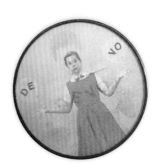

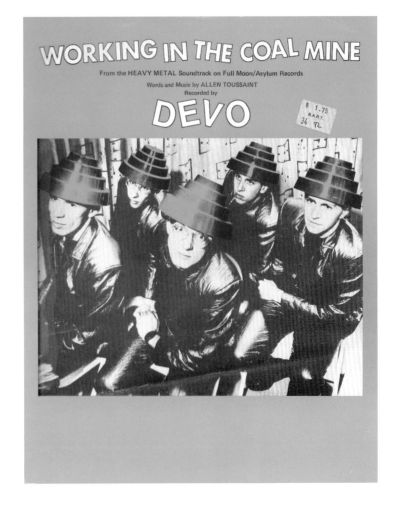

DEVO: (above) 'Working in the Coal Mine' sheet music (Warner Bros. Records, 1981).

TALKING HEADS: Promotional postcard for *More Songs About Buildings and Food* LP (Sire Records, 1978).

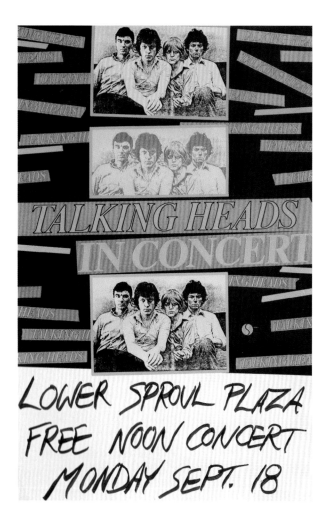

TALKING HEADS: Concert at University of California Berkeley's Sproul Plaza, 18 September, 1978 (Sire Records).

satirical and cartoonish techno-futurism. Devo provided the blueprint for so much of what came to be immediately identifiable as new wave iconography, from their first album *Q: Are We Not Men? A: We Are Devo!* (with its childishly garish primary colours and hideously morphed visage of golf pro Chi-Chi Rodriguez), to their ever-changing array of whimsical but vaguely disturbing 'uniforms', to the simultaneously incisive, tacky and discomforting 'Whip It' video. They were masters of the cheerful uncanny. Looking back on my own first encounter with Devo, I think it ultimately left a deeper and more lasting impression on me than that of either Ramones or Sex Pistols: seeing them in their matching yellow jumpsuits deconstructing the Stones' 'Satisfaction' on *Saturday Night Live* in 1978 as a young teenager, I remember being seized by an inexplicable feeling of horror — but also experiencing the intimations of a great liberation that would open up for me the possibilities of modern music, far beyond the tired old predictable horizons of 'rock' and 'pop'.

The other two bands mentioned above hailed from the mid-1970s CBGB scene in NYC. Talking Heads were in some ways the most visionary and protean of all the early new wave bands, despite their deliberately conservative appearance. They epitomised the 'artist first, musician second' ethos that animated so many of the early punk and new wave bands. Their initial sound created a more understated, even austere, template for new wave, with David Byrne's perplexed, gentle outsider lyrics (alternating between irony and naïveté — like Warhol's perpetual tourist, always seeing the commonplace for the first time), tense, nervous, wavering vocals (as in Devo, although less obviously so, there's rejection of the macho ideal and a suggestion of neurosis), thin, clean, 'clanky' guitar lines (as in punk, there are few if any solos, but unlike punk, no distortion or power chords either) and minimalist keyboards (always subordinated to song structure), all set against a tight, nuanced and surprisingly funky rhythm section. Listening to *'77* and *More Songs About Buildings and Food* is like taking a shower and washing away all the suffocating, heavy-handed clichés of blues-based rock and even punk. Their next two albums — *Fear of Music,* with its highly

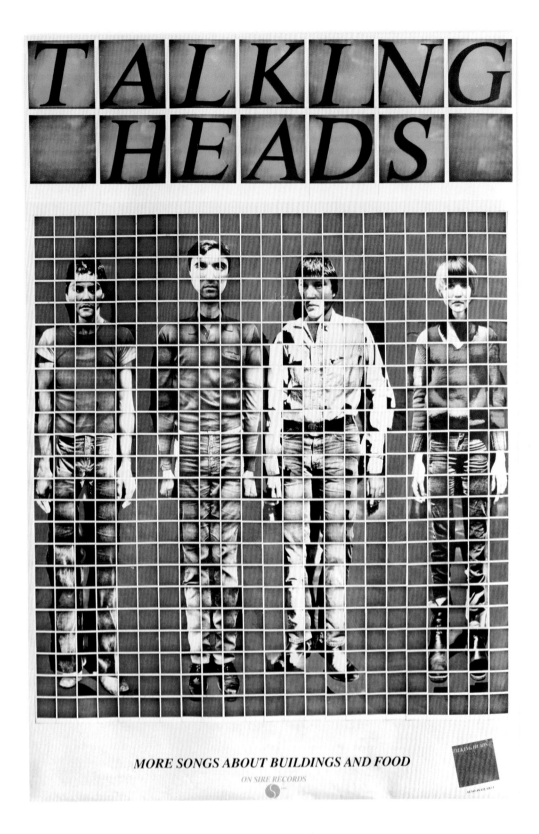

TALKING HEADS: *More Songs About Buildings and Food* LP poster (Sire Records, 1978); **David Byrne** concept for lifesize photomosaic used for the LP cover.

textured, atmospheric and almost claustrophobic art rock constructions, and *Remain in Light*, with its impossibly dense, multi-layered afrobeat-disco-funk grooves and found sound/sampling experimentation — stand as reference points for entirely different avenues of new wave exploration.

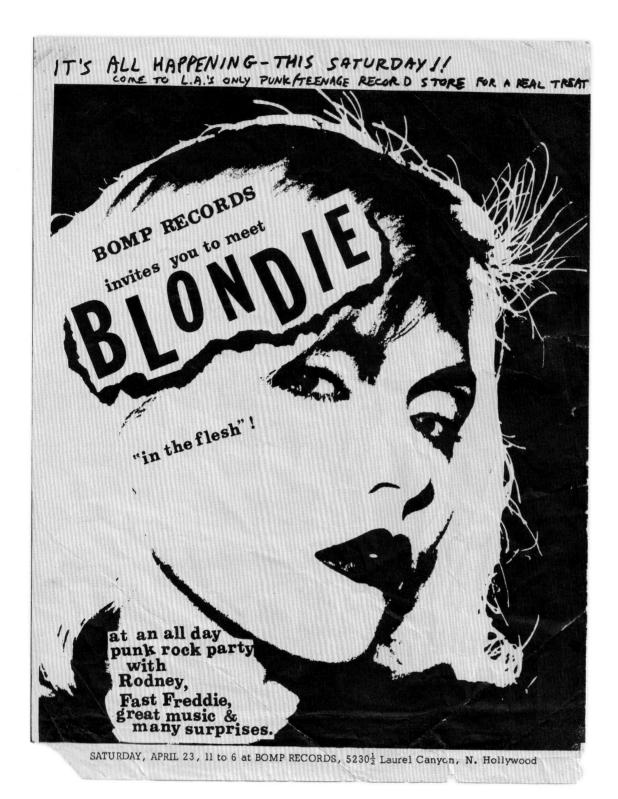

BLONDIE: (above) Concert flyer for Bomp!
Records in Los Angeles, 23 April 1977; (right)
Ticket from concert at The Mabuhay Gardens,
San Francisco, 3 March 1977.

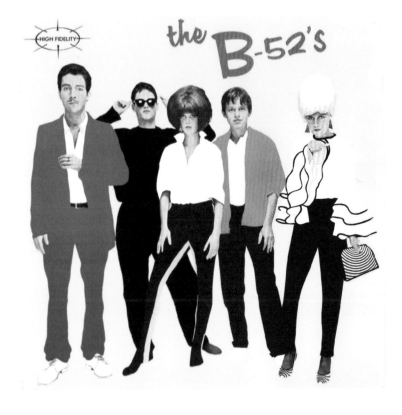

And of course, their concert documentary *Stop Making Sense* (1984) offers a perfect, if belated, distillation of new wave's conceptual sophistication and artistic ambition.

Blondie, on the other hand, set the standard for new wave's campy, kitschy retrieval of pre-*Sgt. Pepper* 1960s pop effluvia (trashy 'True Confessions' lyrical themes, Brill Building girl groups, cheesy farfisa-fuelled garage rock) as well as the simple pleasures of well-crafted power pop (a genre growing out of the British invasion that pre-existed new wave and would come to have a kind of symbiotic relationship with it). They also put their imprimatur on what would become a distinctive new wave/power pop look: simple, solid colours (lots of black and white and red), tailored mod suits with skinny ties, sometimes paired with sneakers. And of course, Debbie Harry as Blondie's iconic singer — sexy but savvy, cool, tough, ironically distant, embracing the artifice of the whole thing — would become a model for punk and new wave frontwomen alike, by complicating and subverting the usual power dynamics of the male gaze. Although Talking Heads and Devo both had their early commercial breakthrough moments ('Take Me to the River' in 1979 and 'Whip It' in 1980), Blondie was the first American punk/new wave act to score multiple mainstream hits (beginning with 'Heart of Glass' in 1979, which went to #1).

BLONDIE: (above) 'Sunday Girl' 45 poster (Chrysalis Records, 1978).

THE B-52'S: (below) *The B-52's* LP poster (Warner Bros. Records, July 1979); **Tony Wright** design (credited as 'Sue Ab Surd'), **George DuBose** photography.

THE WAITRESSES: *Wasn't Tomorrow Wonderful?* LP (Polydor Records, 1982); **Andrew Fuhrmann** and **Chris Butler** design, **George DuBose** photography.

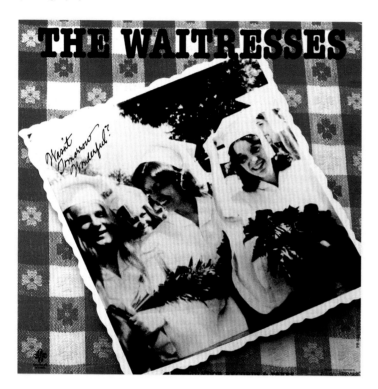

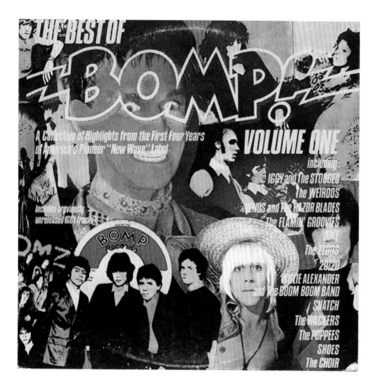

BOMP!: *The Best Of Bomp! Volume One* compilation LP (Bomp! Records, 1978); **Greg Shaw** and **Mary Roth** design, **Cindy Gossert** sleeve retouching.

From this core, we can move outwards to similarly familiar bands, each of which brought its own particular synthesis to the American new wave aesthetic: The Cars, The Pretenders, The B-52's, and The Knack (one is tempted to include Joan Jett and Go-Go's here, but they're more like punk translated directedly into the pop vernacular). Beyond this ring lay a treasure trove of bands often known only as one-hit wonders — The Waitresses, Romeo Void, Berlin, Martha and the Muffins, bands on I.R.S. Records like Oingo Boingo and Wall of Voodoo — but dig deeper into their oeuvres and you'll find some of the most resourceful, imaginative and exciting music of the late 1970s and early 1980s (give me 'Jimmy Tomorrow' over 'I Know What Boys Like' any day of the week, or 'Back in Flesh' over 'Mexican Radio'). Wander off the beaten trail a bit and explore some of the lesser-known, artier and more experimental new wave bands from this period: Urban Verbs, Human Sexual Response, Suburban Lawns, The Fibonaccis, Bunnydrums, early Algebra Suicide. One might expect this stuff to sound dated or contrived or derivative in retrospect, but it emerges after forty or so years as a revelation.

The question then is: where does new wave end and post-punk (or art rock, or jangle pop, or mutant disco or any of a dozen other proximate micro-genres) begin? We may balk at calling artists like The Feelies, The dBs, early R.E.M., Pylon, Cristina, Bush Tetras, Von Lmo, Klaus Nomi, or Laurie Anderson new wave as such, but they are in a sense all logical extensions of its worldview. Even pioneering noise/art damage bands like DNA, The Contortions, The Residents, or Tuxedomoon are inextricably bound up with it (for a sense of the overlapping aesthetic, see the sections on no wave and Ralph Records artists elsewhere

WALL OF VOODOO: 'Wall of Voodoo' EP poster (I.R.S. Records, 1980); **Index Images** design, **Scott Lindgren** photography.

in this book). They all exist at least on the outer periphery of the new wave universe. In a way, hot-take compilations from the late 1970s/early 1980s (*The Best of Bomp!, Troublemakers, Attack of the Killer B's, Trouser Press Presents the Best of America Underground*), as well as soundtracks (*Times Square, Rock and Roll High School, Liquid Sky, Valley Girl*), documentary movies (*Urgh! A Music War, Downtown 81, Smithereens*), public access TV shows (*TV Party, New Wave Theater*) and club bills (from venues like the Mudd Club, Danceteria, Peppermint Lounge, etc.) offer a more catholic and organic portrait of the period's diverse musical fermentations than can be captured by our clunky retrospective categories.

I described Devo, Talking Heads and Blondie as a new wave hypostasis from which subsequent styles and approaches emanated and unfolded. But this is not to say they constitute some stable, unchanging 'essence' of new wave. As with all things, there are no essences, only histories and resemblances. So what, then, is the genealogy of American new wave? As long as we think of new wave as simply a sublimation or dilution of punk, we can pretend its coming-into-being is entirely reducible to that of punk. Of course, the emergent history of new wave *does* overlap to some extent with the emergence of punk in fairly obvious ways. One of the less obvious threads of influence can be found in the nervous, clipped, herky-jerky, sometimes yodely or 'boingy' vocal style popularized by Mark Mothersbaugh, David Byrne and Ric Ocasek (and aped by hundreds of lesser lights until it became instantly identifiable as 'that new wave voice'). Aspects of this style can be found in the earliest CBGB vocalists (Patti Smith, Tom Verlaine, and see Richard Hell, Joey Ramone and Lux Interior for variations), and can be traced back at least in part to Lou Reed. But the style hearkens back further — to the stutterings, hypertrophic glottal stops and amphetamine hiccups of rockabilly singers struggling to express the intensity of their feelings in the repressed libidinal economy

of the 1950s (Buddy Holly was, unsurprisingly, a kind of new wave idol, whose sound and image were often appropriated).

But I think new wave has its own sources, too, distinct from the roots of punk. So instead of the usual narrative (from *Nuggets* garage rock and the Velvets to the MC5, Stooges, Dolls and CBGB/Max's scene), let us imagine multiple alternative lineages. One clearly traces back to early 1960s *pop* music, rather than rock and roll per se (girl groups, surf bands, Tommy James and the Shondells proto-bubblegum), as well as the high-brow/low-brow blurring pop art of that same time (Warhol, Lichtenstein, etc.). Another runs from the British Invasion and mod through power pop, especially the lesser-known American bands of the early to mid-1970s, many of whom found a home on scrappy indie labels like Bomp! and Beserkley: Earthquake, The Rubinoos, Pezband, The Shoes, The Nerves, and perhaps most notably, Flamin' Groovies and Jonathan Richman and the Modern Lovers. The Groovies had been around since the 1960s, when The Beatles, Stones and Stooges all fought a battle for their soul, but by the mid-1970s they had dialled in a raw power pop sound and found themselves right in the thick of the nascent punk/new wave scene. The Modern Lovers, too, are often mentioned in histories of punk, but never really fit comfortably into the dominant narrative. While most proto-punk bands were writing songs about sexual transgression and drug-fuelled self-immolation, Jonathan Richman was singing about how much he loved driving alone at night with the radio on ('Roadrunner'), or how he wanted to date some girl but really wasn't into drug culture ('I'm Straight') or hanging in there through all the bitter disappointments of life to achieve serene happiness in one's golden years ('Dignified and Old'). If Lou Reed or Iggy Pop is the godfather of punk, we might say Jonathan Richman is the godfather of new wave. The clean-cut look, the awkward, amateurish, shaky vocals, the mundane but confessional themes, the crude but surprisingly clean, un-rocky, almost

Rock n' Roll with

JONATHAN RICHMAN AND THE MODERN LOVERS PARADISO ZA.24 SEPT F.7·50.&LIDM

the most fun y' can have with y' clothes on

David Byrne Brian Eno

My Life In The Bush Of Ghosts

THE CARS: (above) Promotional logo sticker (Elektra Records, 1978).

DAVID BYRNE AND BRIAN ENO: (right) *My Life In The Bush Of Ghosts* LP poster (Sire Records, 1981).

THE RESIDENTS: (opposite) 'Satisfaction' 45 front cover (Ralph Records, August 1978); **Pore No Graphics** design.

dinky arrangements created the template for bands like Talking Heads and The Cars (and it's no coincidence that ex-members of the Modern Lovers — Jerry Harrison and David Robinson — would go on to join those bands).

Other lines of descent might involve glam/art rock bands like Sparks and Roxy Music (I think the former in particular is an underappreciated source for the more eccentric, cerebral and hyperkinetic branch of new wave, as well as certain clever power pop touches). Brian Eno is obviously a massive influence here too, in part because of his 'artist-technician rather than musician' ethos, but also in part because of his formative 'Krautrock' collaborations and ambient experiments, which certainly had an impact on the more ambitious outposts of new wave. Again, it's no surprise that Eno became the patron saint of new wave, producing bands like Television, Devo and Talking Heads and collaborating with David Byrne on *My Life In The Bush Of Ghosts* (1981). I think there is a rich seam of experimental underground conceptual/performance art (again, in the early to mid-1970s) that feeds into new wave as well. Devo's parodic 'De-Evolution' philosophy (replete

with a manifesto, homemade instruments, theatrical performances with masks, costumes and characters such as 'Booji Boy', videos, etc.) is a perfect example of this, but also the cacophonic absurdism of The Residents and the cartoonish, surrealist Cab Calloway-themed happenings of the Mystic Knights of the Oingo Boingo (a musical-theatrical performance troupe which preceded the actual band by a good seven years). The extravagant early theatrical performances of The Tubes might even be linked here, as well as the *Rocky Horror Picture Show* cult phenomenon. The common theme is a multi-media counter-cultural project that involves, but goes beyond, mere music-making (a kind of art-damaged version of Wagner's *Gesamtkunstwerk*, as it were). In some cases, the spirit of these projects can likely be traced back to Frank Zappa and the Mothers of Invention (an interesting contrast with the Captain Beefheart-inspired post-punk movement).

The story of new wave has all too often been told from an external standpoint: either a hostile, exclusive one (new wave as disappointingly scrawny changeling swapped at the last minute for the promising *enfant terrible* of punk) or a

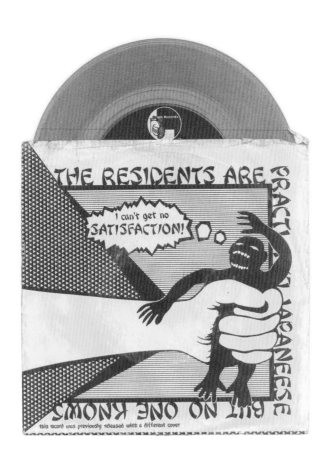

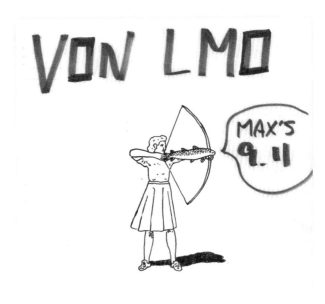

29

shallow, uninformed one (*New Wave Hits of the '80s*-style consumerist nostalgia fodder). I've tried to counterbalance those caricatures by reconstructing, to some extent, new wave's own *self*-understanding. I suggested towards the beginning of this reflection that new wave as a musical movement was in many ways just as liberating and inspiring as punk — perhaps even *more* so. It was in some ways aesthetically bolder and more willing to take chances than punk, and in any case more open to new possibilities. There's a certain musical promiscuity to new wave that punk lacked, both its terms of instrumentation (such as the integration of keyboard, horns, synthesizers, other processed instruments, additional layers of percussion, even sound 'treatments') and its willingness to explore and hybridize different styles (power pop, girl group, surf music, *musique concrète*, early electronica, disco, hip hop, noise, glam, ska, rockabilly, big band, afrobeat, and so on). It could be experimental and ambitious without lapsing into the sometimes rather bleak and abrasive self-mortifications of post-punk. It was also more socially inclusive — ironically so, given punk's

self-mythologizing as the haven of the outsider. New wave ditched the residual 'tough guy' macho pose that punk uncritically inherited from rock, opening the door to less toxic and more malleable forms of masculinity. It was heavily populated with women and LGBTQ artists and welcomed a wide variety of body types (in terms of race and ethnicity, new wave was still predominantly white, although arguably less so than punk). You could say that when punk and new wave went their separate ways in 1978, new wave got the better end of the deal. Punk kept the hog's share of the energy, anger, volume and cathartic rush, but it grew increasingly brittle, earnest, ascetic, puritanical — obsessed with its own righteousness and authenticity. New wave took the intelligence, the playfulness, the openness, the free-spirited cultural *bricolage*, the Apollonian irony, and yes, the *fun*. It could be ridiculous and embarrassing, but it was rarely boring. Don't get me wrong: there's a lot of amazing punk that got made after 1977. But take the best ten slabs of punk from 1978–82 and put them up against your top ten new wave songs: which makes you feel more alive? My money's on new wave.

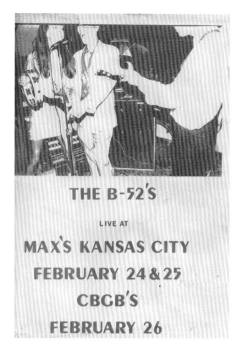

THE B-52'S: 1 Flyer for concerts at Max's Kansas City/CBGB, NYC (February 1978); **2** Flyer for gig at Club 57 NYC with Nervus Rex, 22 and 23 March 1979; **3** Debut LP promo flyer (Warner Bros. Records, 1979).

THE B-52'S

LIVE AT

MAX'S KANSAS CITY

FEBRUARY 24 & 25

CBGB'S

FEBRUARY 26

1

B 52's 急降下!

and
Nervus Rex
THURS. and FRI.
MARCH 22 and 23

Club 57 IRVING PLAZA

17 IRVING PLACE at 15th St. E.

475-9671

2

3

NOTICE!

BAN THE B-52's

STOP THE B-52's BEFORE IT'S TOO LATE!

What has happened to Los Angeles, New York City, Canada, Australia and most of Europe must NOT CONTINUE!

The B-52's have taken over all of those areas. Their VICTIMS have seized radio stations, record stores, dance clubs, high schools, newspapers and even so-called network television like Saturday Night Live.

How did they do it?

With a "record album" which looks just like any other ordinary strange record but which is capable of creating a hypnotic spell ALLOWING THEM TO ENTER YOUR BODIES AND MAKE YOU DANCE.

Scientists, using the latest in laboratory animals, indicate that this BODY TAKEOVER is achieved by what sounds like "Morse Code" on the "LP" and by its PRIMITIVE RHYTHMS!

But what can you do?

• **Stay in your home.**
• **Do not—repeat NOT—turn on the radio.**
• **If you have relatives in known B-52's areas, forget them.**
• **Avoid record stores.**

What are the DANGER SIGNS?

• **People using expressions like "Pass the tanning butter," "I'm gonna jump in a crater" and "I'm not no Limburger."**
• **Albums with bright YELLOW covers.**
• **Bouffant hairdos.**
• **ROCK LOBSTERS.**

The B-52's "album" is soaring beyond ONE QUARTER OF A MILLION sales and "ROCK LOBSTER" looks like a hit single. The result can be CATASTROPHIC.

B-WARE THE B-52's!!!

4

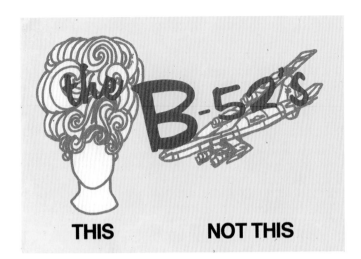

THIS NOT THIS

THE B-52'S: (left) Promotional postcard (Warner Bros. Records, 1979); (below) Self-titled debut LP UK poster (Island Records, 1979); **Tony Wright** design (as 'Sue Ab Surd'), **George DuBose** photography.

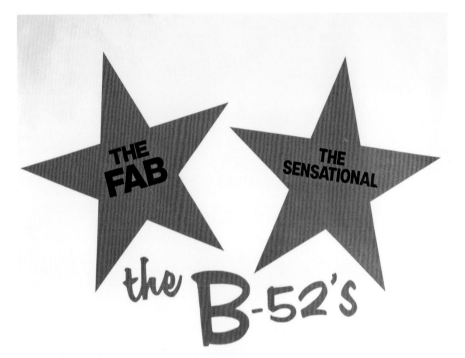

1

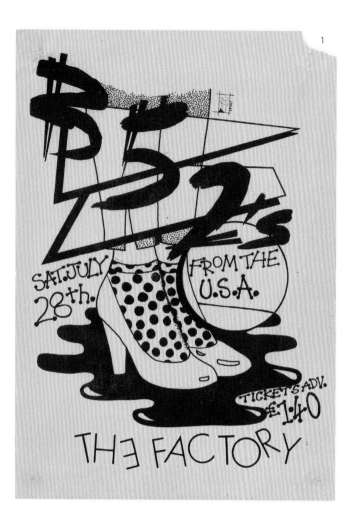

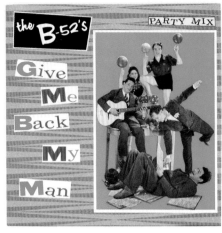

2

THE B-52'S: 1 Flyer for concert at The Factory in Manchester, UK, 28 July 1979; **2** 'Give Me Back My Man (Party Mix)' 45 cover (Island Records, 1980); **3** Afterparty at WREX flyer, Seattle WA, 19 October 1979; **4** Flyer for concert at California Hall, San Francisco, 2 October 1979.
(opposite) Heatwave Festival (with Talking Heads, The Clash, The Pretenders — who did not appear — and others), Toronto, Canada, 23 August 1980.

32

3

4

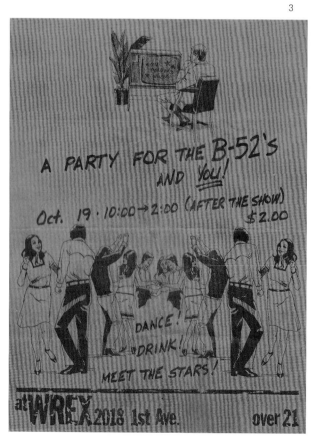

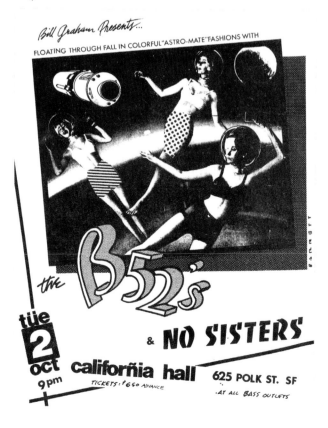

THE B-52'S: 'Strobe Light' 45 front and back cover (Island Records, 1980).

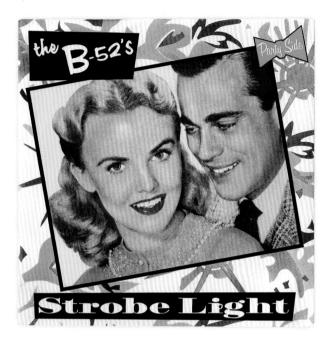

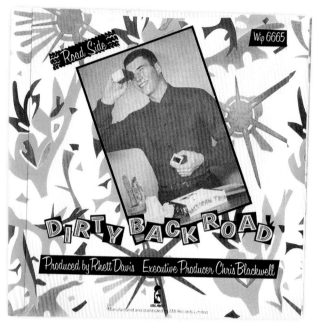

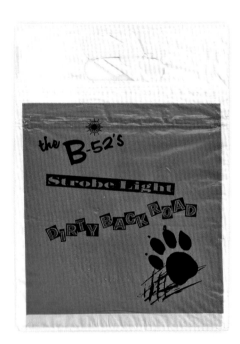

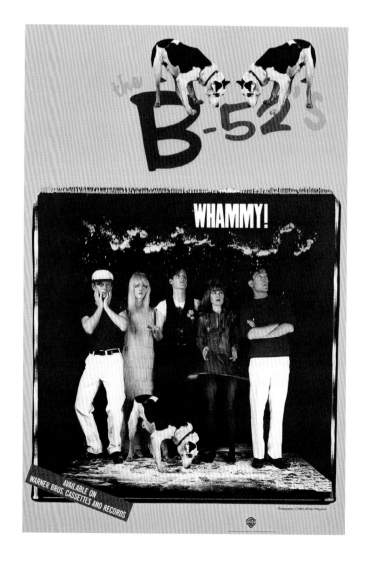

THE B-52'S: (above) 'Strobe Light' 45 branded carrier bag (Island Records, 1980); (right) *Whammy*, third LP poster (Warner Bros. Records, 1983).

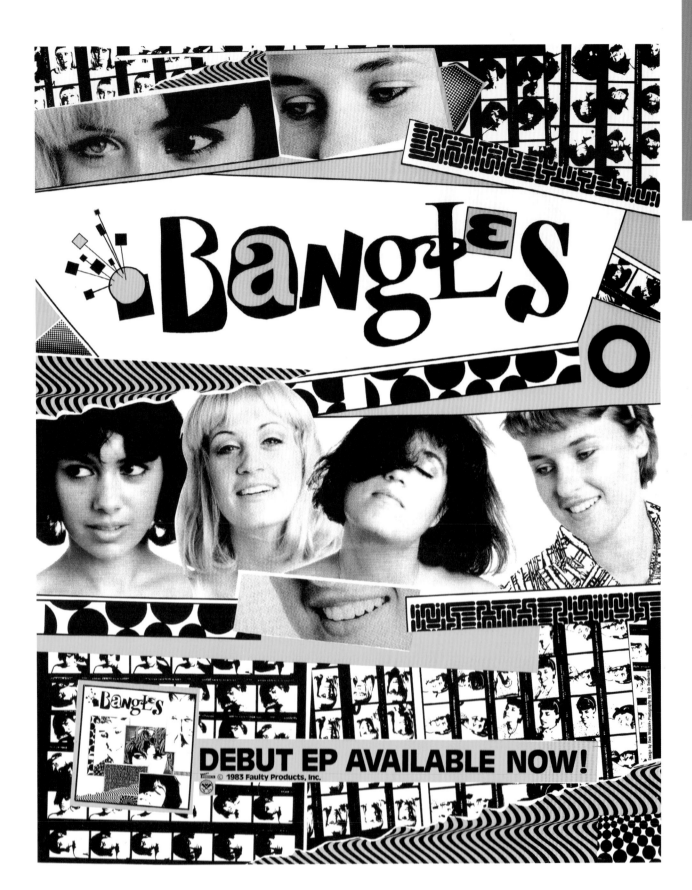

BANGLES: Self-titled debut 12" EP poster (Alternative Tentacles Records, 1982); **Bob Seidemann** photography.

36

BERLIN: 1 Flyer for gig at the Town &
Country Club, London, 9 March 1987;
2 Flyer for concert at Turning Point,
Toronto, Canada (c. March 1980).

BESERKLEY RECORDS: 3 Promotional
poster including Jonathan Richman and
the Modern Lovers, 1976; 4 In-store display
card c. 1976.

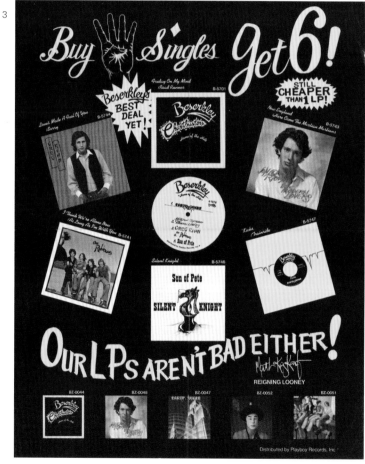

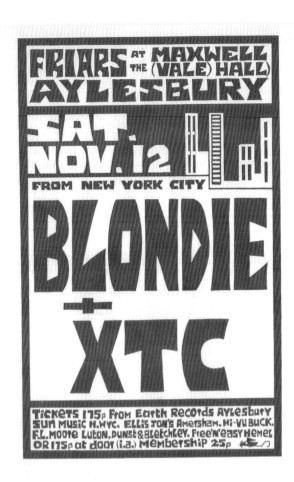

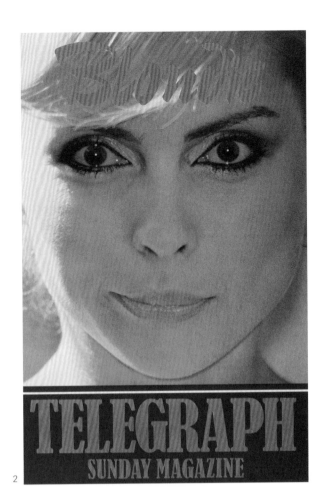

BLONDIE: 1 Concert with XTC, Friars at Maxwell (Vale) Hall, Aylesbury, England, 12 November 1977. This began the six-month tour to promote the *Plastic Letters* LP that catapulted Blondie to international fame; **2** *Sunday Telegraph* poster, 1978; **3** Concert in Erlangen, Germany, 22 September 1978; **4** 'Heart of Glass' 45 die-cut promo poster (Chrysalis Records, 1979).

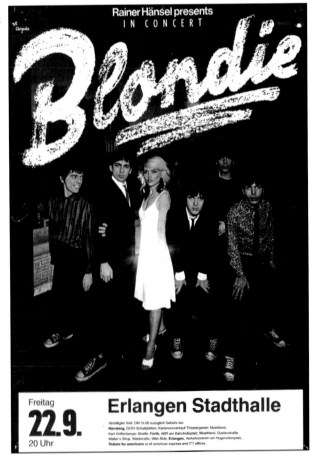

4

A NEW 12" SINGLE FROM
BLONDIE

(I'm always touched by your) Presence, Dear.
c/w Poets Problem. Detroit 442

STOP PRESS
Initial 12" pressings have been sold very quickly. However all 7" singles will also have 3 tracks and a special bag.

CHRI166 PLASTIC LETTERS

Chrysalis
Records & Tapes

CHRI165 BLONDIE

LIMITED EDITION
ONLY 80p.

BLONDIE: '(I'm Always Touched by Your) Presence, Dear' 45 poster (Chrysalis Records, 1978).

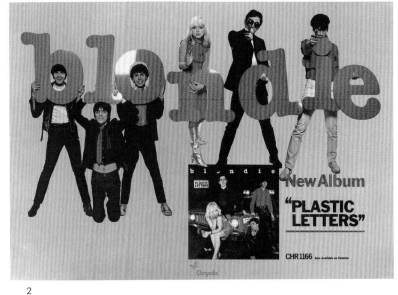

BLONDIE: 1 Image from inside Blondie Valentine's Day card (Chrysalis Records, *c.* January 1977); **Shig Ikeida** photography. The photograph on the front of the card was used for the poster promoting the band's debut LP; **2** *Plastic Letters* LP poster (Chrysalis Records, 1978); **3** 'Picture This' 45 sheet music (EMI Music, 1978); **4** Valentine's Day card, possibly a **Roberta Bayley** design (Chrysalis Records, 1978); **5** *Parallel Lines* LP poster (Chrysalis Records, 1978).

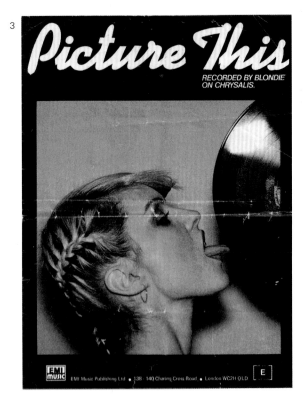

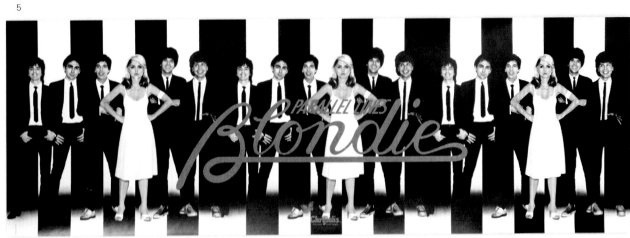

BLONDIE: **1** *Eat to the Beat* LP poster (Chrysalis Records, 1979); **Billy Bass** art direction, **Norman Seeff** design and photography, **John Van Hamersveld** typography; **2** Endorsement posters for Ampex cassette tapes (1978), and **3** (1979).

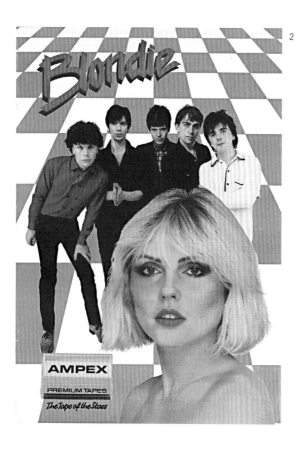

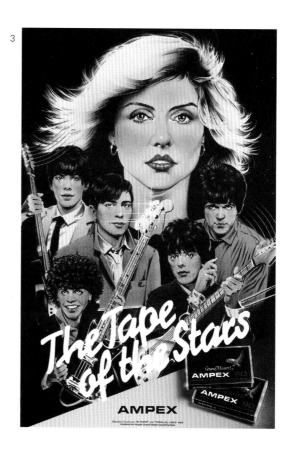

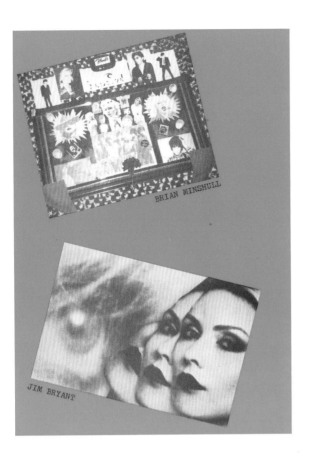

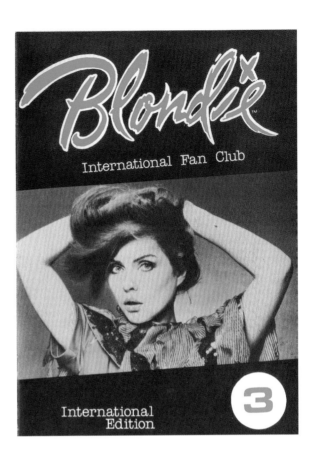

BLONDIE: (above left and right) *Blondie International Fan Club* issue 3, 1981; above left, **Brian Minshull** and **Jim Bryant** photography; above right, with an uncharacteristically brunette Debbie Harry; (below) Poster promoting the *Blondie* book by Lester Bangs (Fireside Books, 1980).

BLONDIE: 3XY Radio (AM 1422) flyers, Melbourne, Australia, 23 March 1979.

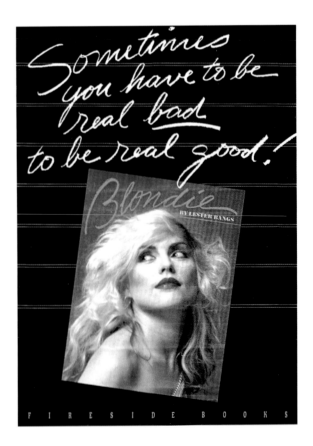

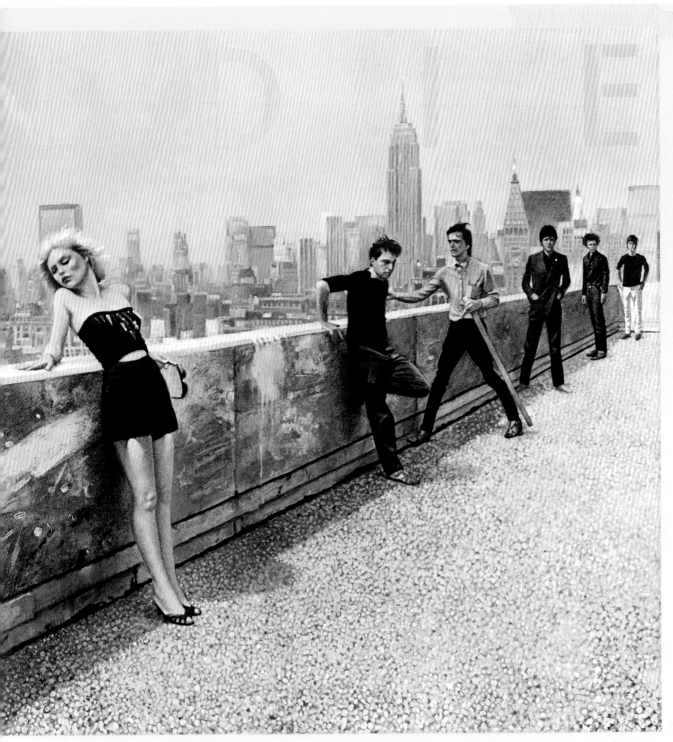

BLONDIE: *AutoAmerican* LP poster
(Chrysalis Records, 1980); **John Van
Hamersveld** design, **Martin Hoffman**
painting.

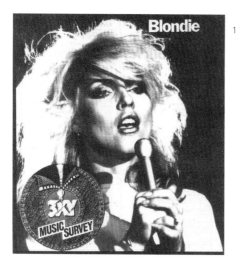

1

2

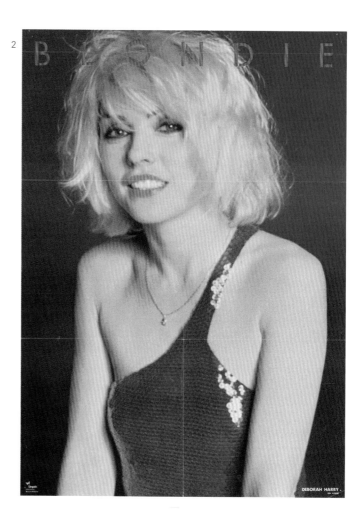

BLONDIE: 1 3XY Radio (AM 1422) flyer,
Melbourne, Australia, 6 June 1980; **2** Poster
included in Japanese pressings of the
AutoAmerican LP, 1980; **3** Poster to promote
a (cancelled) tour, sponsored by Pioneer, of
The Hunter LP (Chrysalis Records, 1982);
4 *KooKoo* solo LP (Chrysalis Records, 1981);
H.R. Giger design, **Brian Aris** photography.

44

3

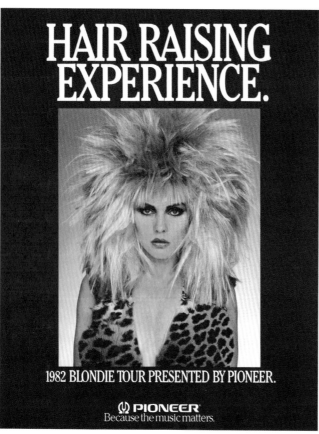

4

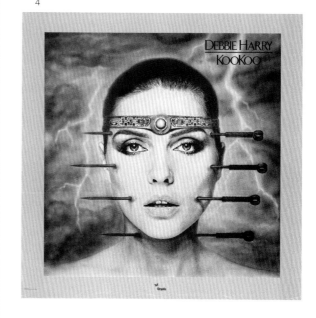

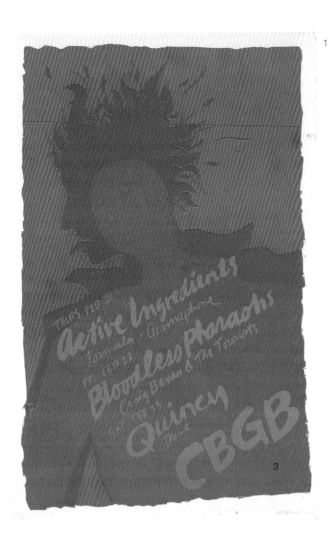

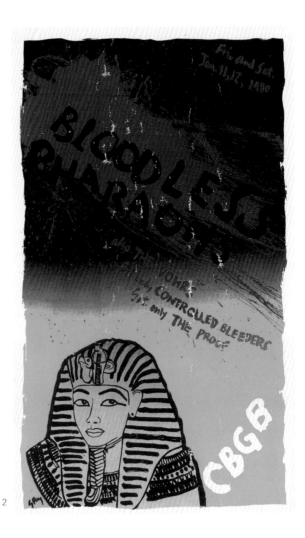

BLOODLESS PHARAOHS: 1 Silkscreen-printed poster for CBGB concert, NYC, 22 February 1979; **2** Serigraph poster for concert at CBGB, NYC, January 1979; **3** Gig flyer for Max's Kansas City, NYC, 24 September 1979. Bloodless Pharaohs never secured a record deal, but a handful of recordings are now available. Notably, the guitar player was Brian Setzer, later of Stray Cats.

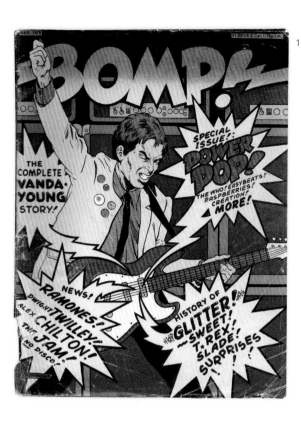

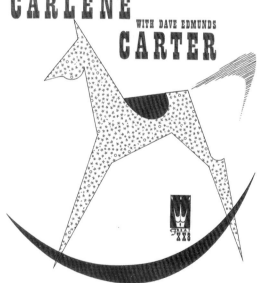

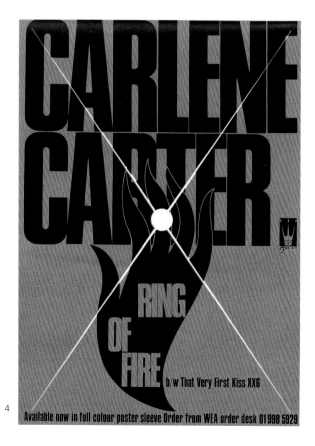

BOMP! MAGAZINE: 1 Special Power Pop! Issue, March 1978; **BRAD LONG: 2** 'Love Me Again/Come to Me' 45 flyer (self-release, 1977); **CARLENE CARTER: 3** Sales sheet for 'Baby Ride Easy/Too Bad About Sandy' 45 (F-Beat Records, 1980); **4** Sales sheet for 'Ring of Fire/That Very First Kiss' 45 (F-Beat Records, 1980). Country music singer Carlene Carter is June Carter's daughter and Johnny Cash's stepdaughter. She was married to Nick Lowe from 1979–90.

THE CARS: 1 *Candy-O* LP promotional mobile (Elektra Records, 1979); **Alberto Vargas** artwork; **2** 'Just What I Needed' 45 (Elektra Records, 1978); **3** 'My Best Friend's Girl' 45 (Elektra Records, 1978); **4** Collage poster for debut album *The Cars* (Elektra Records, 1978); **Jerome Jordan Higgins** design.

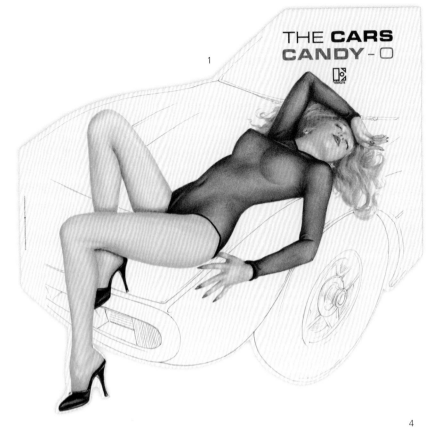

THE CARS: 1 *Shake It Up* LP (Elektra Records, 1981); **David Robinson** cover design, **Clint Clemens** photography; **2** *Panorama* LP advertisement from *Billboard* magazine (Elektra Records, 1980); **David Robinson** design, **Paul McAlpine** photography; **3** *Door to Door* LP poster (Elektra Records, 1987); **Marco Glaviano** photography and design, **Emanuele DiLiberto** painting.

2 3

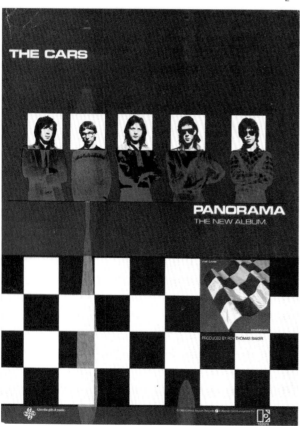

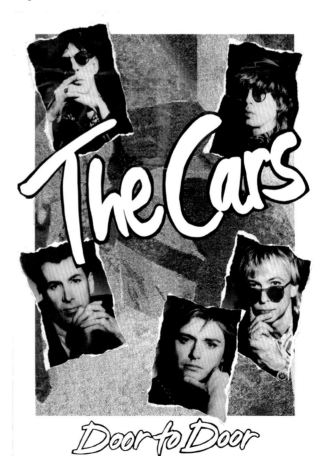

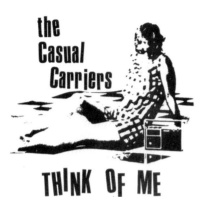

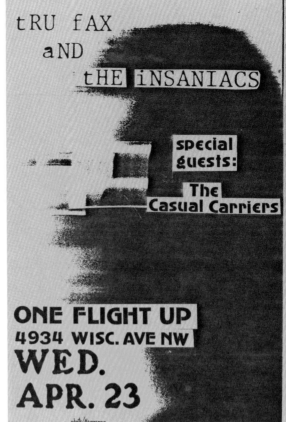

THE CASUAL CARRIERS: 1 'Think of Me' 45, the band's only single (Casual Tones Records, 1981); **2** Flyer for concert at One Flight Up, Washington D.C., 23 April 1980; **Hammerman** photography.

CHRIS STAMEY: 3 *It's a Wonderful Life* LP (dB Records, 1982).

CHROME DINETTE: 4 Flyer for San Francisco synth band, early 1980s.

CLUB FLYERS/CLUB 57: **1** Event calendar at 57 St Mark's Place, NYC, September 1980; **FIRST AVENUE: 2** Monthly calendar advertisement paste-up for venue in Minneapolis, MN, showing the eclectic range of bands that were touring in August 1983 — both Alan Vega and New Order appeared at First Avenue that year; **HOT BODIES: 3** At Ron's Place, New Haven, CT, 27 and 28 April, and the Alehouse 30 April, c. 1980; **SAUCERS: 4** With The Human Switchboard at Ron's Place, New Haven, CT, 10 and 11 August 1980.

1

2

CLUB FLYERS/NEW JOHNNY 5: 1 At Ron's Place, New Haven, CT; 'Music for the Modern Age', *c.* 1980; POODLE BOYS: 2 With Saucers at Saloon, formerly Oxford Ale House, *c.* 1980; THE NEXT: 3 At Ron's Place, 16 and 17 November, *c.* 1980; SPEEDIES: 4 At Studio 10, NYC, *c.* March 1980.

3

4

CLUB FLYERS / THE STARSHIP: Milwaukee club monthly gig schedule flyers (clockwise from upper left): March 1981; April 1981; September 1981; June 1981.

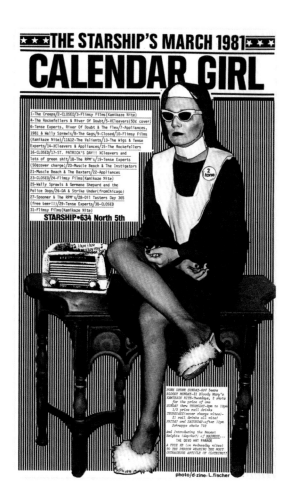

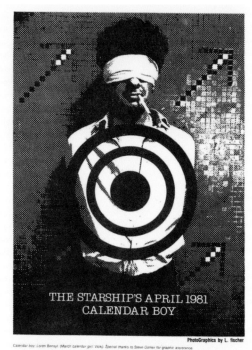

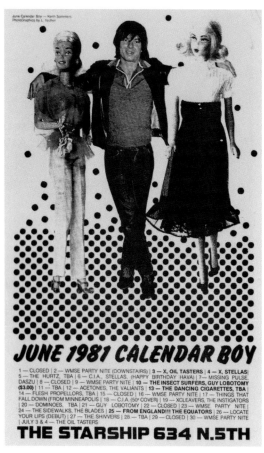

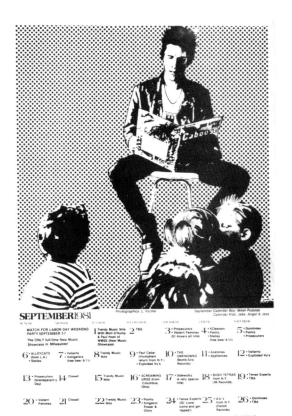

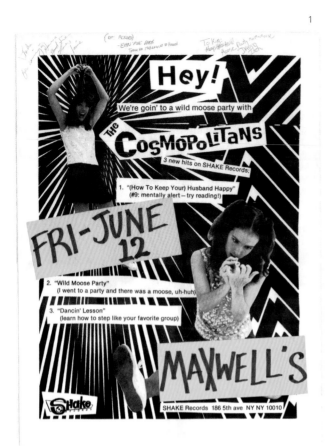

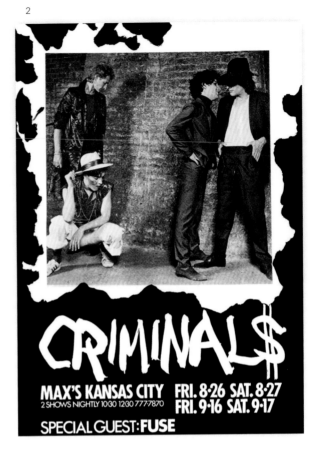

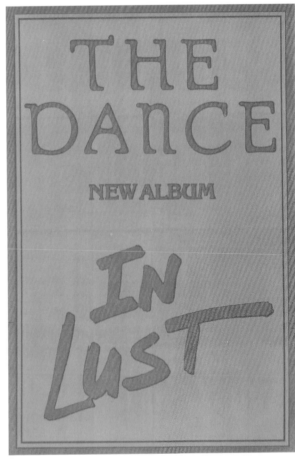

THE COSMOPOLITANS: 1 Poster for gig at Maxwell's in Hoboken, NJ, 12 June 1980 (Shake Records).

THE CRIMINALS: 2 Fronted by Sylvain Sylvain, co-founder of New York Dolls. With The Fuse at Max's Kansas City, August and September 1977.

THE DANCE: 3 *In Lust* LP poster (Statik Records, 1982).

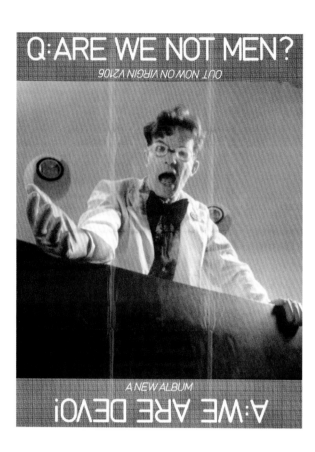

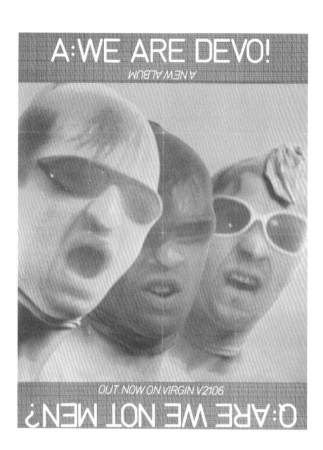

54

DEVO: (above) *Q: Are We Not Men? A: We Are Devo!* LP posters (Virgin Records, 1978); **Devo Inc.** graphic concept and execution, **Bobbi Watson** photography.

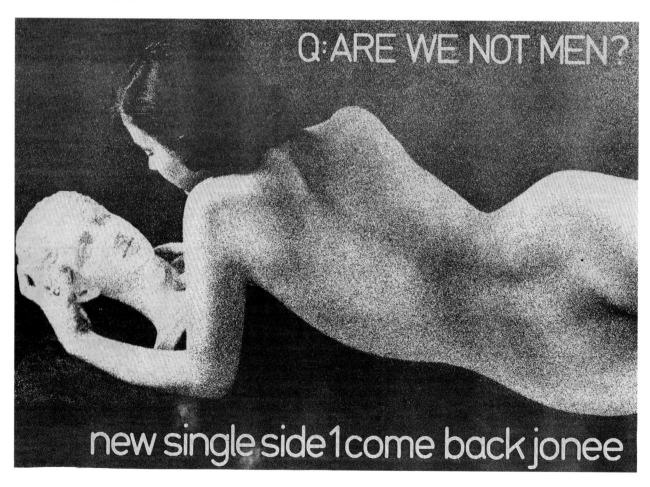

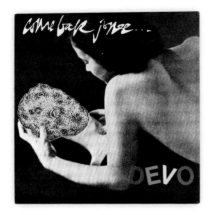

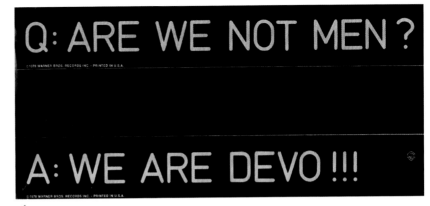

1

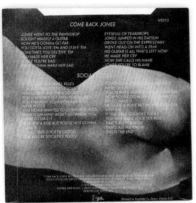

2

DEVO: 1 *Q: Are We Not Men? A: We Are Devo!* promotional stickers (Warner Bros. Records, 1978). This question and answer motif was likely inspired by the movie *The Island of Lost Souls* (Paramount Pictures, 1932). In this horror masterpiece Bela Lugosi plays the leader of Dr Moreau's half-man/half-beast creations, responding to Moreau's demand 'What Is the Law?' with 'Are We Not Men?'
2 'Come Back Jonee' 45 front and back cover (Virgin Records, 1979); **3 (includes facing page)** 'Come Back Jonee' 45 advertisement from *NME* magazine (Virgin Records, 1979); **Devo, Inc.** graphics.

55

3

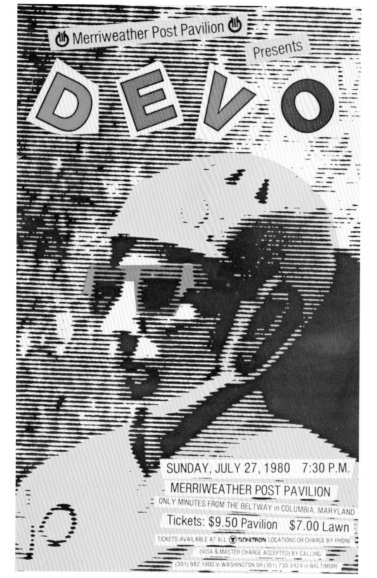

DEVO: 1 Badge sheet (Stiff Records, 1978); **2** German tour poster, June 1980; **3** *Shout* LP poster (Warner Bros. Records, 1984); **Devo** concept, **Karen Filter** photography.

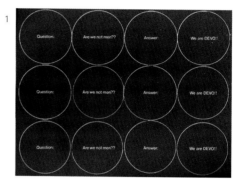

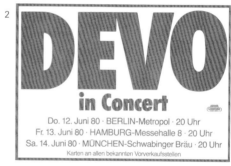

THE DIODES: (below left) Self-titled debut LP poster
(Columbia Records, 1977); **Ken Steacy** design, **Carol
Starr** photography; (below right) With The Erasers at
Max's Kansas City, November 1977 (CBS Records);
Carol Starr photography.

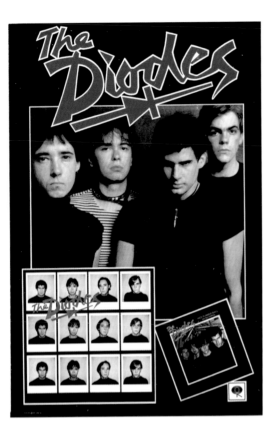

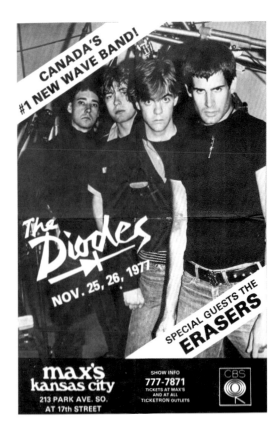

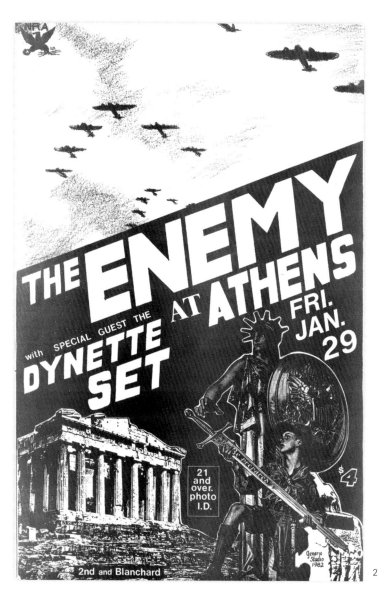

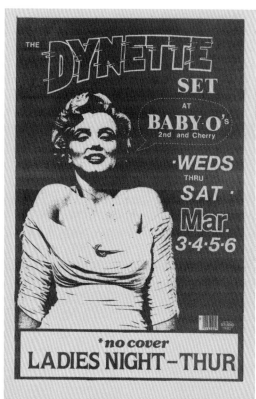

THE DYNETTE SET: **1** At Baby-O's, Seattle, WA, March 1982; **2** At Athens Cafe, Seattle, WA, supporting The Enemy, 29 January 1982.

THE EXTRAS: **3** *Bit Parts* LP poster (Ready Records, 1981).

1

2

3

4

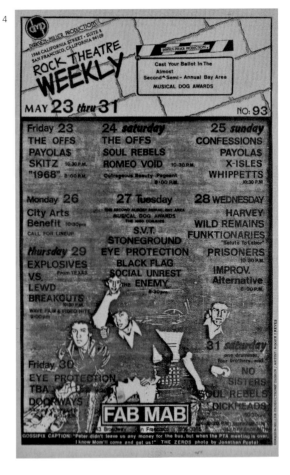

VIDEO KILLED THE RECORD COVER?

Philip Brophy

If you're in a hipster band putting your latest drone/ noise/vaporwave/Italo-disco/witch-house release on Bandcamp, you'll need something that lets people know where your image allegiances lie. You'll have to either go full arty and have some vague out-of-focus photo of nature, or do something that looks really bad, like an embarrassing 1980s high-school science textbook with pseudo-computerized imagery and awful colour clashes. A quick Google search will help: maybe try emulating the 7" cover to Buggles' 'Video Killed the Radio Star' (1980).

The font is a simulation of LCD lettering, as on old digital clock-radios. Trevor Horn and Geoff Downes are on the cover, sporting short yellow shirts with skinny green tie and grey trousers. Mulleted hair, pouting stares with hands on hips, they look like a couple kids who work at Radio Shack but dream of being in a band like The Cars. They have been rendered in faux-scanned lines, somewhere between an extreme close up of a 1970s CRT monitor or a lo-res fax scan. It's not, but it's been made to look like that. It joins a lineage of graphics pretending to be made by computer before computers were invented to make such imagery. It's a quaint historical moment, when the means by which one makes an image could be foregrounded as a strategy in and of itself. Nowadays (feigned hipster sigh) all imagery is hi-res, cine-styled, Google-searched, Instagram-prepped. So it's no wonder that so many Bandcamp covers resemble the Buggles' cover.

What was that cover like forty years ago? It looked pretty awful. Compared to what Kraftwerk, Devo, The Residents and M were doing with their various brands of 'meta-pop' musically and visually, Buggles was like a pop industry signing riding the avant-garde experiments of others. But Buggles was unashamedly pop. That cover signposts what was happening to record cover graphic design at the dawn of the 1980s. As record companies deployed their resources for all sorts of new wave gambits, their managerial infrastructure determined the visual marketing of their signed artists. This entailed either in-house company design, or subcontracts for design companies already soaked in advertising mentality. Punk/post-punk independent graphic designers who worked closely with musicians and bands (mostly by being friends, fans, punters or

MTV: First sticker, part of pre-launch promotional package for the music video channel, 1981.

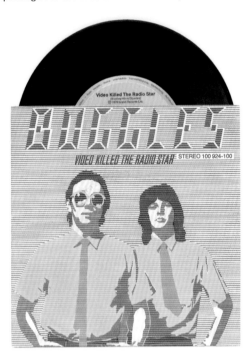

BUGGLES: 'Video Killed the Radio Star' 7" 45 (Island Records, 1979).

art-school comrades) were largely out of this professional loop. This accounts for the wide range of styles adorning new wave record covers through the early 1980s. Many of them lack spark and edge; most look moulded by mainstream aesthetics dressing-up in ill-fitting concepts.

Yet as larger record companies took over much new wave releasing (thereby determining a mass reading of what new wave should look and sound like), punk/post-punk strategies still percolated. The early 1980s is a period where rock-aligned new wave was drowned out by the neo-pop, hyper-produced, electronic/ sampled sonics of club mixes which energized New Romanticism and Synth Pop. The Human League's *Dare* (1980) is the boldest statement of its era, mainly because it so fully cannibalizes its reference to a *Vogue* magazine cover. The same sophistico Didot font spells out LEAGUE. Phil Oakey's made-up face is boxed by a white void, his key facial features left to resonate like a human logo, cunningly referencing the band's name. The earlier incarnation of The Human League flirted with industrial cut-up imagery and alienating corporate visuals, but the new band — going for synth-pop glory — empties itself of such expressionistic traits.

ABC's *The Lexicon of Love* (1982) is postmodern affectation writ large, signalled by the cover photograph of singer Martin Fry playing a detective, shooting off-screen while holding a fainting damsel. The clincher is the setting: a West End London stage production, replete with red curtain and faux brick wall. The conservative classy font (tall, seriffed, elegant) is positioned more like a theatre programme from the 1940s than a 1980s record sleeve. The record is possibly the first declaration of a love of theatrics and artificiality in the 1980s — two themes the preceding countercultures fought hard and long to dismantle, if not destroy. Fry's sassy lurid lyrics and anguished Billy Fury vocals are perfectly set against the neo-pop production, provided by one Trevor Horn. The whole package is archly British, and clearly enamoured of the British stylistics produced by the creative team of Michael Powell and Emeric Pressburger for their cycle of stunning stylized movies in the 1940s.

ABC: *The Lexicon of Love* LP (Mercury Records, 1982); **Visible Ink** design, **Gered Mankowitz** photography.

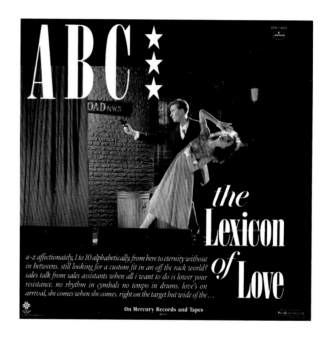

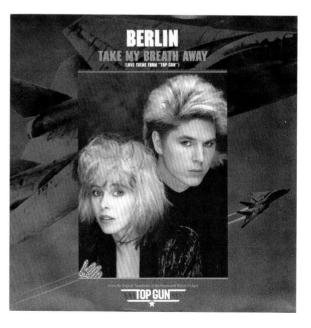

BERLIN: 'Take My Breath Away (Love Theme from "Top Gun")' 45 (Columbia Records, 1986); **Brian Aris** photography.

THE HUMAN LEAGUE: *Dare* LP poster (A&M Records, 1982); **Philip Oakey** and **Philip Adrian Wright** design, Ken Ansell at **Ansell Sadgrove** artwork, **Brian Aris** photography.

The Human League and ABC were emblematic of being 'image-conscious': they weren't simply attracted to images; they wanted to control how they made themselves into images. It's part-glam, part-punk, all-retro. 'Video Killed the Radio Star' looks like it's trying to be the future and failing. *The Lexicon of Love* looks like it's in a frozen time-warp of any era but its own, which allows it to carry on the punk/post-punk strategy of subcultural signification. *Dare* looks like a promotional tie-in with *Vogue*. It flagrantly refuses all interest in the reality of rock music

whatsoever. These smarmy moves constitute a deliberate reversal of communication. No wonder advertising agencies and their graphics departments did such woeful new wave designs, because according to their logic, marketing is always about clearly communicating something to sell it.

The Smiths' 'This Charming Man' (1983) is the second of what would be twenty-eight record covers over four years featuring portraits or stills of actors, writers and playwrights who inspired The Smiths' leader Morrissey. This was an anti-

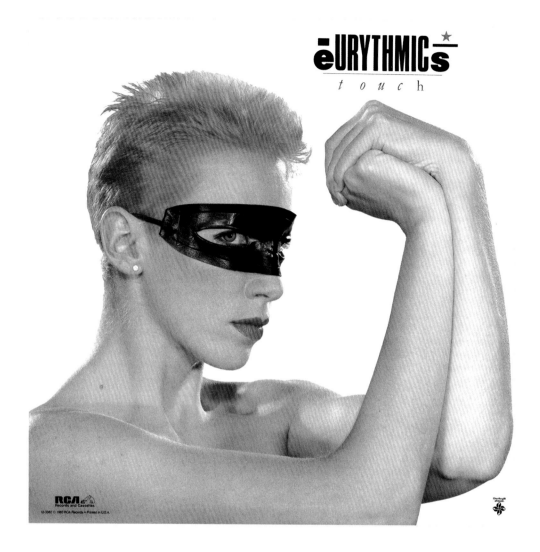

EURYTHMICS: *Touch* LP poster (RCA Records, 1983); **Laurence Stevens** artwork and design, **Peter Ashworth** photography.

marketing declaration by Morrissey, refusing to be the 'product' labelled by the record cover, something that an independent like Rough Trade clearly supported. 'This Charming Man' features Jean Marais, in a scene from visionary French cinéaste Jean Cocteau's *Orphée* (1950) where he is lying prone, gazing into his image on a mirrored surface. Morrissey's connection with the image dances around Continental allure, homoeroticism, and libertine poetics. Little did he realize how those same sensibilities would be rerouted into something entirely opposite by a new image-making concern: MTV.

As is well known, the first music video played by the fledgling cable start-up was Buggles' 'Video Killed the Radio Star' in mid-1981. That single video would unintentionally set off the second British Invasion of the recording industry, as MTV's subscriber-service channel needed content to feed its subscribers. For various reasons, the American majors were not initially interested in supporting the production costs of video for what they viewed as a radio station with images. It was the record companies of British artists who footed the bill for videos to break them in the US, hence the deluge of British artists appearing in heavy rotation for the first few years of MTV.

British bands meant British aesthetics and sensibilities. Visually, these were inherited from the styles, tastes and interests expressed by punk, post-punk, new wave, New Romantic, industrial and synth pop. A few years earlier, these designers had been scouring the past of cool-looking print sources for their record covers.

CULTURE CLUB: (right) *Kissing to be Clever* debut LP poster (CBS, 1982).

BILLY IDOL: (below) 'Eyes without a Face' EP poster (Chrysalis Records, May 1984).

Now 1980s designers were fast-forwarding VHS tapes to find scenes to re-do in the pseudo-cinema spectacles of music videos. MTV's first few years are chock-full of videos aping moments from Hollywood classics, underground movies and European arthouse epics. Jean Cocteau in particular provided a bounty of scenes for these video-makers, with giddy Surrealism and arch staging. For a short time, pop music seemed to be all about arty movies, symbolism and Freudian dreams. MTV definitely presented things that way.

Accordingly, the record covers of some of its early stars were glossy portraits of singers posing as if they lived their artiness 24/7: Culture Club's 'Karma Chameleon' (1983) (Boy George's ambigender transcultural hybrid of stylistic overload); Eurythmics' *Touch* (1983) (Annie Lennox restaging David Bowie's *"Heroes"* as a glossy Euro femme fatale); and David Bowie's *Let's Dance* (1983) (a melange of art allusions with Bowie shadow-boxing in front of a projected slide). A twist on this was Billy Idol: former Generation X front-man, now repackaged as a Brit-punk Elvis. Fuelled by peroxide and Keith Forsey's massive snare drum reverb, his record covers all feature him in heart-throb-portrait mode, emblazoned with a tilted logo of extended Futura-font caps: IDOL. It's quite cynical when you think about it.

As well as this televisualization and the US marketing drive, a key 1950s print source for designers was the British Independent group, British

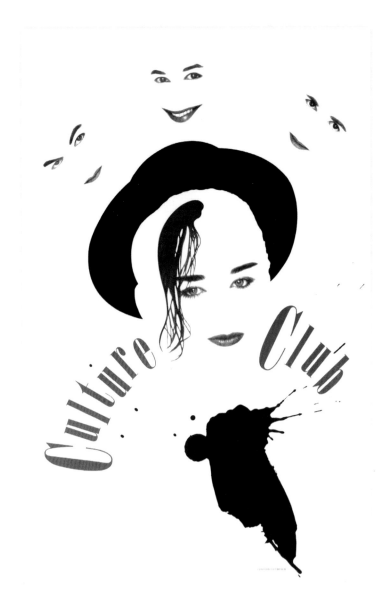

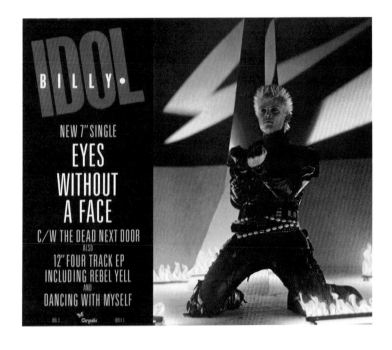

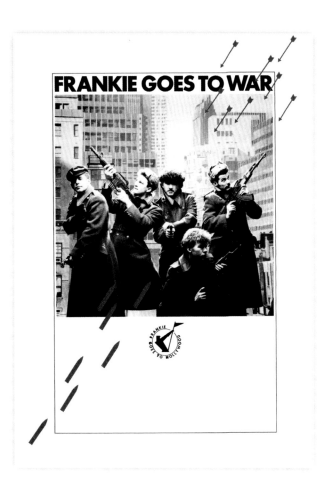

FRANKIE GOES TO HOLLYWOOD: (left) 'Frankie Goes to War (Two Tribes)' 45 poster (ZTT Records, c. 1984); **Eric Watson** photography.

Pop artists smitten by pop iconography (mostly derived from affluent US post-war culture), whose seminal exhibition, *This is Tomorrow*, had been staged at London's Whitechapel Art Gallery in 1956. The Independent group's love of pop imagery can be sensed in record covers like The Cars' *Candy-O* (1979) and Duran Duran's *Rio* (1984). The Cars' sound is classic AM-pop (hence Buggles' similar sonics) but tinged with a transatlantic nod to British new wave. They commissioned Alberto Vargas, an icon of 1940s illustration, to paint one of his slinky vixens atop a pencil-outlined car. A very 'meta' cover indeed. Duran Duran commissioned big-dollar illustrator Patrick Nagel to draft one vixen in his inimitable hard-lined pop-ish flatness. Duran Duran had previously released records where they posed like rich mannequins (a staple tactic for young New Romantics at the time) but now they were moving into hyper-image mode. This coincided with their extensive employ of Australian director Russell Mulcahy, whose videos became synonymous with the big-budget extravaganza, each one part-ironically and part-shamelessly based on movies. Nestled into MTV's aggressive rotation lists, these videos could make you think that bands no longer played instruments, but instead lived in fantasy worlds of big-screen dreaming. One of Mulcahy's earlier arty studio-shot clips? 'Video Killed the Radio Star'.

If Trevor Horn's bespectacled face birthed MTV, his glitzy sound contributed to its maturation. His production of Frankie Goes To Hollywood's 'Two Tribes' (1984) takes explosive dance-mix sample-drum explosions to an apocalyptic height. British duo Godley & Creme (another key British team providing cine-image content for MTV and whose later hit 'Cry' was produced by Horn) directed the music video, featuring a memorable WWF-style fight between actors portraying Ronald Reagan and then Soviet leader Chernenko. Holly Johnson sports a plaid suit and sings as if he's the commentator. The video was edited and censored by MTV, adding to its marketable controversy. One version of the 12" cover features a photo of the Leninist mural in Saint Petersburg (Soviet propaganda art was another mainstay of early punk/post-punk referencing). A second cover simply features a still from the music video. Might this be the moment when video killed the record cover?

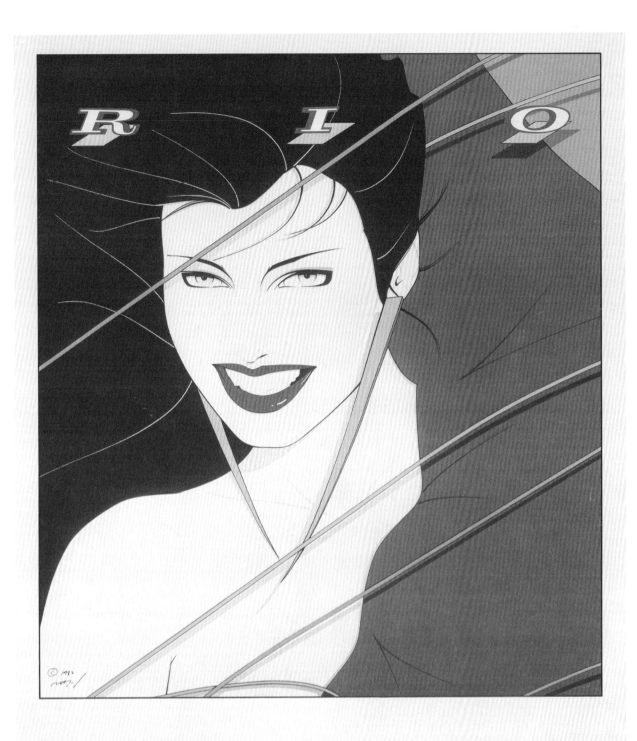

DURAN DURAN: *Rio* LP poster (EMI Records, 1982); **Malcolm Garrett** design, **Patrick Nagel** illustration.

A-HA: 1 *Hunting High and Low* debut LP poster (Warner Bros. Records, 1985).

1

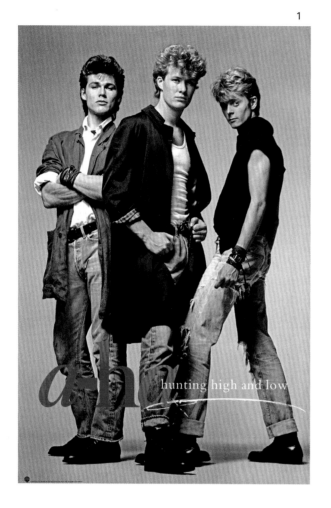

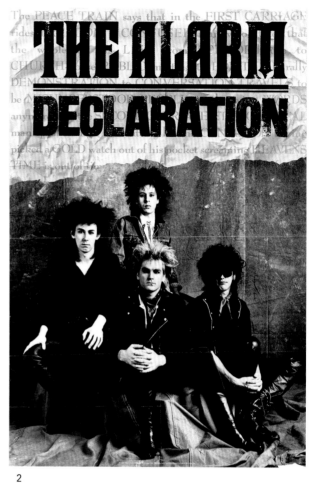

2

3

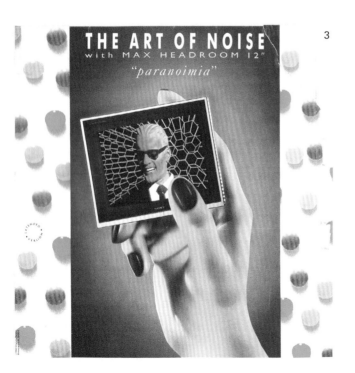

THE ALARM: 2 *Declaration* debut LP poster (I.R.S. Records, 1984); **Simon Adamczewski** artwork, **Stephen Oliver** photography.

THE ART OF NOISE WITH MAX HEADROOM:
3 'Paranoimia' Extended Version 12" poster (China Records/Chrysalis, 1986); **John Pasche** design.

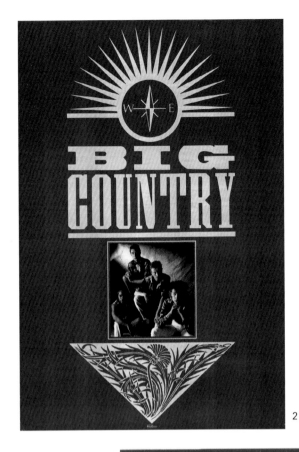

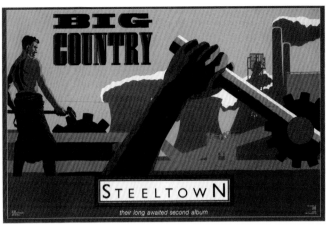

1

2

BIG COUNTRY: 1 *Steeltown* LP poster
(Mercury Records, 1984); **Jeremy
Bird** artwork; **2** *The Crossing* debut
LP poster (Mercury Records, 1982);
J. B. & Q. Branch artwork, **Paul Cox**
photography.

BILLY IDOL: 3 Self-titled debut LP
poster (Chrysalis Records, 1982);
Janet Levinson design.

3

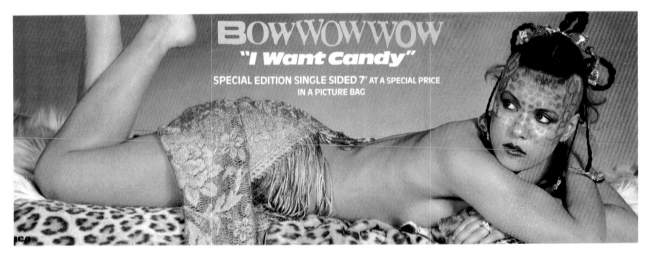

BOW WOW WOW: 4 'I Want Candy' 45 poster (RCA Records, 1982).

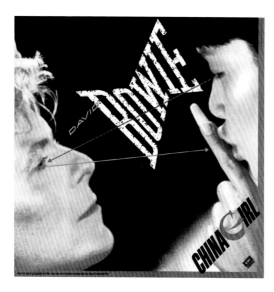

DAVID BOWIE: (left) 'China Girl' 45 poster (EMI America Records, 1983).

THE CARS: (right) *The Cars Greatest Hits* LP poster (Elektra Records, 1985).

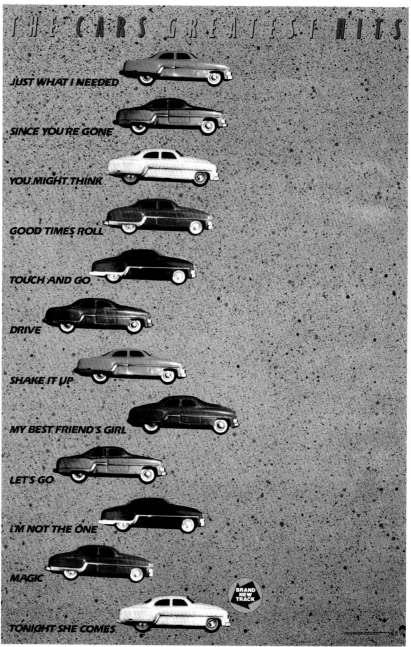

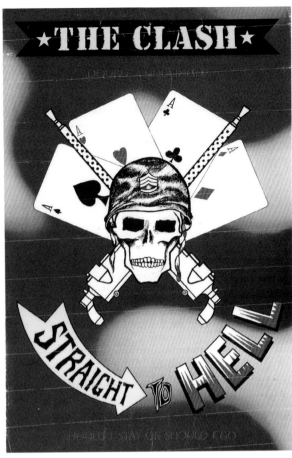

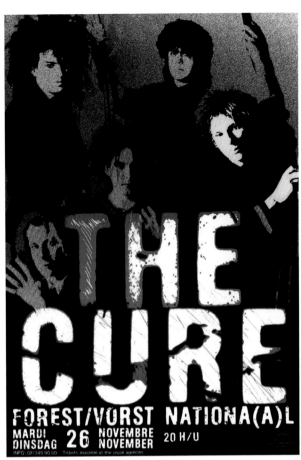

1 2

THE CLASH: 1 'Should I Stay or Should I Go / Straight to Hell' 45 poster (CBS Records, 1982); **Eddie King** artwork and design.
THE CURE: 2 Poster for concert in Belgium, 26 November 1985; **3** *The Head on the Door* LP poster (Elektra Records, 1985).
CYNDI LAUPER: 4 *True Colors* LP poster (Portrait/CBS Records, 1986); **Annie Leibovitz** photography.

3 4

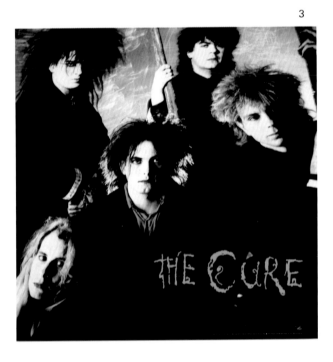

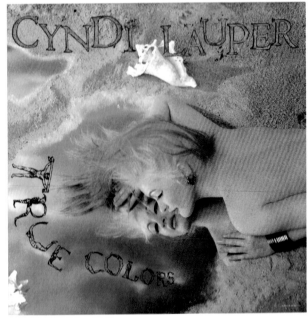

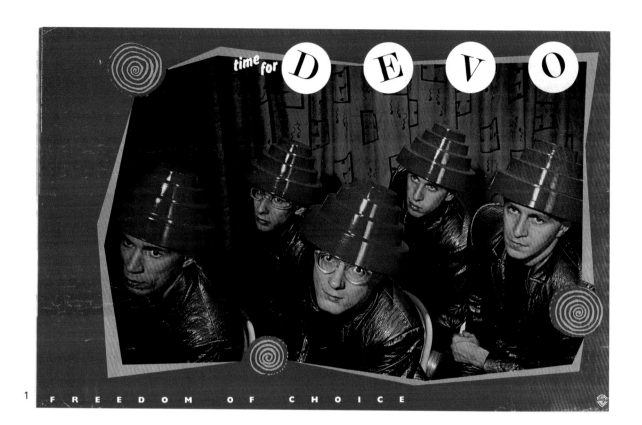

1 FREEDOM OF CHOICE

72 **DEVO: 1** *Freedom of Choice* LP poster (Warner Bros., 1980); **Artrouble** design; **DEXYS MIDNIGHT RUNNERS: 2** *Too-Rye-Ay* second LP poster (Mercury Records, 1982); **Peter Barrett** design, **Andrew Ratcliffe** painting; **DURAN DURAN: 3** *Seven and the Ragged Tiger* third LP poster (Capitol Records, 1983); **Malcolm Garrett** design (**Assorted iMaGes**), **Rebecca Blake** photography.

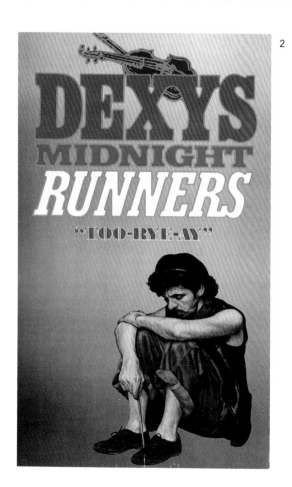

2

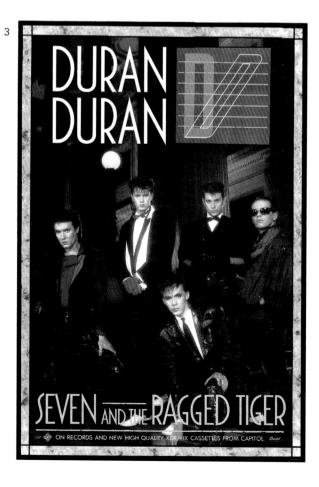

3

EURYTHMICS: 1 *Be Yourself Tonight* LP poster (RCA, 1985); **Laurence Stevens** artwork, **Paul Fortune** photography; **ELVIS COSTELLO AND THE ATTRACTIONS: 2** *Punch the Clock* LP poster (F-Beat Records, 1983); **Phil Smee at Waldo's Design & Dream Emporium** design, **Nick Knight** photography; **THE FIXX: 3** *Phantoms* LP poster (MCA Records, 1984); **George Underwood** design; **A FLOCK OF SEAGULLS: 4** *The Story of a Young Heart* LP poster (Jive/Arista Records, 1984).

73

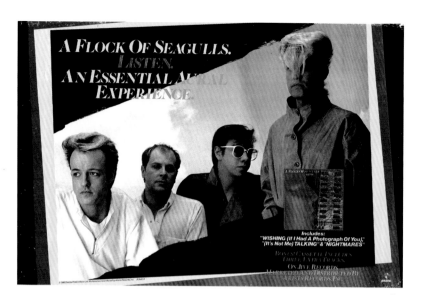

1

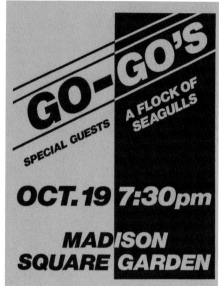

2

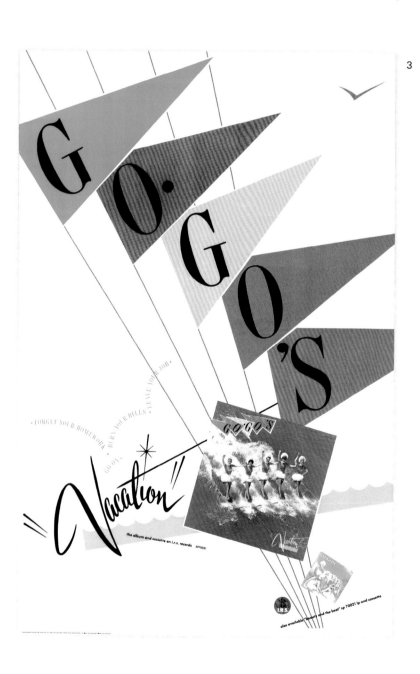

3

A FLOCK OF SEAGULLS: 1 *Listen* LP poster (Jive/Arista Records, 1983); **Pete Watson** cover design.

GO-GO'S: 2 With A Flock of Seagulls at Madison Square Garden, poster, 19 October 1982; **3** *Vacation* LP poster (I.R.S. Records, 1982).

HAIRCUT ONE HUNDRED: (right) *Pelican West* LP poster (Arista Records, 1982); **Gered Mankowitz** cover photography; (below) Set of three promotional plastic combs (Arista Records, 1982).

HOWARD JONES: (left) *Dream into Action* LP poster (Elektra/WEA Records, March 1985); **Rob O'Connor** design, **Simon Fowler** photography.

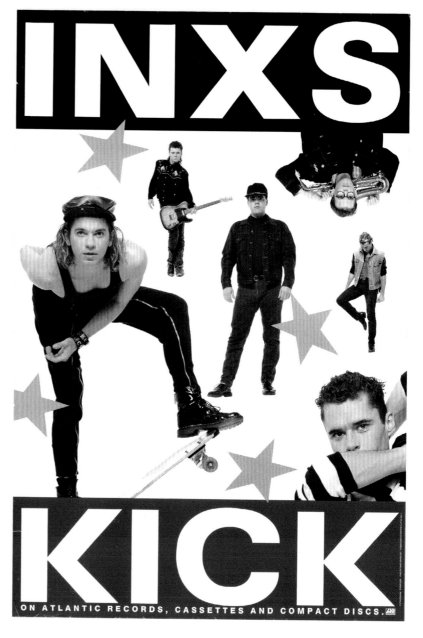

INXS: (above) 'What You Need' 45 poster (Atlantic Records, 1985; (right) *P*oster for *Kick* LP, the group's sixth album (Atlantic Records, 1987); **Grant Matthews** photography.

1

2

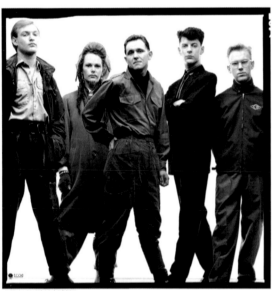

3

MEN AT WORK: 1 *Business as Usual* debut LP poster (Columbia Records, 1981).

MEN WITHOUT HATS: 2 *Rhythm of Youth* debut LP poster (Backstreet Records, 1983).

MODERN ENGLISH: 3 *After the Snow* LP poster (Sire Records, 1983).

THE POLICE: *Ghost In The Machine* LP poster (A&M Records, 1981); Mick Haggerty design.

PRETENDERS: (above left) 'Extended Play' EP poster (Sire Records, 1981); R.E.M.: (above right) *Document* LP poster (I.R.S. Records, 1987).

THE REPLACEMENTS: (above) *Tim* LP poster (Sire Records, 1985); **Robert Longo** cover artwork.

THE SMITHS: (left) 'How Soon Is Now' 45 sheet music (Rough Trade Records, 1984); **Morrissey** artwork, **Caryn Gough** layout.

SOFT CELL: (below) small banner poster for 'Tainted Love' 45 (Sire Records, 1981).

SPANDAU BALLET: (above) *True* LP poster
(Chrysalis Records, 1983); **David Band** illustration,
Lynn Goldsmith photography, **Stephen Horsfall**
typography.

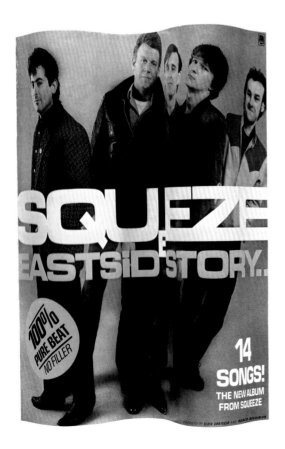

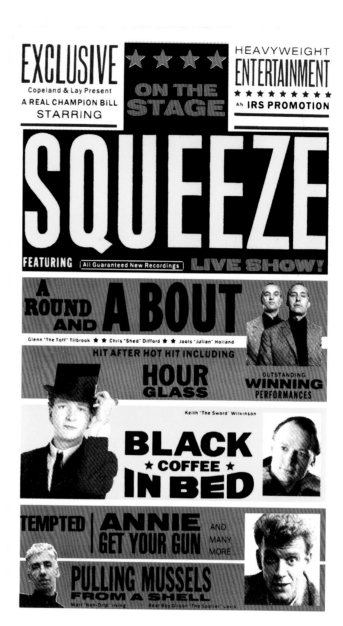

SQUEEZE: (above) *A Round and a Bout* Live
LP poster (I.R.S. Records, 1990); (left) *East
Side Story* LP poster (A&M Records, 1981);
Bob Bromide photography.

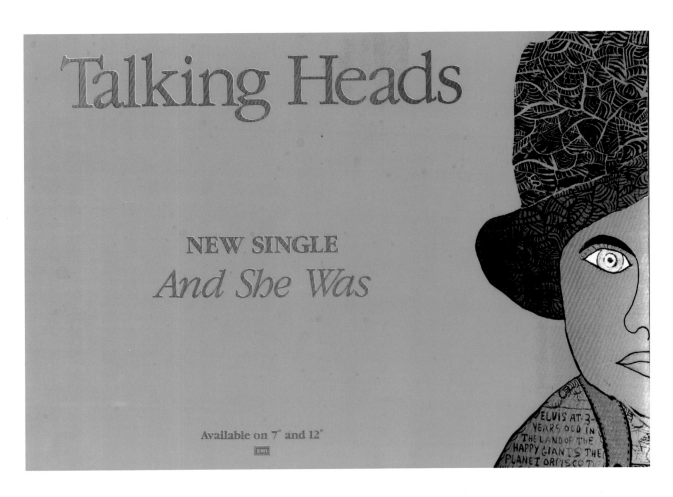

TALKING HEADS: (above) 'And She Was' 45 poster (EMI Records, 1985); **M&Co** design, **Rev. Howard Finster** artwork.

TALK TALK: (right) *It's My Life* LP poster (EMI Records, 1984); **Keith Breeden** design, **James Marsh** illustration.

82

TEARS FOR FEARS: (left) *Songs from the Big Chair* LP/tour blank (PolyGram/Mercury, 1985); **Tim O'Sullivan** photography.

THOMPSON TWINS: (left) *Here's to Future Days* LP poster (Arista, 1985); **Andie Airfix** artwork and design, **Rebecca Blake** photography.

'TIL TUESDAY: (above) *Voices Carry* debut LP poster (Epic, 1985); **Britain Hill** photography.

TOM TOM CLUB: (above) Self-titled debut LP banner poster (Island Records, 1981); **James Rizzi** illustration.

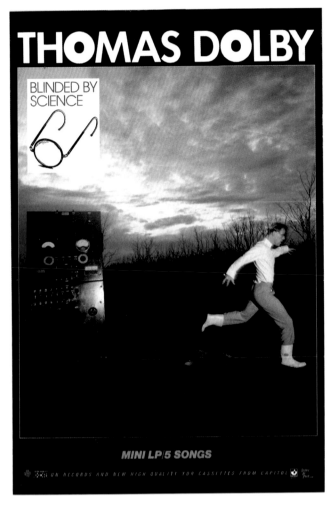

TONI BASIL: (above) 'Mickey' 45 banner poster (Chrysalis Records, 1981).

THOMAS DOLBY: (left) *Blinded By Science* mini-LP poster (Harvest Records, 1983); **Andrew Douglas** photography.

UB40: 'Red Red Wine' 12" 45 poster (DEP International, 1983).

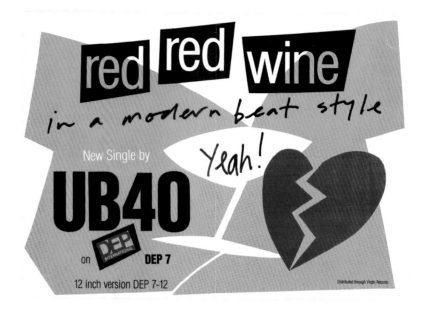

U2: (above) *War* LP poster (Island Records, 1983); **Anton Corbijn** photography.

VIOLENT FEMMES: (right) Self-titled debut LP poster (Slash Records, 1983); **Jeff Price**, **Laurie Lindblom**, **Geoff Worman** design; **Ron Hugo** photography.

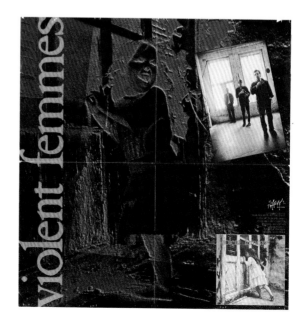

WALL OF VOODOO: *Call of the West* LP poster (I.R.S. Records, 1982); **Stan Ridgway, Francis Delia, Stephen Sayadian** cover design; **Francis Delia** photography.

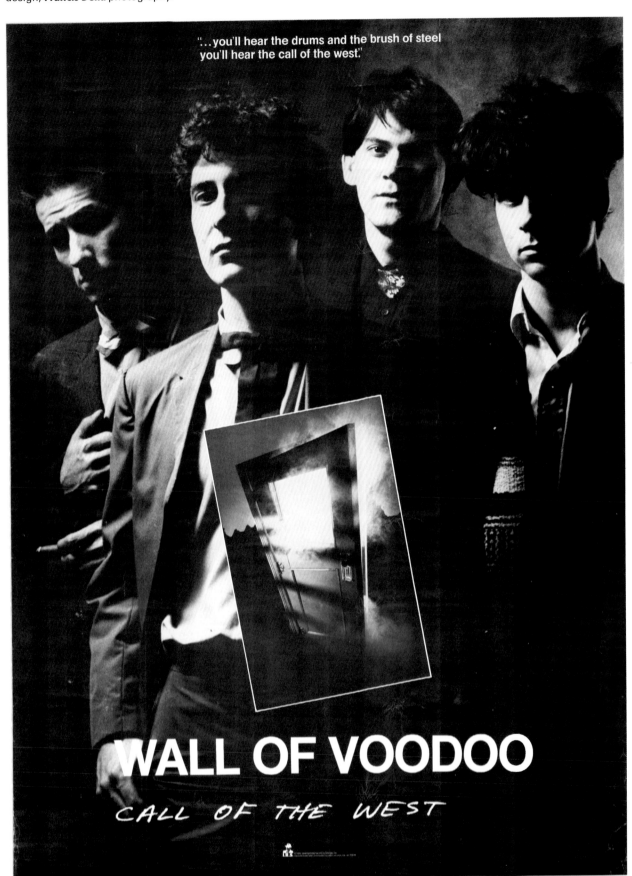

FINGERPRINTS: '(Now I Wanna Be A) Space Girl' EP (Twin/Tone Records, 1978); **John Henry** artwork.

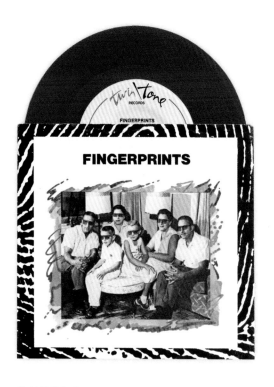

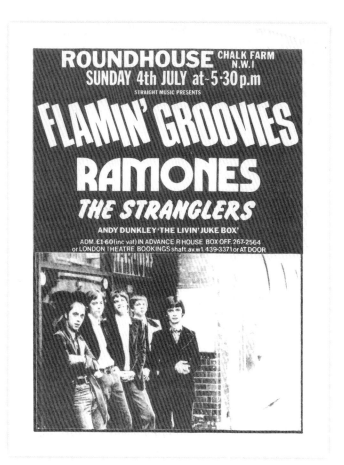

FLAMIN' GROOVIES: (below) With Radio Birdman, 1978 UK tour (Sire Records); (above) With Ramones at the Roundhouse flyer, London, 4 July 1976; **Armand Haye** photography.

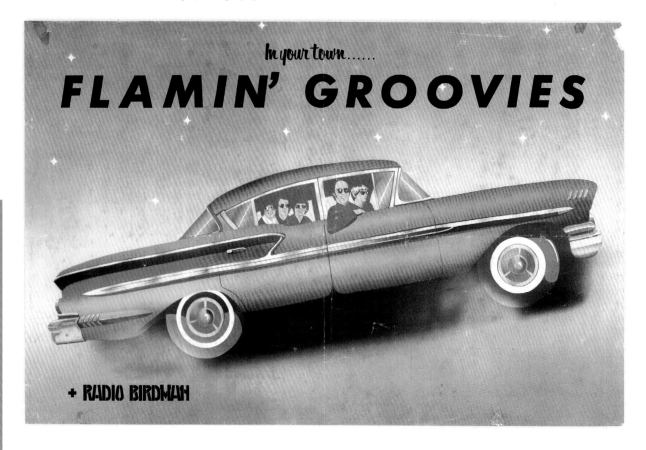

GO-GO'S: (above) 'We Got the Beat' 45 sheet music (Daddy-Oh Music, 1980); (above left) Debut LP teaser poster (I.R.S. Records, 1981); (below) *Vacation* 45 promotional sticker (I.R.S. Records, 1982); **Mick Haggerty** design and photography.

GRACE JONES

NEW YEARS EVE 1983
RIVER CLUB

MUSIC ☐ JOHN CEGLIA ☐ LIGHTS ☐ RICHARD TUCKER
10 PM ☐ ADVANCE TICKETS: MEMBERS $18 ☐ NON-MEMBERS $23 ☐ AT THE DOOR $30
TICKETS AVAILABLE WEDNESDAY THROUGH FRIDAY NOON TO 7 PM
OR DURING REGULAR CLUB HOURS ☐ 491 WEST STREET ☐ 924/6855
DESIGN GREG PORTO

GRACE JONES: 1 *Warm Leatherette* LP poster (Island Records, 1980);
2 *Island Life* compilation LP (Island Records, 1985); **Jean-Paul Goude**
design and photography. This image of Grace was created in 1978 using
several still photographs which were reassembled by Jean-Paul; **3** Poster
for New Year's Eve 1983 show at The River Club (NYC); **Greg Porto** design.

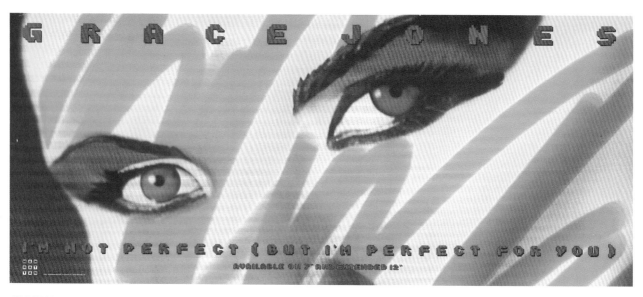

GRACE JONES: 'I'm Not Perfect (But I'm Perfect for You)' 45 poster (Manhattan Records, 1986).

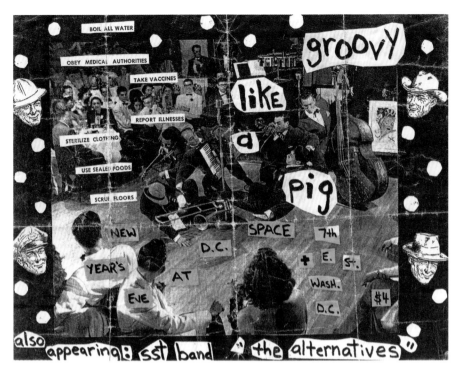

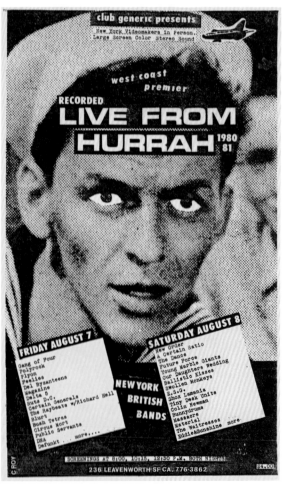

HUMANS: (left) 'Humans Play' mini-LP poster (I.R.S. Records, 1980); **Su Suttle** photography; (right) Flyer for a two-day festival of videos filmed at Hurrah, NYC, in 1980 and shown at Club Generic, San Francisco, c. 1981; **C. Roy** artwork. Frank Sinatra image from musical *On The Town* (MGM, 1949), which co-starred Gene Kelly and Ann Miller.

HUMAN SEXUAL RESPONSE

Fig. 14

HUMAN SEXUAL RESPONSE: (above) *Fig.14* LP (Passport Records, 1980); **Hipgnosis** and **Paul Maxon** cover artwork, **Richard Manning** photo-colouring.

HUMAN SWITCHBOARD: (right) *Who's Landing in My Hangar?* LP poster (Faulty Products, 1981); **John Thompson** design, **Thomas Simon** photography.

INTERNATIONAL RECORD SYNDICATE, INC.

I.R.S. GREATEST HITS VOLS. 2 & 3

ALTERNATIVE TV	THE POLICE	THE FALL	WAZMO NARIZ	BUZZCOCKS	
FLESHTONES	SECTOR 27	PAYOLA$	THE HUMANS	JOHN CALE	KLARK KENT
BRIAN JAMES	SQUEEZE	PATRICK D. MARTIN	THE STRANGLERS	SKAFISH	CHELSEA
HENRY BADOWSKI	JOOLS HOLLAND	OINGO BOINGO	THE CRAMPS	THE DAMNED	FASHION

I.R.S.: (left) *Greatest Hits Vols. 2&3* poster (I.R.S. Records, 1981); **Carl Grasso** design, **Scott Lindgren** photography.

1

2

3

THE JIM CARROLL BAND: 1 *Catholic Boy* debut LP poster (ATCO Records, 1980) (photo with his parents); **Annie Leibovitz** photography;
2 *Catholic Boy* LP poster (ATCO Records, 1980) (photo with his band); **Michael Haisband** photography; **3** *Dry Dreams* LP poster (ATCO, 1982); **Annie Leibovitz** photography.

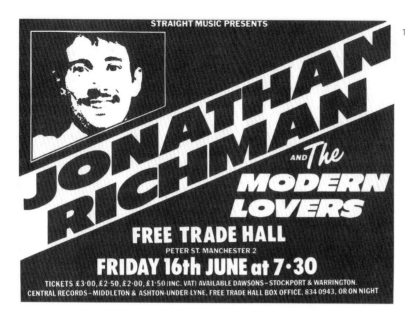

JONATHAN RICHMAN AND THE MODERN
LOVERS: **1** Flyer for concert at the Free
Trade Hall Manchester, 16 June 1977.

THE KINGBEES: **2** At Cal Poly Pomona
Theater, Pomona, CA, poster, *c.* 1982.

KLARK KENT: **3** 'Too Kool To Kalypso' 45
(Kryptone Records, 1978); **Klark Kent**
design, **Janette Beckman** photography.

THE KNACK: **4** At Eric's Liverpool flyer,
24 May 1979; **5** Personality poster
(Capitol Records, 1980, distributed by
fan club).

Laurie Anderson was a phenomenon. In the 1970s, she was a conceptually inclined artist with an established place on the New York art scene. Then, both to her own and everyone else's surprise, in 1981, her haunting 8-minute song 'O Superman' — 'So hold me, Mom . . . in your electronic arms' — went to number 2 in the UK single charts. She performed in London later that year at the Riverside Studios and she was electrifying. This was at the tail end of post-punk, but Anderson's emergence and 'crossover' was a perfect example of what made those years such a fertile and exciting time in rock music. The portrait by Greg Shifrin, used on her first album *Big Science* (1982) as well as the poster, captures her charismatic presence. Anderson radiated intelligence and cool. In her spoken performances, she was unnervingly observant, a natural storyteller, with a quirky, understated sense of humour. The focus on Anderson in the picture reflects the intense experience of watching her on stage, where apart from some simple visuals, she was the centre of attention, spinning her strange tales of technology, hat-check clerks and falling airplanes, with the aid of a vocoder to distort her voice to become different characters. Although Anderson never pretended to be any kind of seer, there was something mediumistic in her ability to act as a transmitter for outlandish perceptions and curious findings. The hands testing the air, the outsized protective shades, the white shirt, jacket and tie combo, as the stylized getup that a notional 'big scientist' might wear, all express the theatrical panache of her persona as a performer.

Rick Poynor

LAURIE ANDERSON: (above) *Big Science* debut LP poster (Warner Bros. Records, 1982); **Laurie Anderson** cover artwork, **Cindy Brown** design.

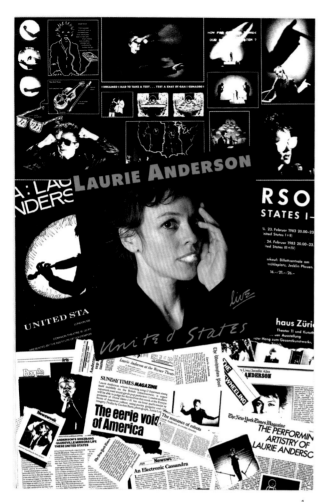

1

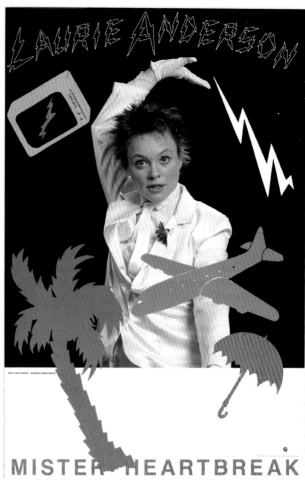

2

3

LAURIE ANDERSON: 1 *United States Live*
LP poster (Warner Bros., 1984) (triple LP);
Laurie Anderson design; **2** *Mister Heartbreak*
LP poster (Warner Bros., 1984); **Laurie
Anderson** artwork and graphics.

LIQUID SKY: 3 Film poster for VHS release,
c. 1984 (film released theatrically in April
1983).

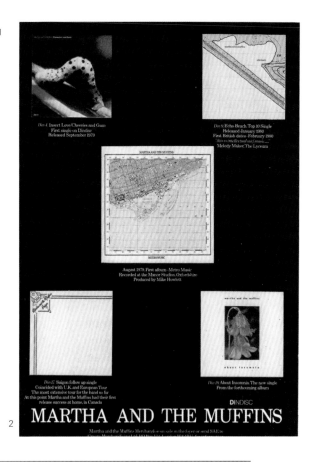

MARTHA AND THE MUFFINS: 1 *Metro Music* LP (Dindisc, 1980); Martha And The Muffins cover concept; **Peter Saville** design; **2** Record shop order flyer (Dindisc Records, 1980); **3** Supporting Rip Rig and Panic with Orchestre Jazira and Laurel and Hardy poster, Hammersmith Palais, London, 16 May 1982.

1

2

3

LA MERE VIPERE: 1 (Chicago club) Slideshow event 'Real' poster, *c.* 1978; **Steven Blutter** presentation, **D.K. Golden** artwork; **2** New Wave Two Nights a Week advertisement, 213 N. Halstead Street, *c.* 1977; **CLUB NEO: 3** Pyjamarama! event poster, Chicago, IL, *c.* 1979.

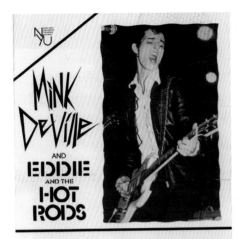

1

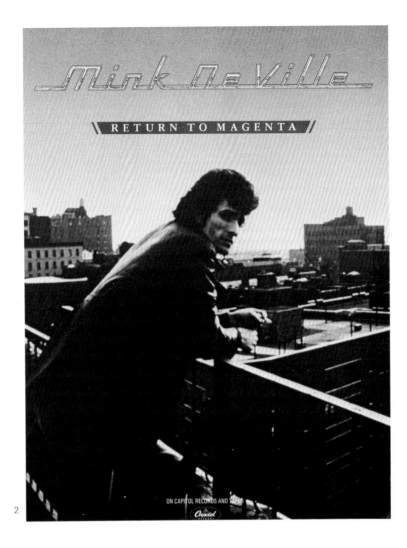

RETURN TO MAGENTA

ON CAPITOL RECORDS AND TAPES

2

MINK DEVILLE: 1 Poster for concert with Eddie & the Hot Rods at Loeb Center, NYU, 17 December 1977; **2** Poster for *Return to Magenta* LP (Capitol Records, 1978); **Ken Anderson** design, **Duana Lemay** photography; **3** *Cabretta* LP poster (Capitol Records, 1977); **Eric Stephen Jacobs** photography.

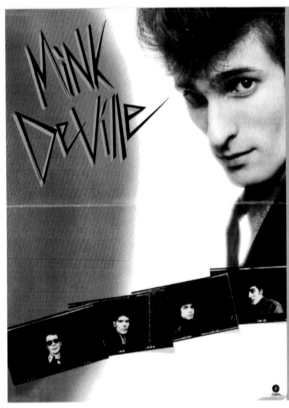

3

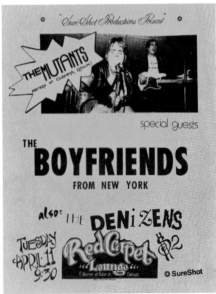

THE MUTANTS: (above) Flyer with The Boyfriends at the Red Carpet Lounge, Detroit, MI, 11 April 1978; **Dan Cadillac** design.

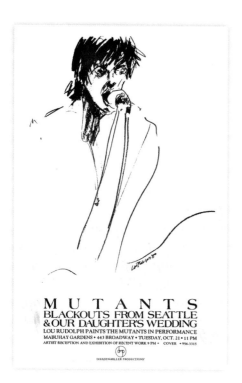

MUTANTS: (above) Two-sided poster for concert at Mabuhay Gardens, San Francisco, CA, 21 October 1980.

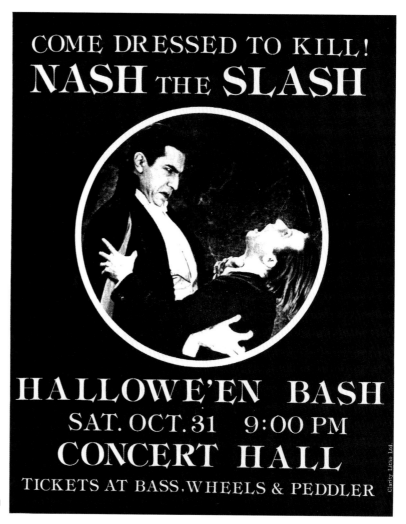

1

2

3

NASH THE SLASH: 1 Flyer for concert at Concert Hall, Ontario, Canada (31 October *c.*1980); Still of Bela Lugosi and Dwight Frye from the horror classic *Dracula* (Universal Films, 1931); **2** *Children of the Night* LP poster (Dindisc Records, 1981); **Martyn Atkins** artwork, **Gavin Cochrane** photography; **3** Badge sheet printed by de Graff printers, London (Cut-Throat Records, *c.* 1979).

NEOPARIS: With The Futures at Hong Kong Café, flyer, Los Angeles, 29 September 1979.

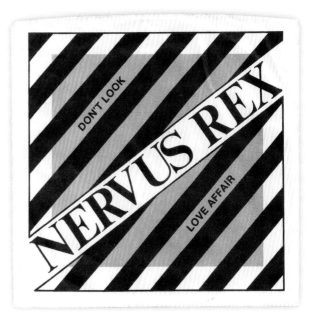

NERVUS REX: (above) 'Don't Look/Love Affair' 45, front and back cover (The Cleverly Named Record Company, 1979); **Paul Erdman** photography. 3,000 copies of this 45 were pressed.

THE NEW FLAMINGOS: (left) With Lonesome City Kings at Mr. Bill's, poster, Seattle, mid-1980s.

RIDING A NEW WAVE

Andrew Blauvelt

The first wave of punk came ashore in America and England in the mid-1970s and was washed back out to sea by the late 1970s. It left in its immediate aftermath, however, a rich and varied post-punk landscape. Seeking to move beyond the back-to-basics instrumentation and stripped-down sound offered by the first wave of punk, post-punk bands embraced an eclectic array of influences, including electronic and synthesized music; the Afro-inspired beats of reggae, dub, funk and disco; pop music; noise and atonal sound experiments; and the global currents of world music. Post-punk also sought to move beyond the straight, white, male, working-class concerns and experiences of many punk bands. Issues of gender, race and sexuality emerged, and with them a more diverse range of participants, and a more critical form of social and cultural politics. Post-punk embraced the fusion of music and art, with an avant-garde sensibility seeking to disrupt some of the heroic posturing, commercial success, and retrograde musicality of punk. This post-punk period, stretching from about the late 1970s to mid-1980s, has been broadly termed new wave. The term would soon be stretched beyond meaningful categorization as post-punk birthed numerous new and divergent sub-genres, including synth-pop, New Romantic, goth rock, ska, no wave, neo-psychedelia, hardcore and industrial music, among others.

Although punk garnered plenty of media attention and proved that a listening audience was eager to consume its offerings, the record companies and their distributors recoiled at the negative press and the hostile antics of punk's irrepressible progeny. The subsequent remarketing of post-punk music as new wave — less threatening, more listenable, more danceable, more inclusive — followed on the heels of the splintering of punk into numerous new genres.

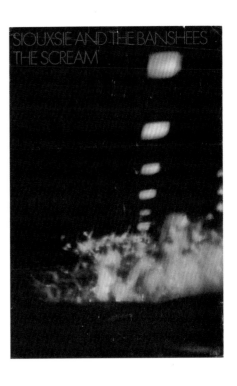

SIOUXSIE AND THE BANSHEES: *The Scream* LP poster with draft sleeve artwork not used in the final version (Polydor Records, 1978).

THROBBING GRISTLE: *Heathen Earth* LP poster (Industrial Records, 1980).

i-D MAGAZINE: (right) No. Zero, Fiorucci Manual of Style (1982); **Terry Jones** design, **Thomas Degen** photography, **Scarlett** model.

i-D MAGAZINE: (below) Issue No.2 (1980), **Terry Jones** design; Issue No.3 (1981), **Terry Jones** design; Issue No.5 (1981), **Terry Jones** design, **Malcolm Garrett** Lady Di cover design.

With the new sound came new approaches to graphic design. By the late 1970s, post-punk music was establishing or re-affirming the careers of many designers, including among others Jamie Reid, Barney Bubbles, Alex McDowell, Peter Saville, Neville Brody, Malcolm Garrett, Terry Jones, Vaughan Oliver, Winston Smith, Mike Coles, Arturo Vega, 8V0 and Tibor Kalman. The new music encouraged the invention of a new and postmodern graphic language, and this, alongside the pre-existing body of experimental graphic design in circulation, would influence the direction of graphic design for decades to come.

New wave design was a direct reaction against the kind of graphic modernism widely disseminated in and then codified by the corporate world of the 1960s and 1970s. Dubbed the International Typographic Style by design historian Philip Meggs, this had favoured a graphic language elaborated and refined in Switzerland in the 1950s and 1960s. Flat, abstract symbols and logos were married to sans-

serif typography using typefaces such as Helvetica and Univers rendered in a limited colour palette and then joined to crisp, black-and-white photography, which was all held together in tightly gridded compositions. Smooth and precise, these designs exuded a seamless sense of objectivity and universality that projected clarity of purpose — a fitting design language for the kind of transnational corporate capitalism that was emerging in the late twentieth century. Just like the corporation itself, Swiss-style design had become so successful and ubiquitous in its global domination that it became the default style of numerous professional designers.

Punk and post-punk music would disrupt the music profession and its conventional mainstream tastes, in particular assailing the corporatizing influence in the music industry in the 1970s. New wave design would challenge the profession's conventions and, in particular, the hegemony of corporate-style Swiss design of the era. Perhaps surprisingly, the roots of new wave graphic design would also emerge from Switzerland, but via a new generation of practitioners, such as Rosmarie Tissi, Wolfgang Weingart, Willi Kunz and Hans-Rudolf Lutz, who grew restless in the face of Swiss design's utter predictability. Under the direction of Weingart, with an international coterie of graduate students, the Basel School of Design would disseminate this form of typographic experimentation well beyond the cantons of Switzerland. Basel students, including Americans like Dan Friedman and April Greiman, would expand the idiom by developing their own idiosyncratic approaches, incorporating charged imagery, vibrant colour and graphic textures, fuelling what would become known as 'Swiss punk'. The term itself signals the interconnectedness of both the music scene (and the designs produced for it) and the influence of the new Swiss approach, although not many Basel-trained designers crossed over into the music industry. Many graphic design programs in the US adopted

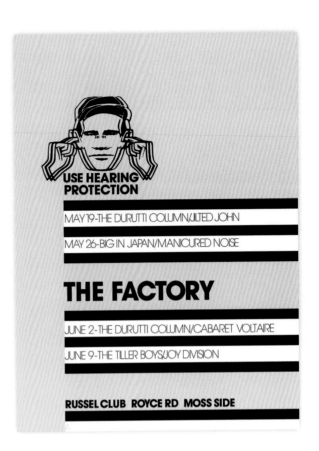

THE FACTORY: (above) Poster (Factory, 1978); **Peter Saville** design. (Image courtesy of Peter Saville.)

MARATHON '80: (below) 'A New-No-Now Wave Festival' flyer, Walker Art Center, Minneapolis, MN, 22 and 23 September 1980.

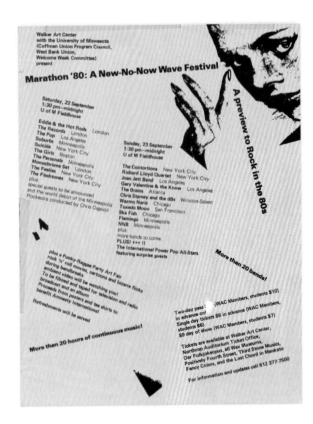

NOT FOR SALE FOR PROMOTIONAL USE ONLY 90018 PRINTED IN U.S.A

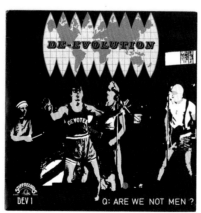

GRACE JONES: (above) *A One Man Show* poster (Island Visual Arts/ PolyGram Music Video, 1982); **Jean-Paul Goude** design.

DEVO: (left) 'Jocko Homo / Mongoloid' 45 back and front cover (Stiff Records, 1978); **Devo** design, **Jeff Seibert** layout, **Greg Kaiser** photography.

ISLAND RECORDS ON CASSETTE

DISTRIBUTED BY ATCO RECORDS. A DIVISION OF ATLANTIC RECORDING CORP.

the new Swiss approach, but at Cranbrook Academy of Art in Michigan, Katherine McCoy and her students created a distinctly American rendition, one which brought elements of vernacular typography and imagery into the mix. These found elements of popular culture were collected from commercial lettering along Detroit's numerous strip malls or lifted from adverts placed in the *Yellow Pages*, America's phonebook for businesses. Incorporating things like stock drawings or 'clip art', highly stylized letterforms, and a fit-it-

wherever-you-can layout strategy, the vernacular injected a more punk, more DIY look and feel into new Swiss design. Like punk, these elements were unschooled, a naive simulation of professionalism, but now embraced by aspiring professionals, sometimes ironically, sometimes earnestly.

In its stripped down asceticism, classic punk rock's graphic expressions tended to match the music. A high-contrast, monochrome landscape of black and white graphics and imagery, stripped-down sans-serif typography or hand-scrawled lettering expressed, like the music, a bare bones urgency without pretensions. Like the music, unlearnt was better. Punk rock was for amateurs in the best sense of that word. To borrow a phrase from anthropologist Claude Lévi-Strauss, it was served raw, not cooked.

New wave music was an amalgam of influences drawn from innumerable sources. As such it was additive and hybrid, complex and layered, not simple or clear. Accordingly, the graphic design for new wave music matched its rich eccentricities, embracing a multitude of styles and plethora of approaches. If classic punk was embodied as a thin, white, straight, disaffected working class male, then new wave was his inverted cousin: less thin, less white, less straight, and more female with a more crowd-friendly, cosmopolitan orientation.

Rock music has always been a great assimilator and cultural appropriator of other sounds and styles. New wave was no different. It would set the stage for sampling and other forms of bricolage, freely borrowing and mixing to create, at its best, a creolization, or a new hybrid, one irreducible to its constituent

BUZZCOCKS: *A Different Kind of Tension* LP, front and back cover (United Artists, 1979); **Malcolm Garrett (Assorted iMaGes)** design, **Jill Furmanovsky** photography. (This image is of the reissue on EMI Records, 1989.)

Reversing Into The Future

ingredients. New wave graphics would similarly draw from a range of aesthetic references, blending new with old and high with low.

Swiss punk or new Swiss design had freed itself from the compositional tyranny of the modern grid system, which was a scaffolding normally invisible but nevertheless articulated through a series of alignments and shared coordinates on the page. When the grid itself was not abandoned, it was stripped of its functionality and made visible, skewed and/or violated — all actions that turned what was a layout tool into a symbol of the postmodern. Perspective was deployed against the flatness of Swiss modernism, including the use of drop shadows for both text and images, such as Jayme Odgers' layered 'deep space' photography, or typography rendered as dynamic lines of letterforms of descending size, getting smaller as it approaches the vanishing point.

If classic punk graphics were film noir, new wave graphics were full-on Technicolor. New wave designs witnessed an explosion of colours and forms, compared to their sombre punk predecessors. Primary shapes such as circles, triangles and squares — reminiscent of

BUZZCOCKS

tension | a different kind of | tension
tension | a different kind of | tension

Bauhaus, De Stijl and Constructivist geometries — were often rendered in non-primary, tertiary colours, such as oranges, purples and greens. Neon colours printed as day-glo or fluorescent inks were popularized, taken from the garish packaging found on supermarket shelves or shop window signs. If one colour typified new wave palettes, however, it was pink. Loaded with symbolism, this typically gendered hue would be reassigned: intensified as a pure and bold 'hot pink' or magenta, and applied to both male and female musicians; or reclaimed from its Nazi-era stigma to identify homosexuals by a burgeoning gay rights scene in Britain. Molly Ringwald might have been sitting pretty in pink, but the rosy tint also found its way into men's fashion, queering the polo shirt — an iconic 1980s garment.

Textures and patterns prevailed on post-punk surfaces. These patterns were most easily applied to designs using Chartpak films — self-adhesive textures printed on a clear substrate — which could be layered to create moiré effects, intentionally embracing what would be otherwise considered a printing mistake. Other patterns were created through repeated enlargements made on a photocopier — its

ELVIS COSTELLO AND THE ATTRACTIONS: (opposite) *Armed Forces* LP (Radar Records, 1979); **Barney Bubbles** design, **Bazooka** illustration. The images show the interior and reverse of the UK release, with flaps folded-out (top) and the primary folded-in record sleeve images (bottom).

IAN DURY AND THE BLOCKHEADS: (left) *Do It Yourself* LP poster, based on one of twenty-four cover designs printed on wallpaper (1979); **Barney Bubbles** design screenprinted onto Crown Wallpaper.

PRAXIS 5: Chicago art magazine, front (top) and back (bottom), 1980.

rough, contrasty, disintegrated textures a haptic metaphor for the grit of the street. Other patterns were throw-backs to 1950s Formica or Atomic Age textiles.

Torn letters and words — ransom-note-style typography from classic punk — were exchanged for softer, torn paper edges — another illusionistic disruption of the surface of the page. The presence of the designer was brought to the fore, symbolized through the application of random paint drips and ink splatters. This gestural mark-making went on to become a graphic cliché for signifying creative expression, but at first it was seen as a fresh reference, albeit a weak one, to the elaborately embellished and larger-than-life spray-painted tags of urban graffiti writers. The use of colour blocking, or multicolour panels set in gridded blocks, would appear both in 1980s fashions and in new wave graphics. Full-colour printing had not yet become ubiquitous and was still expensive, so colourizing black-and-white imagery through overlays of translucent colour and the use of two and three ink colours dominated graphic designs.

In new wave design, the restrained and very limited typographic palette of Swiss design gave way to an eclectic range of typefaces — classical serif fonts as well as thicker slab-serif choices commingled with script and stencil letters. Centuries of typographic forms were resurrected — premodern, classical and even early

twentieth-century type treatments were open for investigation. This kind of historical eclecticism was part of a larger tendency within postmodern design. As critic Tom Wolfe would note, designers were once again rifling through what he called the big closet of history.

Back to the Future

Some post-punk genres openly embraced a retro or vintage look and sound that, while nostalgic, could also be progressive. Mining the early post-World War Two period (mid-1940s to early 1960s) would naturally include the beginnings of rock and roll itself — a sound to which many punk and post-punk performers consciously sought to return to musically. In London, just before punk, there had been a revival of the Teddy Boy look popularized in England in the 1950s, with its long jackets, tapered trousers, and elongated shoes, or brothel creepers. It bore a resemblance to the 1940s zoot-suit phenomenon in the United States, which also featured long tailored jackets but

JOE JACKSON: (below) French concert poster for *Look Sharp!* debut LP at Bataclan, 21 June 1979 (A&M Records, 1979); **Brian Griffin** photography.

ELVIS COSTELLO AND THE ATTRACTIONS: (opposite, top) *Get Happy!!* LP poster insert, **Barney Bubbles** design; (opposite, bottom) 'New Amsterdam' 45 sales sheet (F-Beat Records, 1980), **Barney Bubbles** design.

with padded shoulders and high-waisted, wide-legged pegged trousers — a look popular among Latino, African American and Filipino American men. The zoot-suit look was also revived in 1970s London by Acme Attractions, a boutique on Kings Road opened by John Krivine and Steph Raynor, who would later launch Boy, with a punk fashion focus. A leading purveyor of the revived Teddy Boy look in London was Let It Rock, a fashion boutique also on Kings Road, owned by Malcolm McLaren and Vivienne Westwood, who would later be responsible for the look of British punk. Both venues were capitalizing on the revived rockabilly scene in London just before punk broke.

The retro pendulum would swing backwards and forwards in time. The retro look in graphics also included the revival of the dramatically spot-lit and deep-shadow effects popularized in film noir thrillers of the 1940s and 1950s. The classic device of a window blind casting its shadow across the face of a protagonist is supremely captured in a promotional poster for The Cure's 'Let's Go to Bed' (1982). But witness also the return of the early 1960s Mod look of swinging London, with its skinny ties, trim suit jackets, and drainpipe trousers, often updated and simultaneously downgraded with Converse sneakers, as featured on the cover of Blondie's classic pop exploration *Parallel Lines* (1978). In Britain, Barney Bubbles designed graphics for Elvis Costello and the Attractions that drew upon the graphic and typographic palette of the 1950s, featuring period typefaces, diamonds, argyle and biomorphic shapes, and whimsical line drawings. Certainly, the pop sound of new wave often hearkened back to the 'happier times' portrayed in American sitcoms like *Happy Days* (1974–1984). Often presented through the dual lens of loving kitsch and sarcastic send-up, groups such as The B-52's adopted the look and even the beehive hairdos of the 1950s for their

new surf music sound, while Go-Go's merged their punk rock roots with the pop sensibilities and female empowerment encoded in Motown's 'all-girl' lineups. Nostalgia continued to play itself out through new wave's geek chic look of the 1950s — as personified, in different ways, by the twitchy dance moves of Talking Heads' David Byrne, the retro eyeglasses of Elvis Costello, or the prop hearing aid worn by Morrissey of The Smiths.

Some professional graphic designers had also been mining historical motifs since the 1960s, in their search for an alternative to the rigid rules of a high or corporate modernism. This would reach a crescendo in the 1980s when postmodernism peaked, graphic design history boomed, and just as America and Britain were experiencing a neo-conservative political resurgence. These conditions left the retro movement open to criticism that it was ultimately an exercise in nostalgia — trying to recapture a time that never truly existed in the way it was being remembered. The recuperation of trends, whether in fashion or music, serves only to exhaust the original, emptying it of historical power and resonance. This is the problem with retro styling when it becomes merely a pastiche, something critic Fredric Jameson has described as 'blank parody' or 'speech in a dead language'. However, as is the case of most remixing strategies, the past can be better transformed through its hybridization, by adding something or through its contact with something different, which allows it to move forward in a new way, bringing the past with it.

THE B-52'S: *Wild Planet* LP poster (Warner Bros. Records, 1980); **Robert Waldrop** art direction, **Lynn Goldsmith** photography.

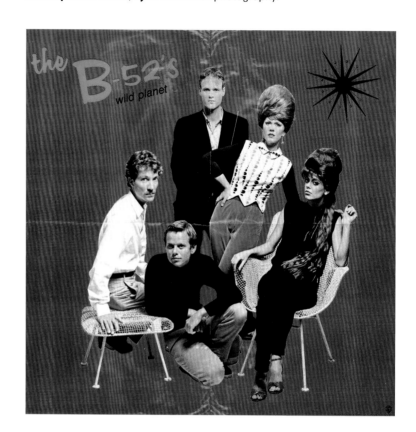

ELVIS COSTELLO AND THE ATTRACTIONS: *Get Happy!!* LP cover (F-Beat Records, 1980); **Barney Bubbles** design.

NEW ORDER: *Movement* LP poster (Factory Records, 1981); **Peter Saville** design, influenced by **Fortunato Depero**'s poster promoting the 1932 *Futurismo Trentino* exhibition.

One particular strand of new wave design deliberately drew on the graphic language of those early avant-garde art movements which were particularly driven by design, including Italian futurism, Dutch De Stijl, Germany's Bauhaus, and Russian constructivism. Returning to an early, pre-corporate and non-capitalist form of modernism offered an exhilarating array of forms for designers to mine.

Power to the People

While punk embraced a provisionally anarchistic stance, against what it saw as government oppression of all partisan stripes and fascist control over people's lives, it nevertheless adopted the graphic look and militant gestures of various forms of agitprop. As a blend of the words agitation and propaganda, the term agitprop is historically associated with the Russian Revolution and the official Soviet state propaganda of the early twentieth century.

This transformation from anarchic to partisan was particularly evident in the post-punk era, when bands began to identify with particular political causes and social issues as the new conservative regimes of Reagan and Thatcher came to power. Designers embraced the style of communist and socialist propaganda as a seemingly natural fit for punk's often left-leaning causes and politics. At the height of the Cold War with both the Soviet Union and China, such references were contrarian gestures against

ROCK AGAINST RACISM: (above) Poster for concert in London's Victoria Park (30 April 1978); **David King** design.

NICK LOWE: (above) 'Cracking Up' 45 poster (Radar Records, 1979); **Barney Bubbles** design.

both British and American governments.

Influenced by earlier bands such as Detroit's MC5 and their connections to the White Panther Party — a radical, anti-racist group in support of the Black Panthers — The Clash embraced a progressive politics, lending their support to striking British workers, jailed political prisoners of the Irish Republican Army, and the Rock Against Racism movement, among other causes. Their 1980 triple LP *Sandinista!* was an *hommage* to the Sandinistas, the rebels fighting against the US-backed military dictatorship in Nicaragua. Recording it in New York City, The Clash were inspired by the emergent rap scene, as well as the reggae and funk that other forms of post-punk music were drawing on.

Despite broader musical influences and a slowly but steadily growing diversity within punk, the scene remained closely aligned with straight white male performers and participants. Increasing racial tensions in Britain — exacerbated by ruinous economic inflation and high unemployment coupled with new policing powers, a 'stop and frisk' targeting Black and brown youth in particular — culminated in 1981 with uprisings in Black and Asian communities across the country. Back in 1976, the growing presence of the White nationalist and nativist movements in Britain prompted earlier counter-movements such as Rock Against Racism, founded by Red Saunders and Roger Huddle, among others. Actively or passively, the punk scene had either encouraged a flirtation with such extremist views, including the wearing of the

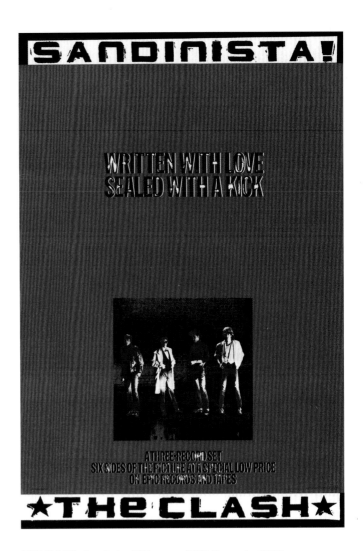

THE CLASH: *Sandinista!* LP poster (CBS Records, 1981); **Pennie Smith** photography.

Nazi swastika as a juvenile way to shock the British public, and tolerating the growing presence of racist skinheads at concerts. In 1978, 100,000 people gathered in Trafalgar Square to march to a music festival in Hackney staged by Rock Against Racism in cooperation with the Anti-Nazi League, where groups such as the Clash, Sham 69 and Generation X performed. They were joined by X-Ray Spex, whose lead singer Poly Styrene was one of the few Black (let alone female) punk performers of the time, and by the Tom Robinson Band, who had broken new ground earlier that year, with its anthemic 'Glad to be Gay'. The song chronicles a list of discriminatory practices of police, the government and the media against gays and lesbians. More British new wave bands would join this roster of openly gay performers as the 1980s unfolded, including Holly Johnson and Paul Rutherford,

singers for Frankie Goes To Hollywood, whose 'Relax' (1983) became a hit single despite being banned by the BBC for its sexually suggestive lyrics, and all the members of Bronski Beat, whose single 'Smalltown Boy' was a hit from their 1984 debut album *Age of Consent*.

FRANKIE GOES TO HOLLYWOOD: (above) 'Relax' 45 poster (ZTT Records, 1983); **Paul Morley** and **David Smart** design, **Anne Yvonne Gilbert** illustration.

Strange Bedfellows

At first glance it might seem odd that postmodern graphic design of the 1970s and 1980s was emanating from academic programs at the very moment that post-punk music provided an eager clientele for new wave-style graphics. They shared a similar disdain for the stifling and formulaic approaches, whether in music or design, that had taken root in their respective professional circles. For many designers, this meant an aggressive assault on the cherished mantle of professionalism that had only recently emerged in the field, an assault that sought to unlearn its forms of mastery and de-skill in the face of industry expectations, and by doing so it embraced what the profession had recently shunned. For many musicians, punk and post-punk offered an exciting alternative to both the aural seamlessness of easy listening and the baroqueness of progressive rock. Urgency of expression trumped technical competency. Embracing eccentricities over normative standards, punk and post-punk culture was for its time radically, if only provisionally, inclusive. Difference was not merely tolerated but actively cultivated. Unexpected sounds and other musical genres offered exciting but not unproblematic creative frontiers for exploration and exploitation, appropriation and extraction. In sight and sound, new wave opened a thousand new directions. Just as in music, new wave design promised only a timely response to the social and cultural moment. It did not and could not accept the kind of timelessness promised by an increasingly ossified modernism.

This essay is an adapted and expanded version of a text originally published in *Too Fast to Live, Too Young to Die: Punk Graphics, 1976–1986* (2018), the catalogue for an exhibition organized by Cranbrook Art Museum in Bloomfield Hills, Michigan.

IAN DURY: *Spasticus Autisticus* 45 poster (Polydor Records, 1981); **Barney Bubbles** design.

One Show Only

NOMI At The **MUDD**
Midnight Performance Tuesday, November 23rd
"A Pre-Thanksgiving Day Operatic Extravaganza"

THE MUDD CLUB
Proudly Presents
KLAUS NOMI
In his only
New York Club Appearance
before his European tour
celebrating the release
of his second RCA LP
"SIMPLE MAN"
Midnight Performance Tuesday, November 23

The Mudd Club is located at 77 White Street
2 blocks south of Canal between Broadway
and Lafayette.
For further information call (212) 227-7777

Join us upstairs for
a champagne Bon Voyage
toast to NOMI with this invitation

Mudd Club, 77 White Street, N.Y.C. 10013

2

3 4

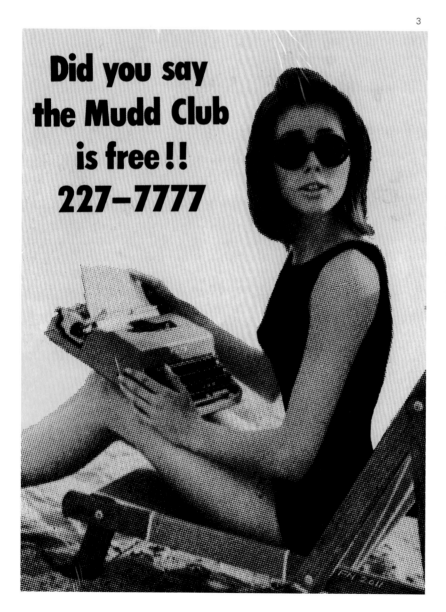

Did you say the Mudd Club is free !!
227–7777

Maybe she thinks you can't afford it!

Surprise her. Dazzle her with your taste and discernment. Give her a night she'll remember at a **Saturday Night Mudd Formal Ball**. You may spend a little more than you planned, but she'll know you appreciate extraordinary nightlife quality—and her. Actually, can you afford to give her less?

MUDD
The quality goes in before the name goes on

NEW YORK CITY CLUBS/MUDD CLUB/ KLAUS NOMI: 1 Flyer for performance 23 November 1982, to celebrate the release of his *Simple Man* LP (RCA Records); **2** ...with a champagne toast upstairs, from the archive of Joey Arias; **3** Poster from 1981, signed by the artist **Fernando Natalici** in 2011; **4** Advertisement from *Non LP B Side* downtown arts and music culture 'zine, January 1981.

NEWS: (above) With Robyrt Delong at the Daily Bread, New Haven, CT, flyer, *c.* 2 September 1980.

NEW YORK CITY CLUBS/PEPPERMINT LOUNGE: (right) Four flyers which chronicle the 'second generation' underground music and dance venues, such as Hurrah, Mudd Club, Danceteria, Peppermint Lounge, and even the Ritz, which attracted a weird mishmash of punk elder statesmen, no-wave bands, new-wave acts, art-rock whatevers, and downtown artists. Flyers, 1981. (below) Advertisement placed in *Non LP B Side* downtown arts and music culture 'zine, 1981.

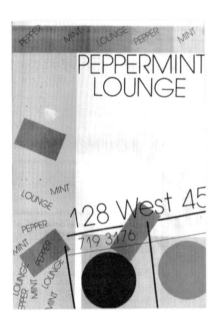

1

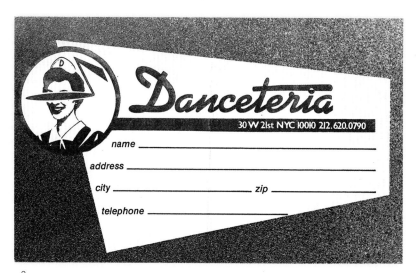

2

3

NEW YORK CITY CLUB/DANCETERIA: New
York club/concert venue **1** Pre-opening
advertisement placed in *Non LP B Side*
downtown arts and music culture 'zine,
December 1981; **David King** logo designer;
2 Mailing list address card, 1982; **3** Drinks
voucher, 1982.

NEW YORK CITY CLUBS: (right)
Advertisements in *Non LP B Side*, 1981.

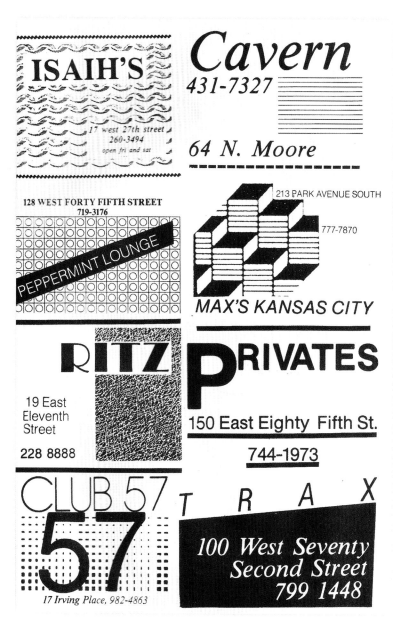

1

2

NON LP B SIDE: New York downtown arts and music culture 'zine **1** Issue no. 13, February 1982; **2** Summer Edition issue no. 8 with Grace Jones and Psychedelic Furs, August 1981; **3** Holiday issue no. 12 with U2 and New Order, December 1981.

NOW WAVE: (below) Sampler EP front cover, featuring The Sinceros, Hounds, The Beat, Jules and the Polar Bears (Columbia Records, 1979).

3

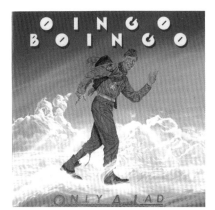

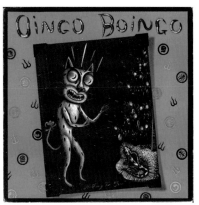

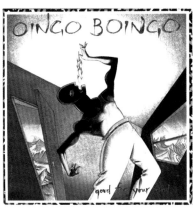

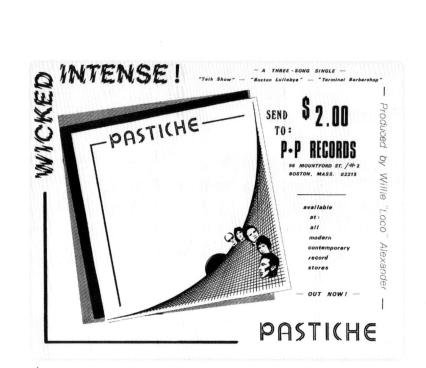

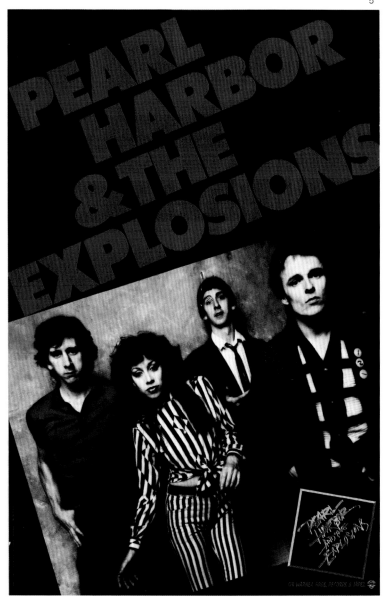

OINGO BOINGO: 1 *Only a Lad* LP
(A&M/I.R.S. Records, 1981); **Chris
Hopkins** illustration, **Paul Mussa** design;
2 *Nothing to Fear* LP (A&M/I.R.S.
Records, 1982); **Georganne Deen** cover
art; **3** *Good for Your Soul* LP (A&M
Records, 1983).
PASTICHE: 4 'Wicked Intense!' EP / gig
flyer (P*P Records-#2, 1980).

PEARL HARBOR AND THE EXPLOSIONS:
5 Self-titled debut LP poster (Warner
Bros. Records, 1980); **Basil Pao** cover
design, **Michael Jang** photography.

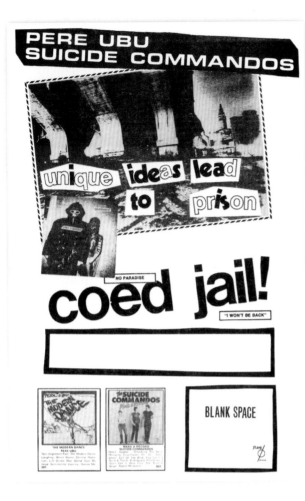

1

2

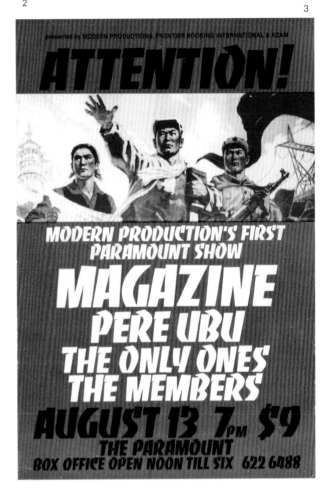

3

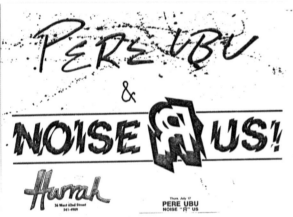

4

5

PERE UBU: **1** With Suicide Commandos on a co-promotion poster (Blank Records [a short-lived Mercury Records subsidiary], 1978); **2** 'Datapanik in the Year Zero' four-track anthology sticker (Radar Records, April 1978); **3** Concert with Magazine, The Only Ones and The Members at the Paramount Theater, Seattle, WA, poster, August 1980; **4** With Noise Я Us at Hurrah, NYC, flyer, *c*. July 1980; **5** *Song Of The Bailing Man* LP poster (Rough Trade Records, 1982); **David Thomas** design.

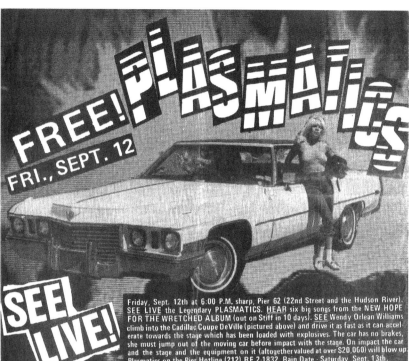

1

124

PLASMATICS: 1 Flyer for concert at Pier 62, NYC, 12 September 1980; **2** 'Monkey Suit' 45 front and back cover (Stiff Records, 1980); **3** Tour blank poster (Stiff Records, 1980).

3

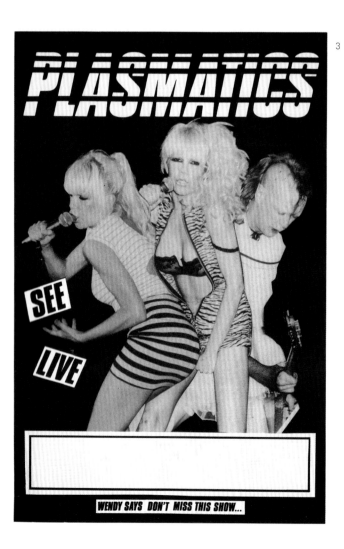

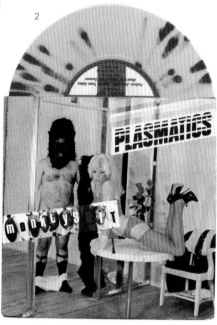

2

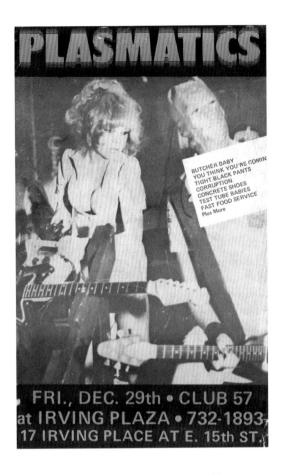

PLASMATICS: (left) Irving Plaza, NYC, poster, 29 December 1980; (below) 'Wendy O. Williams Legal Defense Fund' flyer. In 1981 Wendy was arrested twice, first in Milwaukee and then in Cleveland. In both instances she was charged with obscene conduct on stage (for simulating sex while performing) but was acquitted. This flyer was distributed to raise funds for her legal defence.

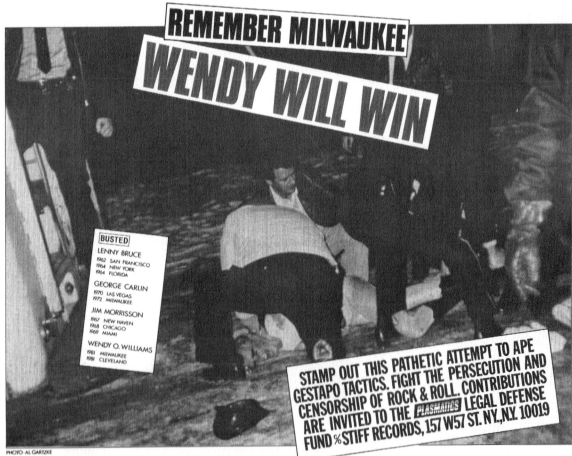

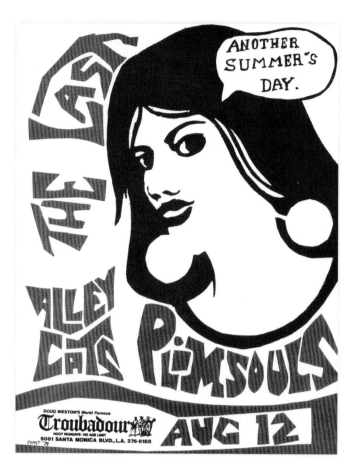

THE PLIMSOULS: (left) With The Last and Alley Cats at the Troubadour, Los Angeles, flyer, 1979.

PRAXIS 2: (below) Chicago art magazine, front and back cover, August / September 1979.

PRAXIS 2: (below) 'Taste Test', Instant -->This | Instant -->That, 'Blinxong', Andy Blinx; clear 6" flexi-single free with issue 2 of *Praxis* magazine, August / September 1979.

PRAXIS 3: (left) Chicago art magazine, December 1979.

PRAXIS 4: (below) Back of two-sided poster, Chicago, IL (1979).

Praxis was an idiosyncratic culture, art and music magazine from Chicago. It was issued sporadically and the issue dimensions were never the same. Issue 4 dates from late 1979 and includes this large glossy fold-out poster (below and right). It is titled 'Decade Dispatch' and subtitled 'Homewreckers Calendar' and 'Road Map to 1980' on the front side. The front (below), printed in yellow and pink against a black and white checkered background, features a full-year calendar across one section. The reverse side (right) is a black and white collage of text, photos and illustrations.

Andrew Krivine

127

PRAXIS 4: Front of two-sided poster, Chicago, IL (1979).

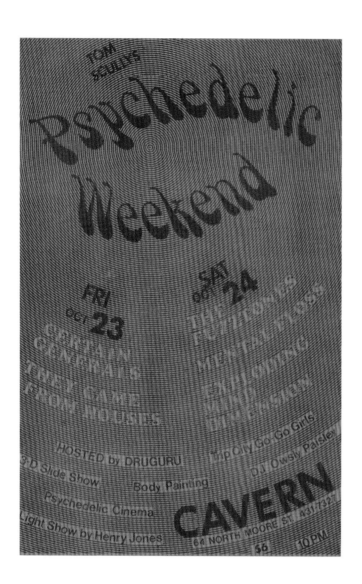

PSYCHEDELIC WEEKEND: (left) Festival at Cavern, NYC, poster, 23 and 24 October 1981.

PYLON: (opposite) *Gyrate* debut LP UK poster (Armageddon Records, 1980).

PYLON: (above left) 'Crazy/M-Train' 45 (DB Records, 1981); (above right) 'Beep/Altitude' 45 (DB Records, 1982).

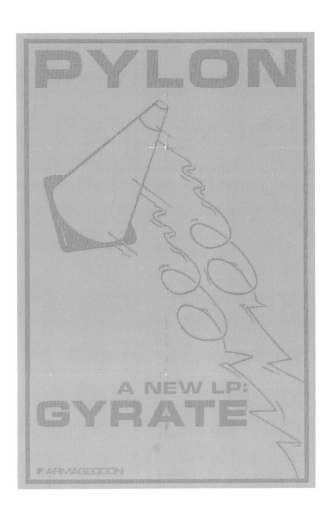

THE RECORD FACTORY: (top right) 45 paper bag, Brooklyn, NYC, *c.* 1979.

RED HEAVEN: (right) Poster for concert at Whisky A Go Go, Los Angeles, 10 March 1984; image of Catherine Deneuve and David Bowie from the erotic vampire movie *The Hunger* (1983).

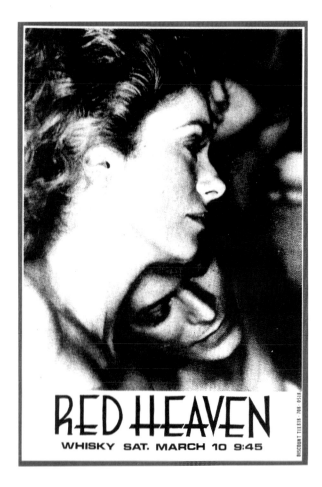

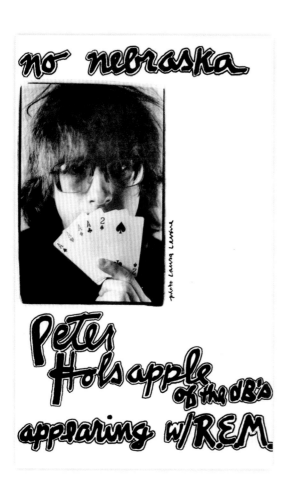

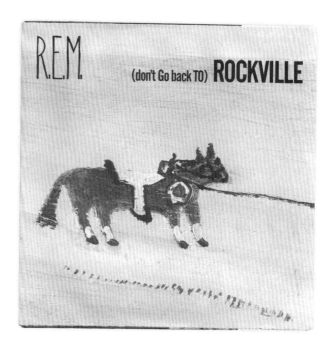

R.E.M.: (above) '(Don't Go Back to) Rockville' 45 (I.R.S. Records, 1984) front; (left) Peter Holsapple of the dB's with R.E.M., No Nebraska flyer *c.* 1982; **Laura Levine** photography; (bottom) *Fables of the Reconstruction* LP tour programme (I.R.S. Records, 1985).

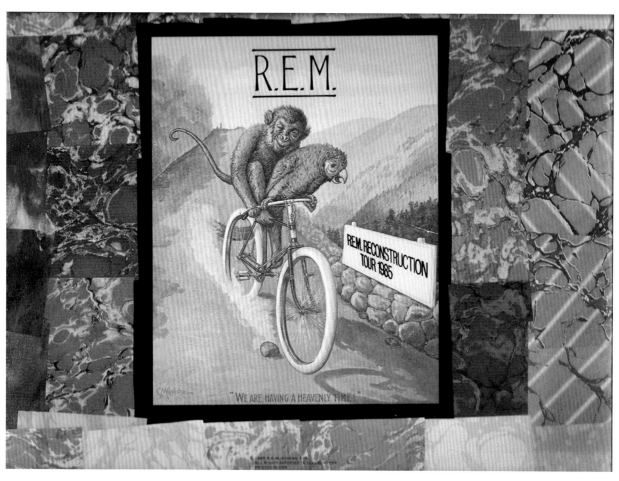

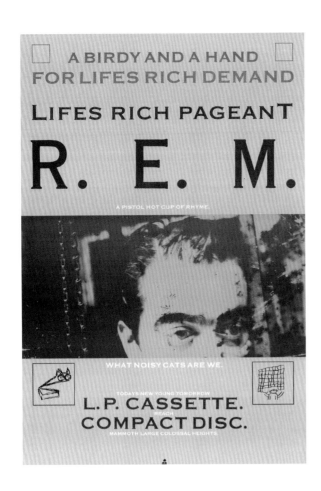

R.E.M.: (left) *Lifes Rich Pageant* LP poster (I.R.S. Records, 1986); (below) *Dead Letter Office* LP poster (mostly B-sides compilation) (I.R.S. Records, 1987); **R. A. Miller** anthropological renderings.

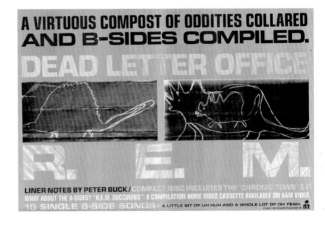

R.E.M.

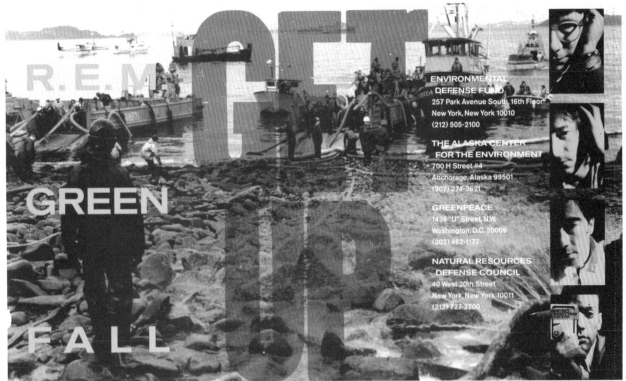

R.E.M: 'Get Up' 45/ Environmental Defense Fund poster (Warner Bros. Records, 1988).

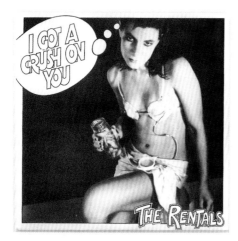

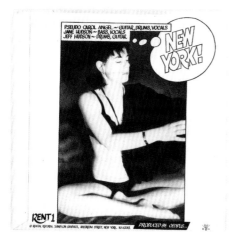

1

2

3

THE RENTALS: 1 'I Got A Crush On You/
New York' 45 front and back cover
(Rental Records, 1979).

ROBERT GORDON WITH LINK WRAY:
2 *Fresh Fish Special* LP poster (Private
Stock Records, 1978); **Jim Houghton**
photography; **3** LP poster (Private Stock
Records, 1977).

THE RUBINOOS: (left) Self-titled debut LP poster (Beserkley Records, 1977); **William Snyder** artwork; (below) Flyer with The Boyfriends and The Smirks at Friars at the Maxwell Hall, Aylesbury, England, 25 March 1978.

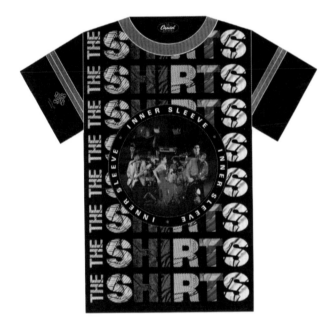

THE SHIRTS: (right) Self-titled debut LP UK advertisement (Harvest Records, August 1978); (above) *Inner Sleeve* LP die-cut poster (Capitol Records, 1980).

DIAGNOSIS: STANDARDEVIATION.

DESCRIPTION: VARIOUS STRAINS OF ATLANTA PNEUMOROCKERS.

SYMPTOMS: RAPID PULSE, HEAVY BREATHING, ELATION, IRRESISTIBLE URGE TO DANCE.

PROGNOSIS: TERMINAL.

TREATMENT: THE ALBUM.

STANDARDEVIATION
KAO₄S
THE BASICS
THE SWIMMING POOL Q'S
THE RESTRAINTS
OPERATOR
NO EXIT

THE ATLANTA SAMPLER. STEREO LP PRODUCED BY BILL MOHR ON PANIC RECORDS ℗ & © 1980 DO NOT REMAIN CALM. PANIC.
A DIVISION OF AIRWAVES DIVERSIFIED COMMUNICATIONS CORPORATION, P.O. BOX 5417, ATLANTA, GA. 30307

STANDARDEVIATION: (left) Atlanta compilation LP poster with Kao4s, The Basics and others (Panic Records, 1980).

THE SUBURBS: (below) *In Combo* debut LP poster (Twin/Tone Records, 1980).

THE SUBURBS
(IN COMBO)
—Pioneers of Art Bovine—

THE SUBURBS DEBUT ALBUM
Produced by Paul Stark
On Twin/Tone Records

Twin/Tone
Twin Tone Records 445 Oliver Ave. So. Mpls., Mn 55405

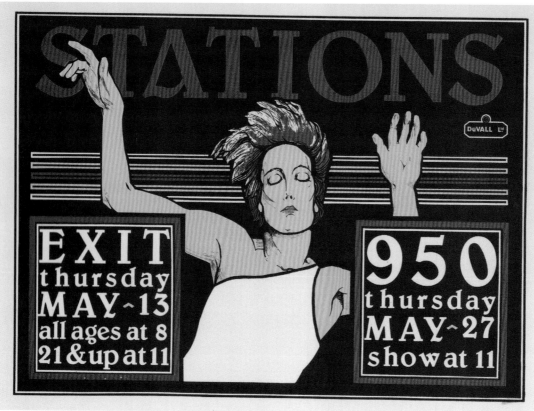

STATIONS

EXIT
thursday
MAY~13
all ages at 8
21 & up at 11

950
thursday
MAY~27
show at 11

DuVALL Ltd

STATIONS: Poster for concerts at the venues Exit and 950, Chicago, 13 and 27 May 1980.

The Shape of Things To Come

STIFF AMERICA

Selected by Shoplifters...Ignored by Intellectuals

STIFF AMERICA: Poster (Epic Records for Stiff America, the short-lived US branch of Stiff Records, 1980); **Marlene Weisman** poster design, **Chris Morton** flag logo design.

ARTISTS IN RESIDENTS

I was attracted to the posters promoting Ralph Records
artists because they are so distinctive and, in my
opinion, reflect a cohesive aesthetic vision. Most of
these posters were created by Pore No Graphics — one
of several aliases for the artistic collective that comprise
The Residents.[1] As I believe will become apparent as
the reader thumbs through *Reversing Into The Future*,
many of the posters in the book reference specific
artistic movements (Constructivism, Dada, German
expressionism, photomontage and Pop Art) but this
is not the case with the graphic designs set forth in
the section that follows. This is outsider art created by
perhaps the most cryptic, mysterious band to settle on
the West Coast (via Shreveport, Louisiana).

Andrew Krivine

[1] The Cryptic Corporation (the management team for The Residents)
included such suspected band members as Jay Clem, Homer Flynn,
Hardy Fox and John Kennedy.

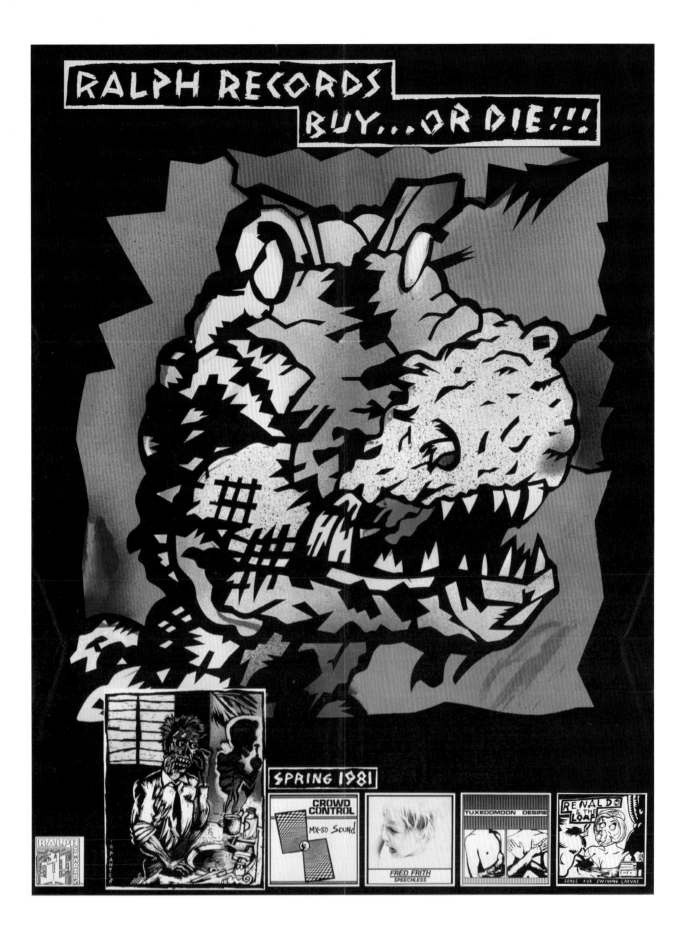

RALPH RECORDS: 'Buy... or Die' EP poster (Ralph Records, 1981); **Gary Panter** artwork.

1

2

FRED FRITH: 1 Poster promoting two LPs: 1980's *Gravity* and 1981's *Speechless* (Ralph Records, 1981); **2** 'Dancing in the Street' 45 front cover (Ralph Records, 1980).

MX-80 SOUND: 3 Poster promoting two LPs: 1980's *Out of the Tunnel* and 1981's *Crowd Control* (Ralph Records, 1981); **Kim Torgerson** design and photography; **4** *Out of the Tunnel* LP poster (Ralph Records, 1980).

3

4

THE RESIDENTS: *The Third Reich 'N' Roll* LP poster (Ralph Records, 1976); **Pore No Graphics** artwork. The LP was comprised of just two marathon songs: 'Swastikas on Parade' and 'Hitler Was A Vegetarian'.

THE RESIDENTS
GOD IN THREE PERSONS

THE OFFICIAL SEMI-CALENDAR

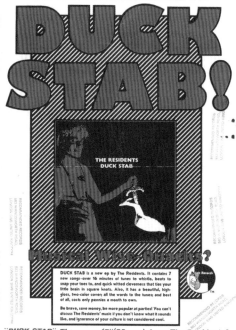

1

2

THE RESIDENTS: 1 *God in Three Persons*, front and back of LP promotional 'Semi-Calendar' (Rykodisc, 1988); **Pore No Graphics** design, **Henrik Kam** photography; **2** 'Duck Stab!' EP poster (Ralph Records, 1978); **Pore No Graphics** design; **3** Poster for concert at Mount Rushmore, South Dakota (Ralph Records/ Cryptic Corp, 1982); **Homer Flynn** photography.

3

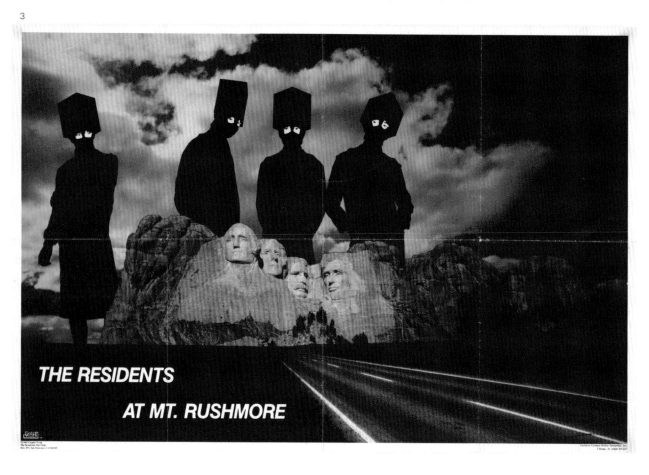

RHYTHM AND NOISE: (left) Mystery concert in support of *Contents Under Notice* LP (Ralph Records, May 1984).

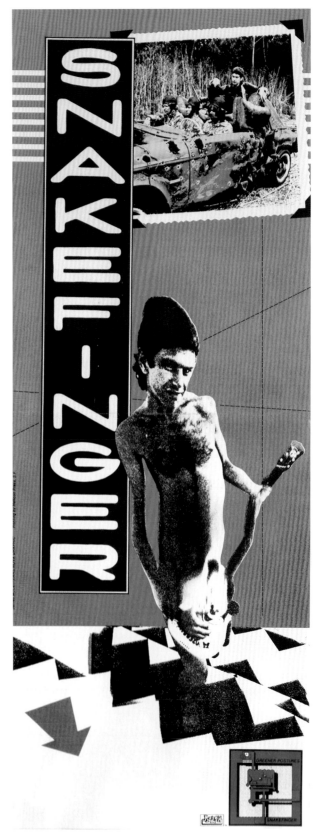

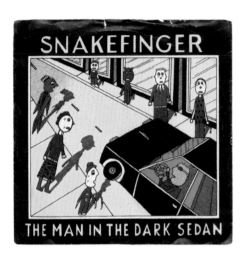

SNAKEFINGER: (right) *Greener Postures* LP poster (Ralph Records, 1980); (above) 'The Man in the Dark Sedan' 45 front cover (Ralph Records, 1980); **Mark Beyer** artwork. Philip Charles Lithman, aka Snakefinger, was an English musician renowned for his virtuosity on the guitar and violin.

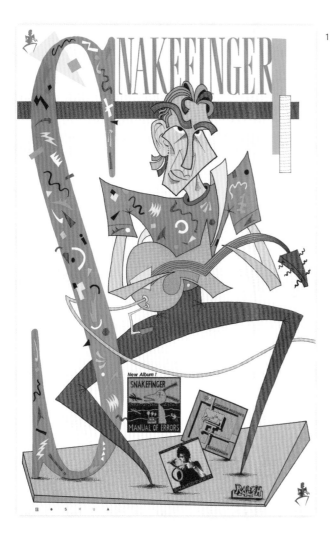

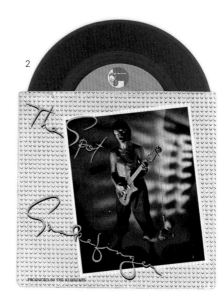

SNAKEFINGER: 1 Poster for concert promoting *Chewing Hides the Sound* (1979), *Greener Postures* (1980) and forthcoming *Manual of Errors* (1982) LPs at The Starship, Milwaukee, WI (Ralph Records, 1981); **2** 'The Spot' 45 front cover (Ralph Records, 1978); **Pore No Graphics** artwork. **SNAKEFINGER'S VESTAL VIRGINS: 3** *Night of Desirable Objects* LP poster (Ralph Records, 1986). **TUXEDOMOON: 4** *Half-Mute* debut LP poster (Ralph Records, 1980); **Patrick Roques** artwork.

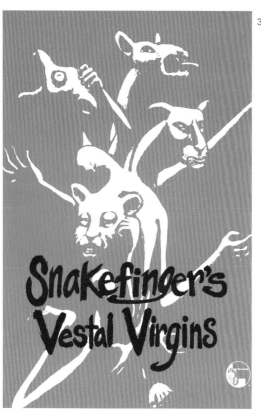

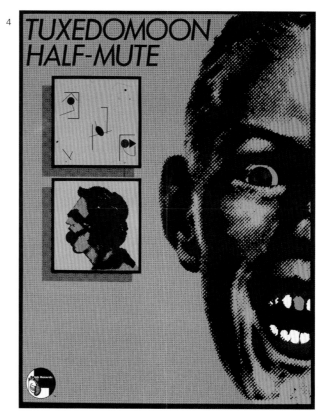

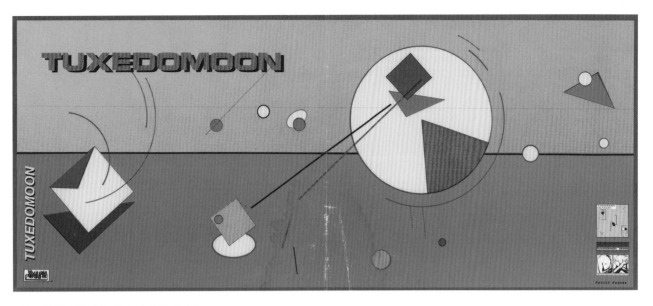

1

2

TUXEDOMOON: (above) Poster promoting two LPs, *Half-Mute* (1980) and *Desire* (Ralph Records, 1981); **Patrick Roques** artwork.

YELLO: 1 'Bimbo' 45 front cover (Ralph Records, 1980); **2** *Solid Pleasure* debut LP promotional badge (Ralph Records, 1980); **3** Poster promoting the *Solid Pleasure* (1980) and the *Claro Que Si* (1981) LPs (Ralph Records, 1981).

3

TALKING HEADS: Concert flyer for Bomp Records in North Hollywood, CA, 17 December 1977.

TALKING HEADS: **1** CBGB Theatre advertisement cut out of a *Village Voice* issue, NYC, December 1977; **2** *More Songs About Buildings and Food* LP promotional badge (Sire Records, 1978); **3** *Fear of Music* LP promotional hospital wristbands (Sire Records, 1979).

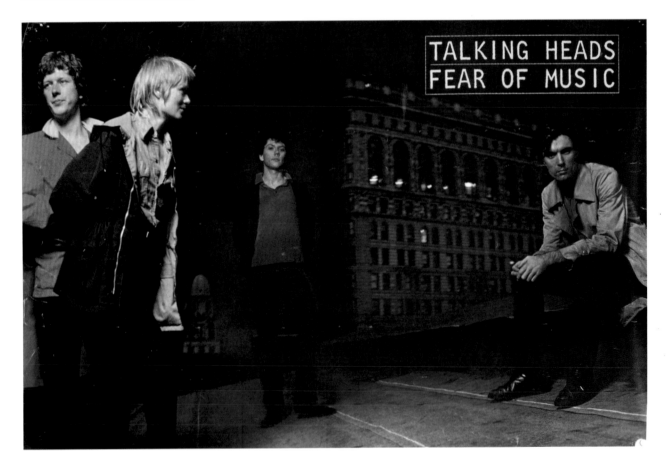

TALKING HEADS: (above) *Fear of Music* LP poster (Sire Records, August 1979).

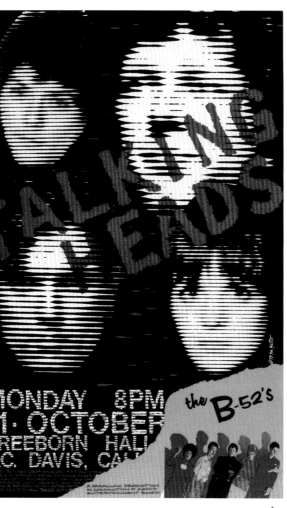

1

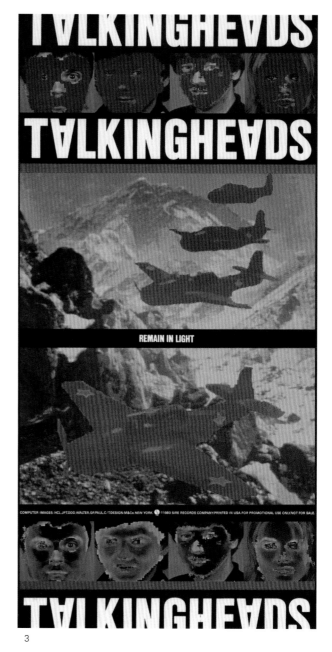

3

4

TΛLKINGHEΛDS

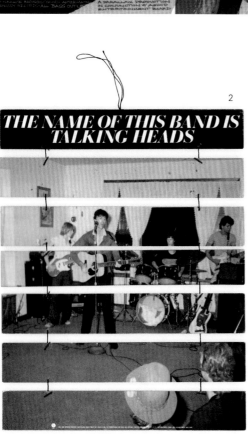

2

TALKING HEADS: 1 With the B-52's at University of California Davis, poster, October 1979; **2** *The Name of This Band Is Talking Heads* live LP mobile (Sire Records, March 1982); **3** *Remain In Light* LP poster (Sire Records, 1980); **M&Co.** design (firm founded by **Tibor Kalman**); **4** *Remain in Light* LP banner poster (Sire Records, 1980).

TALKING HEADS: (above) *Speaking in Tongues* LP poster (Sire Records, 1982); **David Byrne** design.

TALKING HEADS: (below) *Little Creatures* promotional badges (1985); (right) *Little Creatures* LP poster (Sire Records, 1985); **M&Co.** design, **Rev. Howard Finster** artwork, **Neil Selkirk** photography.

TALKING HEADS: 1 *Little Creatures* LP banner poster (Sire Records, 1985); **Rev. Howard Finster** artwork; **2** *Little Creatures* LP pre-release poster (Sire Records, 10 June 1985); **3** David Byrne *True Stories* movie video release poster (Warner Bros., 1987); **Annie Leibovitz** photography, **Bridget DeSoccio**, **M&Co.** logo.

1

TELEVISION: 1 Promotional sticker (Elektra Records, 1977); **2** With The Only Ones at Colston Hall, Bristol, England, flyer, 14 April 1978; **3** *Marquee Moon* LP cartoon banner poster (Elektra Records, 1977); LP cover: **Robert Mapplethorpe** photography; **Mort Drucker/MAD magazine**-inspired illustration; **4** *Adventure* LP poster (Elektra Records, 1978); **Johnny Lee** design, **Gerrit Van Der Meer** photography.

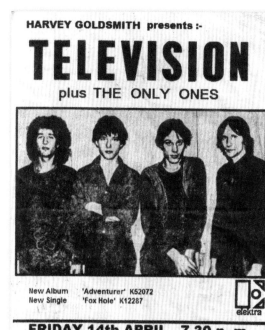

2

3

4

TOM TOM CLUB: (above) *Boom Boom Chi Boom Boom* LP poster (Sire Records, 1988); (below) *Boom Boom Chi Boom Boom* LP promotional postcard (Sire Records, 1989).

TOM TOM CLUB: (above) Self-titled debut LP figure extracts from promotional mobile (Island Records, 1981); **James Rizzi** illustration.

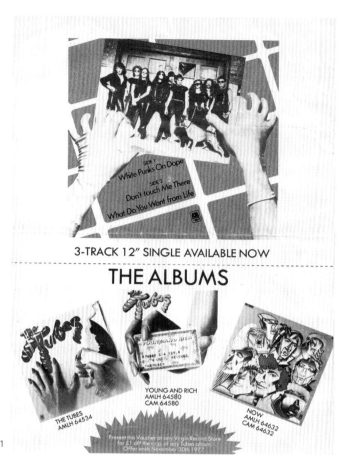

TOM VERLAINE: (above) At Club C.O.D., Chicago, IL, flyer, 31 October 1981.

152

1

2 3

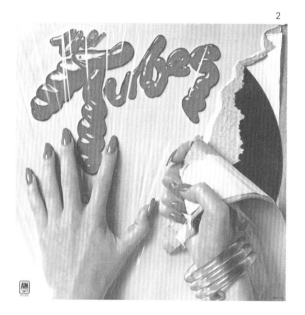

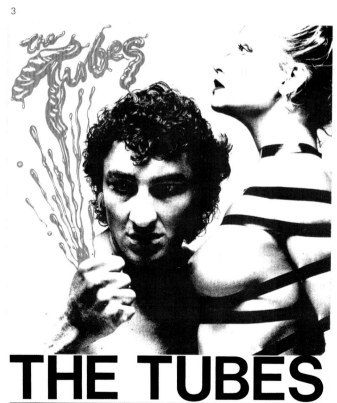

THE TUBES: 1 UK tour two-sided promo sheet (A&M Records, 1977; **2** Self-titled debut LP poster (A&M Records, June 1975); **M. Cotten**, **P. Prince** design; **3** Poster for concert at Koninklijk Circus, Brussels, Belgium, 4 December 1977.

WINNERS WILL PERFORM WITH THE TUBES AT THE WHISKY
TRY OUTS: SUNDAY, MARCH 13, 1 P.M. AT THE WHISKY, 8901 SUNSET, HOLLYWOOD

THE TUBES: Poster for talent contest held at the Whisky A Go Go, Los Angeles, CA, 13 March 1977.

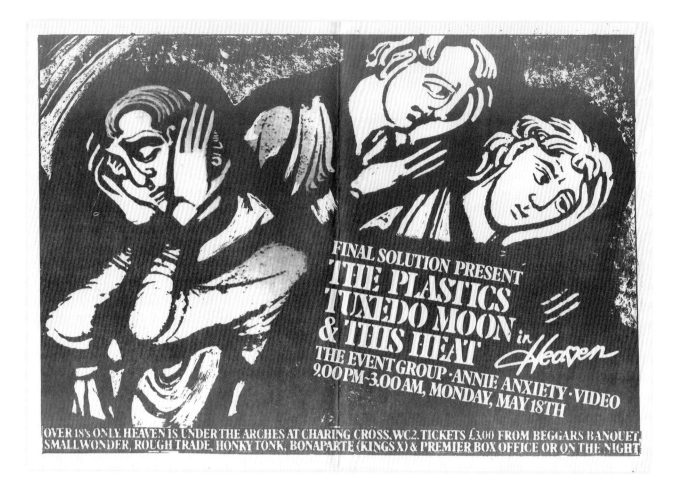

TUXEDOMOON: (above) Flyer for concert with The Plastics and This Heat at Heaven, London, 18 March 1981; (right) 'Dark Companion/59 to 1 Remix' 45 cover (Ralph Records, 1980); **Patrick Roques** design, **Mark Sangerman** photography.

UJ3RK5: Self-titled EP poster (Quintessence Records, 1980).

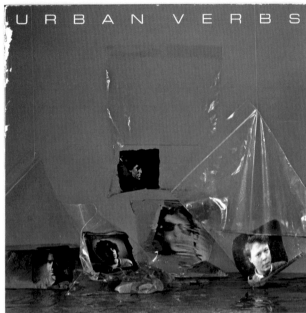

URBAN VERBS: (above) Self-titled debut LP (Warner Bros. Records, 1980).

THE URBATIONS: (right) Poster for concert at B'Stilla Bistro, Detroit, 19 and 23 November 1982.

URGH!: (above) *URGH! A Music War* compilation LP poster (A&M Records, 1981); **Lou Beach** illustration, **Alana Coghlan** design.

VIOLENT FEMMES: (right) *3* LP poster (Slash Records, 1988); **Hanson Graphic** design, **Raymond Kwan** photography.

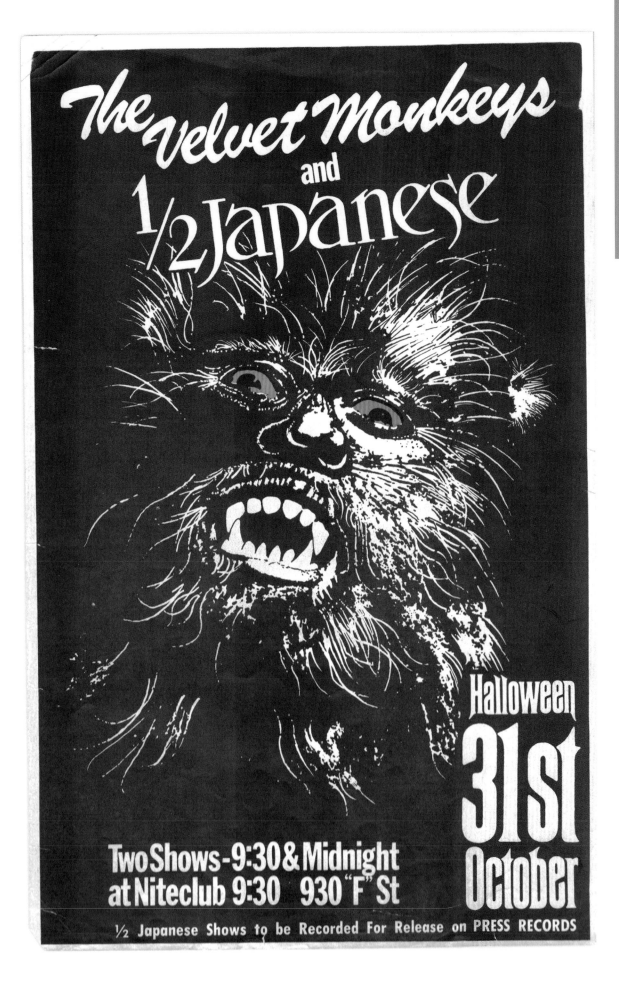

The Velvet Monkeys
and
1/2 Japanese

Halloween
31st
October

Two Shows-9:30 & Midnight
at Niteclub 9:30 930 "F" St

1/2 Japanese Shows to be Recorded For Release on PRESS RECORDS

THE VELVET MONKEYS: Poster for recorded concert with Half Japanese at Niteclub, NYC, 31 October 1986 (Press Records); image from movie *I Was a Teenage Werewolf* (1957), starring Michael Landon — the ultimate manifestation of teen alienation!

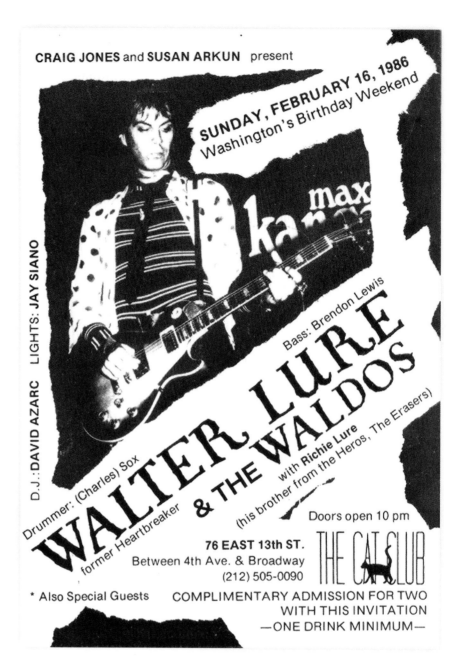

WALTER LURE & THE WALDOS: At the Cat Club, NYC, invitation, 16 February 1986.

WAX TRAX RECORDS: Business card from legendary record store in Chicago, *c.* 1980.

WILLIE ALEXANDER AND THE BOOM BOOM BAND: (below) Self-titled debut LP poster (MCA Records, 1978);
Tony Leow photography.

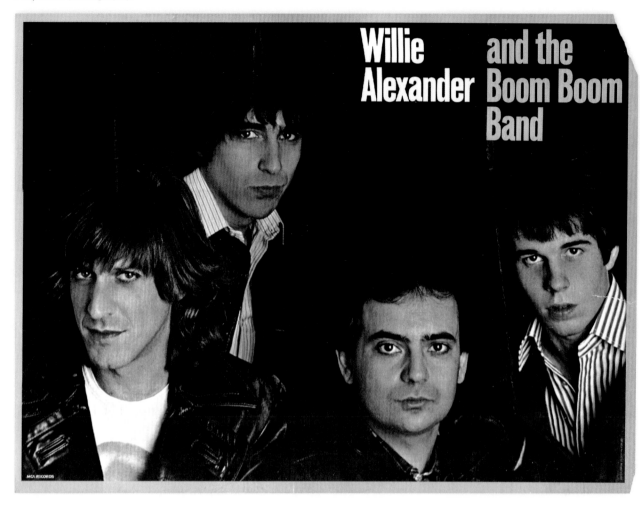

WIPPO: (below) *Totally Hip* mini-LP picture disc front and back (Manmade Records, 1980); **Mick Haggerty** artwork.

ZEITGEIST: (left) 'Wherehaus Jam/Freight Train Rain/Electra' 45 (Kickwood Records, 1984); (below) *Translate Slowly* debut LP poster (DB Records, 1985); **James Flournoy Holmes** and **Linda Mitchell** design.

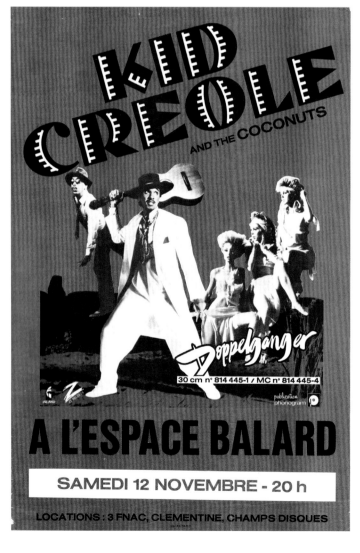

ZE RECORDS: Founded in 1978 in NYC by Michael Zilkha, heir to the British Mothercare retail empire, and Michel Esteban, owner of a Parisian boutique, this label was celebrated for its particularly eclectic sounds.

KID CREOLE AND THE COCONUTS: (left) *Doppelganger* LP/French concert poster, at L'Espace Balard, 12 November 1983 (ZE Records/Island Records). Kid Creole, aka August Darnell, became the label's in-house producer.

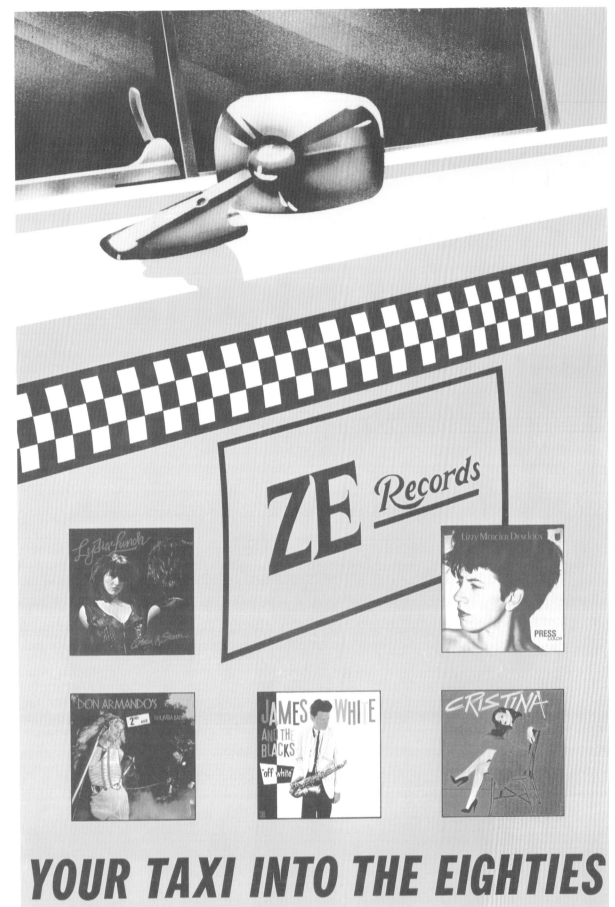

ZE RECORDS: Poster promoting the label's stable of recording artists (ZE Records, 1980).

154 West 57th Street, N.Y.C. 10019

ZE RECORDS/CRISTINA: Self-titled debut LP poster (ZE Records, 1980); **Richard Cramer** design. Cristina Monet-Palaci was married to ZE Records co-founder Michael Zilkha from 1983 to 1990. She died 31 March 2020 in New York at the age of sixty-four, after testing positive for Covid-19.

ZE RECORDS

NO WAVE SONIC ABRASIONS

'No wave' arose soon after new wave in the US in the mid-1970s, but crested more quickly. The movement can be identified from 1976 but is almost exclusively associated with a handful of New York-based bands that flourished between 1978 and 1980, and whose performances were mostly confined below 14th Street in Manhattan. Groups such as Mars, Teenage Jesus and the Jerks, DNA, and James Chance and the Contortions created a noisy, jagged, atonal and resolutely *anti-melodic* music that quickly outflanked punk's uncompromisingly confrontational ethos. These four bands were famously chronicled on the landmark *No New York* compilation record, released in November 1978 and produced by Brian Eno. But the parameters of no wave extended well beyond this iconic core. Its antinomian tendrils reached into (and subverted) other genres as well: jazz (The Lounge Lizards), surf (the Raybeats), funk (Bush Tetras), proto-electronica (Dark Days), and even 'symphonic' music (minimalist/experimental composers such as Glenn Branca and Rhys Chatham assembled massive orchestras of a hundred or more detuned, droning electric guitars played at volumes so deafening they disrupted and distorted the observer's sense perception).

No wave is often cast as a repudiation of the residually traditionalist, 'rockist' aspects of punk and the commercial ambitions of new wave (the name itself is a pun on the latter). But one could argue that its negating gesture was ultimately rooted in a deeper, abidingly parasitic relation. In retrospect, we are struck by the residual continuity of style/form between new wave and no wave (definitely visual, but also arguably musical) — even though the latter strove mightily to critique, disparage and separate itself from the former. Despite its apparent transience as a musical movement, no wave would have an enormous influence on The Birthday Party, Flipper, Sonic Youth, Swans, Big Black and many other underground bands, not to mention independent film, fashion and visual art.

While the seminal proto-punk duo Suicide preceded no wave by several years, some of their material has been included in this section because they are often — and rightly — seen as its spiritual godfathers. One might say that Suicide is to no wave as New York Dolls are to British punk.

The collection presented here also includes two posters promoting no wave festivals in Bologna and Paris during the summer of 1980. These are infused with Dada influences and are among the most artistically interesting pieces in the collection.

Andrew Krivine and Pete Groff

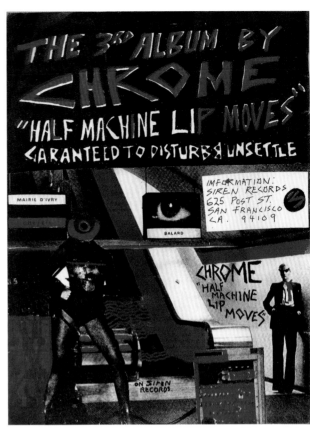

99 RECORDS: (above) Singles bag, NYC, *c.* 1980.

CHROME: (right) *Half Machine Lip Moves* LP advertisement (Siren Records, 1979); (below) 'Read Only Memory' EP/ mini-album insert poster (Siren Records, 1979).

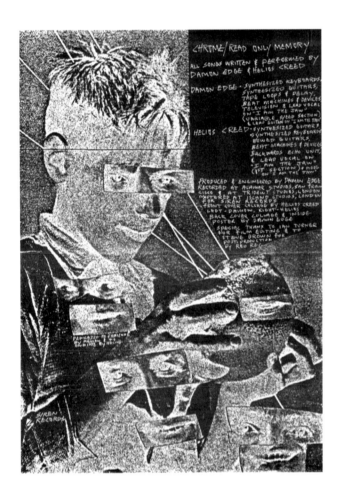

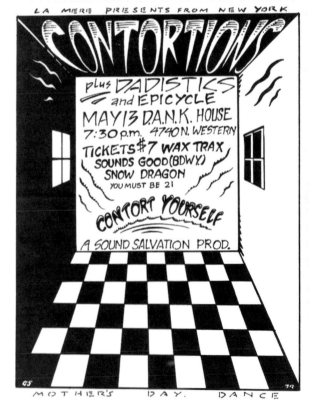

CONTORTIONS: (above) Concert flyer, supported by Dadistics and Epicycle at D.A.N.K. House (Mother's Day Dance), Chicago, IL, 13 May 1979; **GS** design.

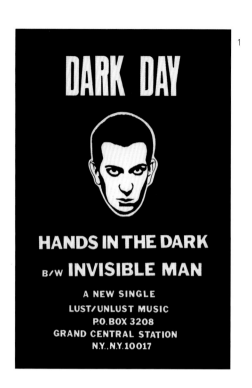

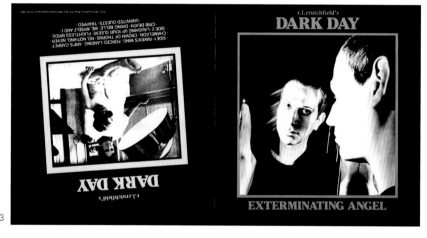

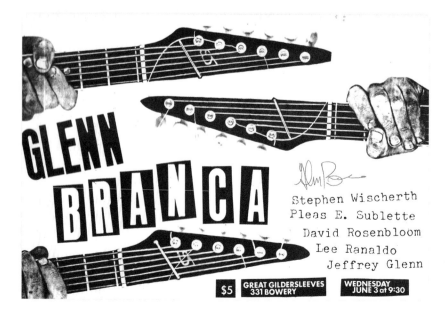

166

DARK DAY: 1 'Hands in the Dark / Invisible Man' 45 poster (Lust/Unlust Records, 1979). Lust/Unlust Music was a no wave label founded by Charles Ball, who previously co-owned the seminal independent punk label Ork Records; **2** Flyer for concert and four film screenings at TR3, NYC, 13 July 1980; **3** *Exterminating Angel* debut LP record slick (the cover of the LP printed on card for promotional purposes) (Infidelity, 1980); **Catherine Churko** design.

GLENN BRANCA ENSEMBLE: (left) Poster signed by Glenn Branca for concert at Great Gildersleeves, NYC, 3 June 1981.

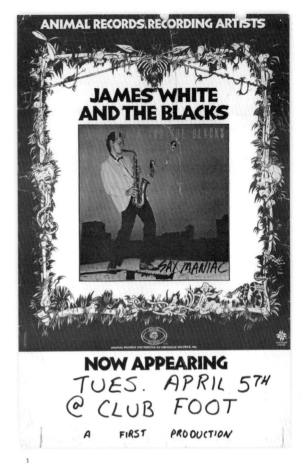

1

2 3

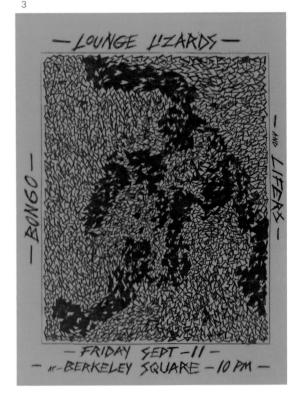

JAMES WHITE AND THE BLACKS:
1 *Sax Maniac* LP and tour poster
(Animal Records, 1982).

JAMES CHANCE: 2 Poster for concert
in Chicago, IL, 13 May 1981.

LOUNGE LIZARDS: 3 Flyer for concert
at Berkeley Square, Berkeley, CA,
11 September 1981.

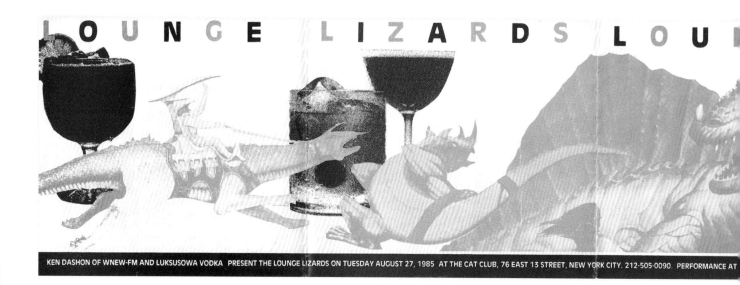

LOUNGE LIZARDS: (above) Foldout invitation for the Cat Club, NYC, 27 August 1985.

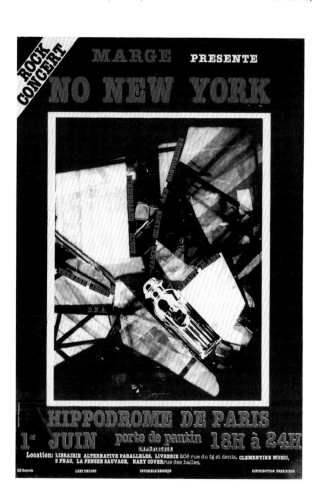

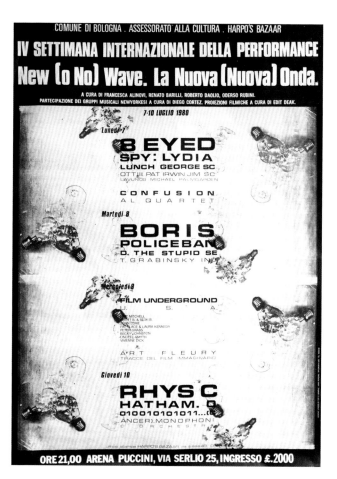

NO NEW YORK FESTIVAL: Poster for concert (including DNA, Teenage Jesus and the Jerks and Beirut Slump) at the Hippodrome in Paris, France, 1 June 1979.

NO WAVE FESTIVAL: Poster for festival in Bologna, Italy, July 1980; **Anna Persiani** and **Gianpietro Huber**, aka **Top O'Graphic**, design. This four-day festival included Lydia Lunch, Ann Magnuson, Boris Policeband and Rhys Chatham.

GE LIZARDS

NCING FROM 10 til 4. ADMISSION: TEN DOLLARS PER PERSON IT'S A NATURAL!

TEENAGE JESUS AND THE JERKS: 1 *Teenage Jesus and the Jerks* 12" record slick (the cover of the LP printed on card for promotional purposes) (Lust/Unlust Music, 1979); **2** 'Orphans' 45 flyer (Migraine, 1978); **Julie Gorton** design; **3** Poster for concert at Max's Kansas City, NYC, 9 January 1978.

1

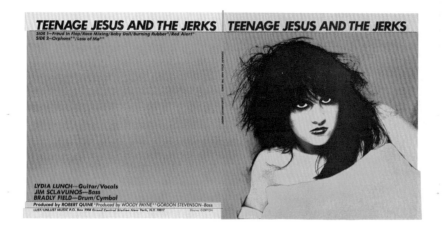

2

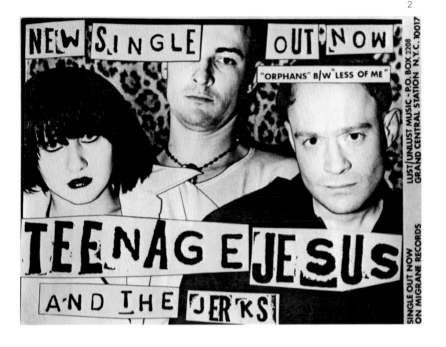

3

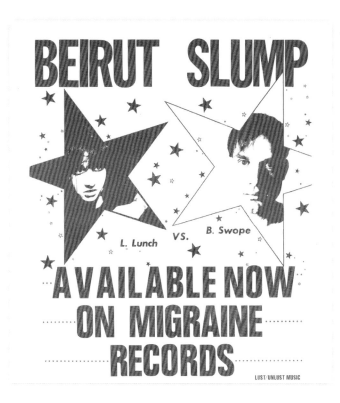

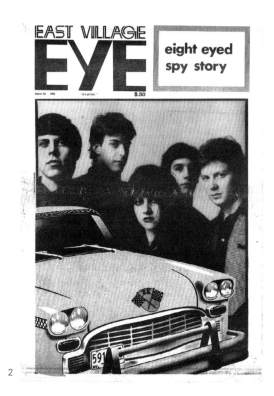

170

LYDIA LUNCH: 1 Beirut Slump, 'Try Me' 45 poster (Migraine Records, 1979). Beirut Slump was formed by Lydia Lunch and Bobby 'Berkowitz' Swope after Lunch left Teenage Jesus and the Jerks; **2** 8 Eyed Spy on the cover of *East Village Eye*, Issue #2, March 1980. 8 Eyed Spy was formed by Lunch with Jim Sclavunos; **3** *13.13* LP poster (Ruby Records, 1982); **Jeff Price** design, **James Partie** photography; **4** *Adulterers Anonymous* by Exene Cervenka and Lydia Lunch, first edition paperback, Grove Press, 1982.

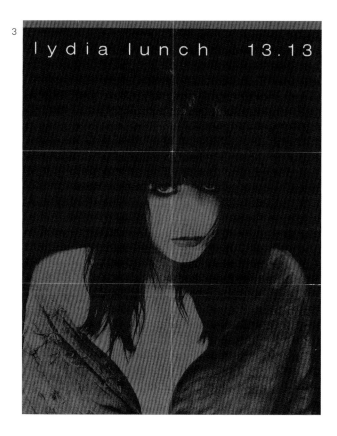

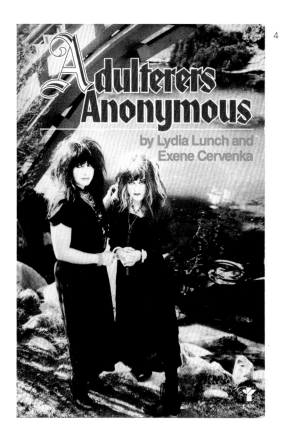

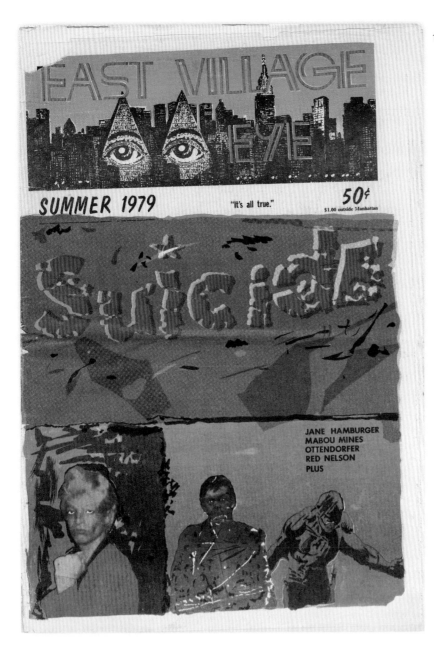

SUMMER 1979 "It's all true." 50¢
$1.00 outside Manhattan

JANE HAMBURGER
MABOU MINES
OTTENDORFER
RED NELSON
PLUS

SUICIDE: 1 *East Village Eye*, Summer 1979 issue featuring a rare interview with Alan Suicide (Vega); **2** Max's Kansas City payment receipt, September 1977, signed Alan Suicide (Vega); **3** Red Star Records T-shirt promoting two of the label's bands (1977).

MAX'S KANSAS CITY
LIVE ENTERTAINMENT
ATMOSPHERE
213
PARK AVE. S.
NEW YORK 10003 777-7870

NAME Suicide
ADDRESS 133 Greene St. N.Y.C.
DATE 9/5
AMOUNT RECEIVED $84.00
SIGNED Alan Suicide

In July 1978 I had the good fortune to attend three Clash concerts over consecutive evenings at the Music Machine in London. Suicide was the supporting act and they were fearless — resolutely completing their set despite a fusillade of bottles, spittle and other physically endangering detritus. Martin Rev and the late great Alan Vega were the two bravest performers I have ever seen.

Andrew Krivine

Suicide
★
Real Kids

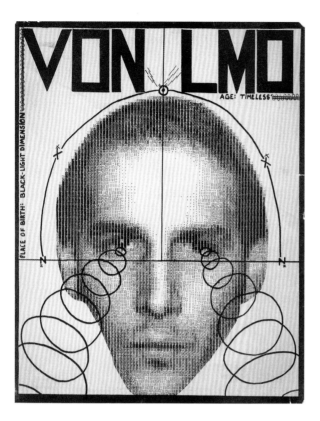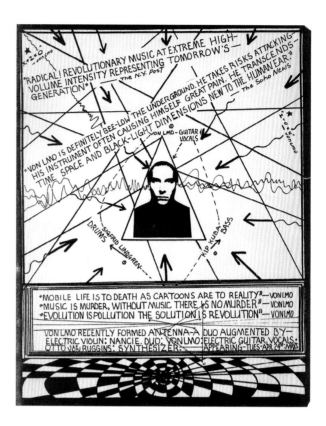

172 **VON LMO (FRANKIE CAVALLO):** Three-page booklet / promotional press kit, *c.* 1979. (above left) Page 1; (above right) Page 2; (opposite, top left) Page 3: Antenna was a band formed by Von Lmo and Otto von Ruggins.

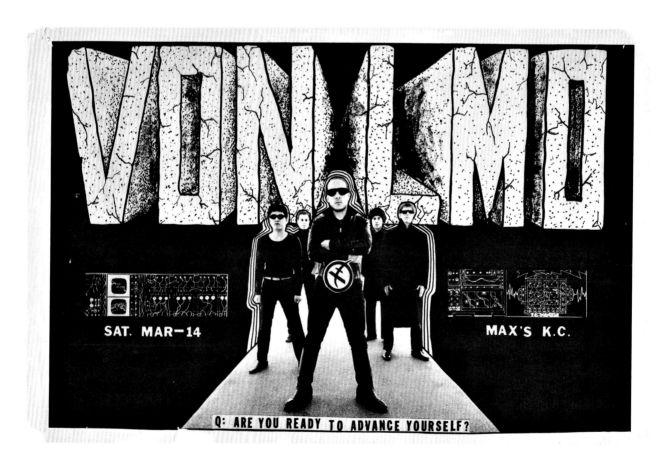

VON LMO (FRANKIE CAVALLO): Poster for Max's Kansas City, New York City, 14 March *c.* 1980.

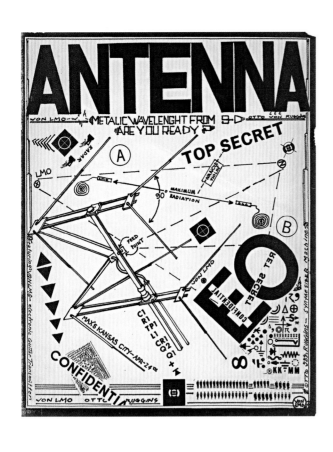

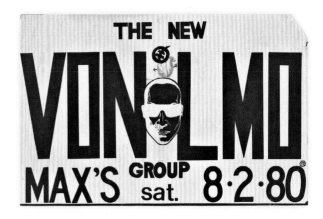

THE NEW VON LMO GROUP: (above) At Max's Kansas City, New York City, poster, 2 August 1980.

WALTER STEDING AND THE DRAGON PEOPLE: (below) With DNA at Hurrah, poster, 27 November 1980.

WALTER STEDING AND THE DRAGON PEOPLE: 'Get Ready' EP front and back cover, produced by Chris Stein (Red Star Records, 1979).

WE'RE GOING DOWN THE PUB

Based on a wealth of fossil specimens, paleontologists often cite the Afar Triangle in East Africa as the cradle of humanity. A compelling case can be made — and chronicled in the graphic design relics in the following section — that both British punk and new wave were birthed in the region north of Regent's Park in London. While pub rock is not exactly as consequential for the human race, the music and its offspring have been a great source of joy to me.

Two channels enabled pub rock to filter out into the wider world: a rather tatty assemblage of Victorian era pubs, paired with record labels whose rosters overflowed with pub circuit veterans. Stiff was notable for Elvis Costello (ex-Flip City), Ian Dury, Mickey Jupp, Jona Lewie, Lew Lewis, Nick Lowe, Roogalator, The Rumour (Bob Andrews and Brinsley Schwarz) and the Tyla Gang (led by Sean Tyla of Ducks Deluxe). Chiswick's roll call included The Count Bishops, The Hammersmith Gorillas, Little Bob Story (from Le Havre, France) and The 101ers (no need to mention the punk luminary in this band).

In such pubs as Dingwalls and the Dublin Castle in Camden, the Hope and Anchor in Islington, the Tally Ho! in Kentish Town and the Nashville Rooms in Kensington, fledgling bands gained invaluable experience (not unlike The Beatles in Hamburg in 1960).

Several pub rock groups and musicians went on to become powerful forces in both punk and new wave. High on this list are Eddie and the Hot Rods, Elvis Costello, Paul Carrack (singer for the rock band Ace, who later joined Squeeze), Ian Dury and Nick Cash (Kilburn and the High Roads), Nick Lowe (Brinsley Schwarz), Graham Parker, Generation X, The Jam, The Police, and The Stranglers.

It was not unusual for pub rock gigs to be supported by opening acts that we now consider punk or new wave. I have one striking example in the collection, for a Talking Heads concert at the Roundhouse on 29 January 1978 with Dire Straits and Slaughter and the Dogs as the support acts. Even in larger venues, such as the Hammersmith Palais and the Roundhouse, the line-ups were often just as varied. I have no idea why this was the case in mid-1970s London. Did the promoters have catholic tastes, or did pub proprietors demand three acts on a Friday night simply to sell lots of beer?

Whatever the motivation, the combinations could be surreal. Dr. Feelgood — probably pub rock's Top Dog circa 1974–76 — introduced audiences to several bands who went on to new wave success. In the pre-digital age, this was how young people were exposed to the bands that could change their lives. If the reader owns old copies of *Sounds* or *Melody Maker* from these years, scour the venue adverts in the back pages and my observation will be validated. Music fans are all the richer for those bonuses.

Andrew Krivine

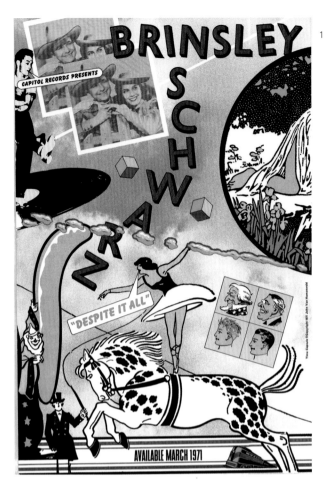

BRINSLEY SCHWARZ: 1 *Despite It All* debut LP poster (Capitol Records, 1971); **2** and **3** Promotional stickers (United Artists Records, 1974); **4** *Nervous on the Road* LP tour blank poster (United Artists Records, 1972); **Jet Power** design.

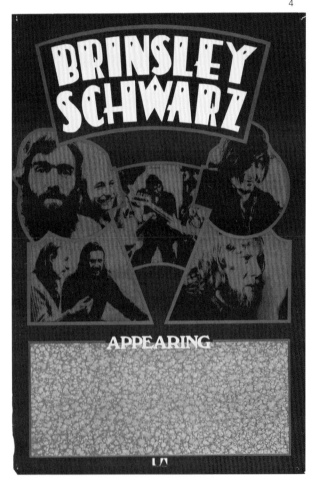

DINGWALLS: (left) Christmas 1980 sticker from the legendary venue in London.

176

DR. FEELGOOD: 1 Personality poster with a distinctively new wave feel in the cartoon illustration and dynamic use of colour (United Artists Records, *c.* 1974); logo designed by **Joe Petagno** (who also designed the iconic 'Iron Boar' logo for the band Motörhead); **2** *Sneakin' Suspicion* LP poster (United Artists Records, 1977); **Paul Henry** design, **Gered Mankowitz** photography; **3** Concert posters, at the Pavilion, Hemel Hempstead: 26 April 1975, and **4** 8 October 1975.

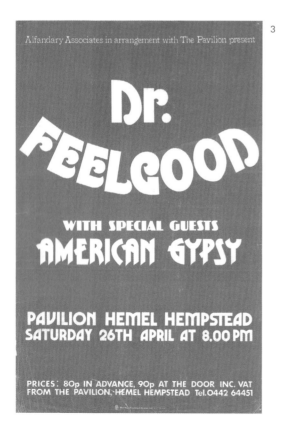

GRAHAM PARKER AND THE RUMOUR: (below) 'The Pink Parker' EP poster (Vertigo Records, 1977).

HOPE AND ANCHOR FRONT ROW FESTIVAL: (right) Cover of *WEA* magazine (1978).

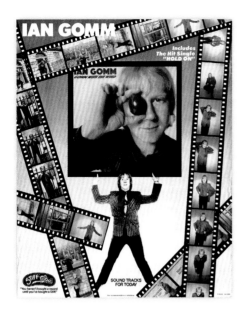

IAN GOMM: (left) *Gomm with the Wind* LP US release poster (Stiff-Epic Records, 1979); **c-more-tone studios** lettering; (below) 'Come On' debut 45 poster (Albion Records, 1977).

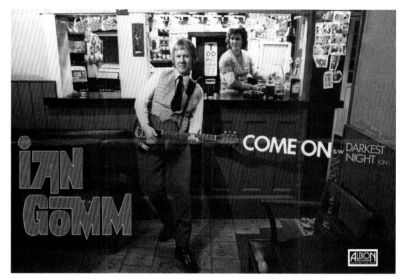

THE INMATES: (below) With The Commuters at University Centre Rotherham, poster, 3 November 1979.

THE KURSAAL FLYERS: (below) *Chocs Away!* LP promotional sticker (UK Records, 1975); **Barney Bubbles** design.

KOKOMO: (right) With The Kursaal Flyers at Hemel Hempstead Pavilion, poster, 29 February 1976.

THE KURSAAL FLYERS: *The Great Artiste* LP poster (UK Records, 1976); **Andrew Douglas** artwork. As in several new wave posters, this design references the past — in this case the triumphs of RAF fighter pilots (the revered 'Few') during World War Two. When I see this poster, the image of Group Captain Lionel Mandrake from the film *Dr. Strangelove* (1964) immediately springs into my mind!

LEW LEWIS REFORMER: (above) '... Win or Lose' 45 poster (Stiff Records, 1979); **Chris Morton** design.

THE STUKAS: (above right) 'I Like Sport' 45/ tour blank (Sonet Records, 1978).

THE TYLA GANG: Promotional poster (Skydog Management, 1976).

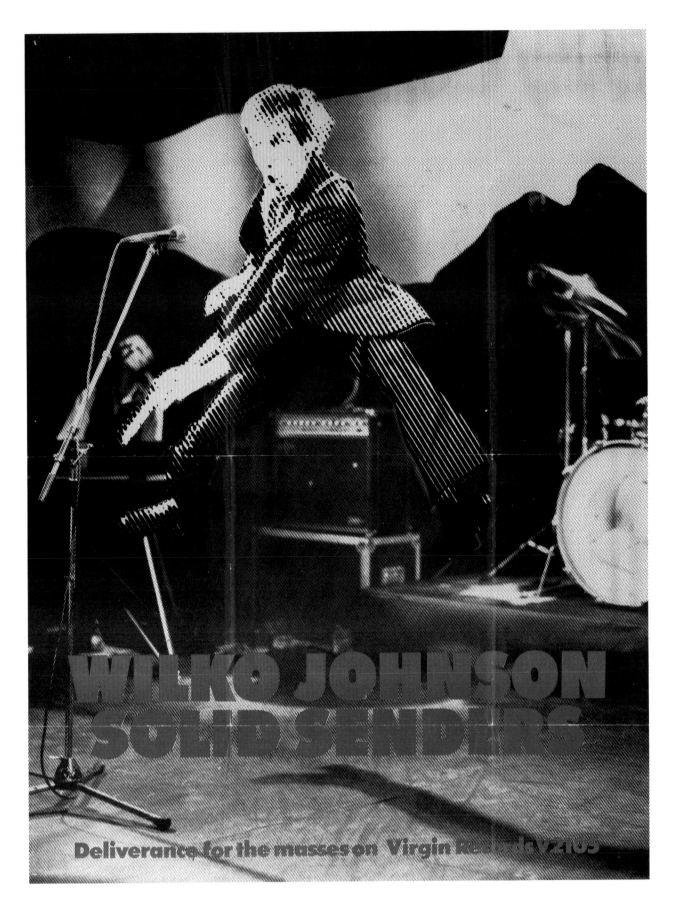

WILKO JOHNSON AND SOLID SENDERS: *Solid Senders* LP poster (Virgin Records, 1978).

PUT A TIE ON,
HERE COMES THE (BRITISH) NEW WAVE

Matthew Worley

In 1980, a committed punk rocker from East Anglia wrote the following in his fanzine, *Trees and Flowers*: 'Frankly the term new wave puts the willies up me now because it's too accessible, with groups like The Police, Squeeze [...] you know, music for *Top of the Pops*.' They might have been 'in it in '77', Steve Toxin continued, referring to the punk connections of the groups he disparaged. But they had since made a 'sensible break away'.[1] Punk and new wave: different things for different people.

Such distinction is now common currency and has been for a long time. In terms of pub chat, new wave — as a musical genre — conjures up images of skinny ties, bright colours and knock-knees. Sound-wise, it might kindle descriptions of jagged guitar lines and jerky riffs. Discussion may reflect on Sire Records' Seymour Stein's infamous decision in late 1977 to embrace the term as means to market the flurry of groups emerging into the mid-1970s, rejecting 'punk' as too vulgar a label for his would-be punters.[2] A rumination on new wave as the sound and style of punk diluted, sanitized and commodified could then ensue, before choice records — by bands both renowned and forgotten — will no doubt be offered as archetypes to signal just what new wave entailed. Almost inevitably, the debate will turn to quibble, revolving around who does or does not fit the (imagined) brief. Should The Rezillos be labelled new wave? Any Trouble would have to be. Joe Jackson for sure. Elvis Costello? Squeeze? What about Nick Lowe? How far does the term stretch? Does it blur into pub rock and what has since become known as post-punk? Did you need to

THE REZILLOS: *'I Can't Stand My Baby' 45 poster (Sensible Records, 1977).*

NICK LOWE: (right) Flyer for concert in Glasgow, Scotland, 2 May 1982.

[1] *Trees and Flowers*, 2 (1980), p. 2.
[2] Theo Cateforis, *Are We Not New Wave? Modern Pop at the Turn of the 1980s* (Ann Arbor: University of Michigan Press, 2011), p. 25.

wear glasses? Was 'power pop' just new wave by another name? What else did The Vapors do other than 'Turning Japanese' …

Put bluntly, new wave was — and is — an ill-defined and contested term. There is no reason to change that (the quibbling can be fun). And it maintains the fact that 'new wave' was originally used interchangeably with 'punk' in the British context from at least 1976 (and earlier in the US). In the UK Neil Spencer may have employed the phrase 'punk rock' in the first live review of the Sex Pistols in February 1976, but the *Sounds* journalist John Ingham recalled 'new wave' being the moniker of choice for Malcolm McLaren around this time.[3] 'Punk', certainly, was a label attached to — rather than produced from within — the Sex Pistols' inner circle.[4] As a result, many of the early fanzines inspired by Mark Perry's *Sniffin' Glue* referred both to 'punk' and 'new wave' long into 1977, covering a range of artists from the pub circuit as well as those — Elvis Costello, XTC, Boomtown Rats — that appeared more musically adept than those forming in and around the Sex Pistols' wake. For many a music writer, 'new wave' provided a catch-all term for a generation of bands and artists emerging into the mid-1970s (as in 'a new wave of bands'). These were (typically) younger than the established groups from the 1960s or early 1970s and generally committed to streamlining rock's form and/or reconfiguring it in angular — often twitchy or angsty — ways. Writing in 1976, Caroline Coon — whose *Melody Maker* articles did much to define punk in the British context — described 'new wave' as an 'inclusive term used to describe a variety of bands like Eddie and the Hot Rods, The Stranglers, Chris Spedding and The Vibrators, Suburban Studs, Slaughter and the Dogs, who are not definitively hardcore punk but, because they play with speed and energy, are part of the scene'.[5]

THE VAPORS: Trade advertisement for *New Clear Days* debut LP/'Turning Japanese' 45 (United Artists Records, 1980).

THE BOOMTOWN RATS: (opposite) **1** *The Adventures of Big Red*, cover of promotional magazine (Columbia Records, February 1979); **John Holmstrom** artwork, **Bruce Carleton** photography; **THE VIBRATORS: 2** 'Automatic Lover' 45 poster (Epic Records, 1978); **EDDIE & THE HOT RODS: 3** Concert poster for Top Rank Suite, Swansea (February 1978); **SLAUGHTER AND THE DOGS: 4** *Do It Dog Style* LP and UK tour poster (Decca Records, 1978).

184

[3] Neil Spencer, 'Don't Look Over Your Shoulder …', *NME*, 21 February 1976, p. 31; Jon Savage, *England's Dreaming: Sex Pistols and Punk Rock* (London: Faber & Faber, 1991), pp. 158–9.
[4] John Ingham, 'Welcome to the (?) Rock Special', *Sounds*, 9 October 1976, p. 22; Caroline Coon, 'Punk Alphabet', *Melody Maker*, 27 September 1976, p. 33.
[5] Caroline Coon, 'Punk Alphabet', *Melody Maker*, 27 September 1976, p. 33.

1

2

3

4

1

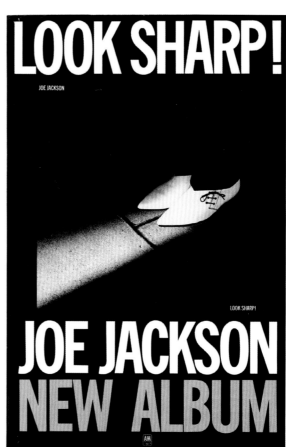

2

186

3

NEW WAVE: **1** Sales sheet for compilation record (Vertigo Records, 1977).

JOE JACKSON: **2** *Look Sharp!* debut LP poster (A&M Records, 1979); **Michael Ross** artwork, **Brian Griffin** photography.

ANGELIC UPSTARTS: **3** *Reason Why?* LP poster (Anagram Records, 1983); **Jim Phelan** artwork; **THE SAINTS: 4** *(I'm) Stranded* debut LP poster (Sire Records, 1977).

4

Listening to the records and looking at the artworks/designs that came to be recognized as new wave may help posit certain traits. The *New Wave* compilation issued by Vertigo/Phonogram in the summer 1977 only reveals the vagaries of the term, with tracks by The Damned and Ramones running alongside The Saints, Boomtown Rats, Flamin' Groovies and Little Bob Story. The cover shows Derek Gibbs in suitably punk mode, gobbing his beer towards the camera. Once we glimpse Barney Bubbles' sleeve designs for Stiff Records, however, or Joe Jackson's pointy white shoes caught in the doorway light for *Look Sharp!* (1979), we begin to gain a sense of an identifiably new wave sound and aesthetic developing in parallel to all things punk and distinct from the 'new musick' that begat the alienated desolation of post-punk (Siouxsie and the Banshees, Throbbing Gristle and on through PiL, Joy Division *et al*).[6] Bright colours — all yellows, blues and reds — adorned covers and posters, not to mention suits, shirts and trousers that fitted tight and appeared suitably *modern*, as distinct from 1970s' flared autumnal tones. These colours weren't psychedelic either; they were sharp and crisp, decorating rather than distorting, reaching an apotheosis of sorts with The Police's *Synchronicity* cover art of 1983. Drop the needle and there's a craft to the songs; they tend to be skilfully arranged and adeptly played; the instrumentation is varied and the pace more likely to ebb and flow than a standard punk assault. Though punk's rougher edges and lyrical bite could (and did) cross over to inform new wave's taut energy – think early Costello or the subject matter of The Boomtown Rats' 'I Don't Like Mondays' (1979) – this was a music and a style that swerved away from abjection, provocation and blunt impact. New wave tended to charm rather than confront. It was not tied into — or concerned with forging — a (sub)culture; it existed on the airwaves, in the record racks and soundtracked the odd night out. It was pop music first and foremost.

As it was, new wave in Britain was never quite so aggressively defined as it was in the US, not commercially anyway. Punk broke through following the moral panic that enveloped Sex Pistols in late 1976, infiltrating the charts and over-running the music press. Despite early misgivings, the industry soon absorbed and packaged the first wave of British punk, until 1977–79 saw *Top of the Pops* — the UK's flagship chart-show — feature everyone from Sex Pistols to The Lurkers, Angelic Upstarts and Siouxsie and the Banshees. There was no real need to construct a new wave to channel punk's cultural assault. Even so, record shops from the later 1970s began to designate sections to 'punk and new wave' — and, as punk became ever more codified into the early 1980s, to provide discrete partitions for each: 'new wave' was that which was not overtly 'punk' (before 'indie' and 'alternative' afforded further sub-division). Therein were records made from 1976–77 onwards and distinct from heavy metal or such genres as soul, reggae and disco. As the journalists suggested in 1976 and 1977, punk was part of a new wave and the new wave was informed by punk.

Maybe, just maybe, we might conceive new wave as punk with the *noise and disruption* removed, with the *disaffection* subdued. Or perhaps we should conclude punk was the new wave all ripped and torn and imbued with a harder attitude and a darker heart. Whatever, punk and new wave were aligned in time — and sometimes in space — but separated in terms of style, sound and sensibility. By 1979–80, we might even say that new wave had broken from the new wave, so diverse had the musical terrain become. Quite where all the lines divide remains unclear and will entertain old men for at least another twenty-five years, arguing the toss to justify their own tastes and display their knowledge. Look closely and a day-glo badge may even still be stuck to their lapel, an old reminder of what once was 'new'.

6 Jon Savage, 'New Musick', *Sounds*, 26 November 1977, p. 23.

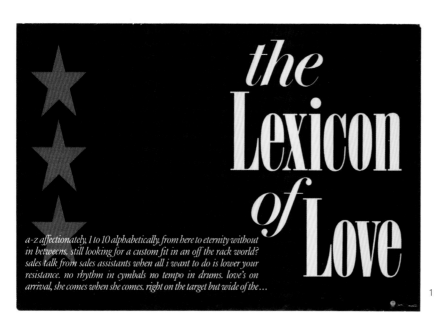

a-z affectionately, 1 to 10 alphabetically, from here to eternity without in betweens, still looking for a custom fit in an off the rack world? sales talk from sales assistants when all i want to do is lower your resistance. no rhythm in cymbals no tempo in drums. love's on arrival, she comes when she comes. right on the target but wide of the ...

1

ABC: 1 *The Lexicon of Love* LP, glossy poster (Neutron Records/Mercury Records, 1982); **2** 'How to be a Millionaire' 45 (Neutron Records/ Mercury Records, 1984); **Keith Breeden** design; **3** *Beauty Stab* LP poster (Neutron Records/Mercury Records, 1983); **ABC** and **Keith Breeden** design; **4** *How to be a Zillionaire* poster (Neutron Records/Mercury Records, 1985); **Keith Breeden** design.

2

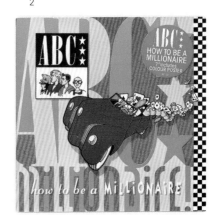

3

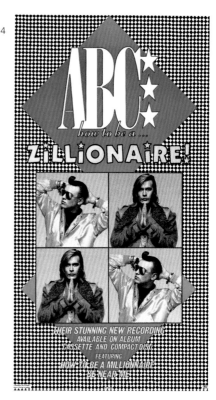

4

ABC: 'How to be a Millionaire' 45 folded poster sleeve (Neutron Records/Mercury Records, 1984).

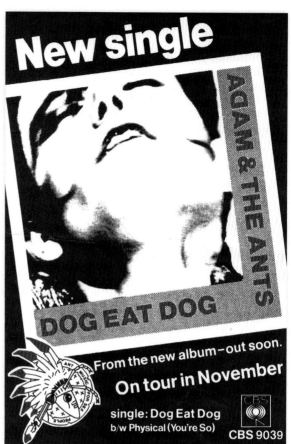

ADAM & THE ANTS: (above) Moonlight Club Railway Hotel gig ticket, West Hampstead, London, 31 July 1978.

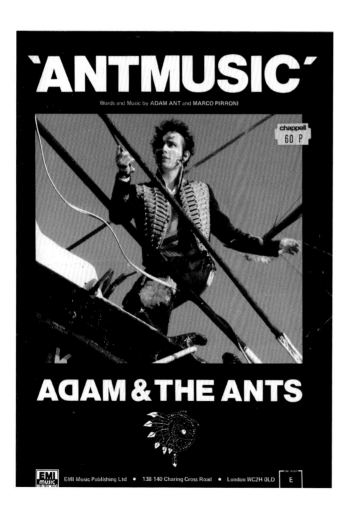

ADAM & THE ANTS: (top) 'Dog Eat Dog' 45 flyer (CBS Records, November 1980); **Danny Kleinman** design (including Warrior Ant logo); (left) 'Antmusic' 45 sheet music (EMI Music Publishing Ltd, 1980).

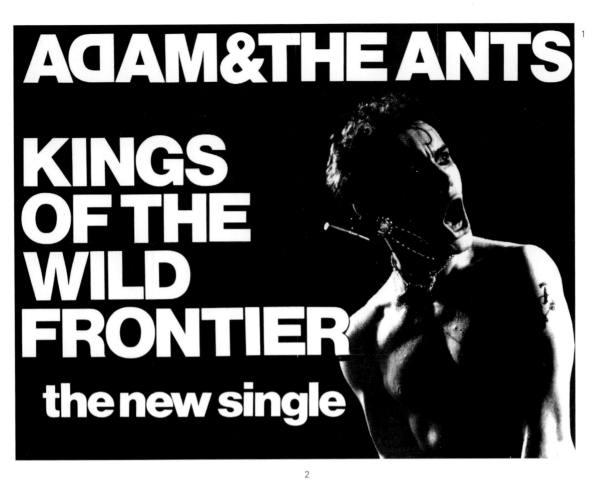

ADAM & THE ANTS: **1** 'Kings of the Wild Frontier' 45/LP/US (CBS Records, 1980); **2** Poster for concert at the Palladium, NYC, April 1981 (promoting the *Kings of the Wild Frontier* LP) (CBS Records, 1981); **Peter Ashworth** photography, **Danny Kleinman** design (including Warrior Ant logo); **3** *Vive Le Rock* LP poster (CBS Records, 1985); **Rob O'Connor** design and concept with **Adam Ant**; **Nick Knight** photography.

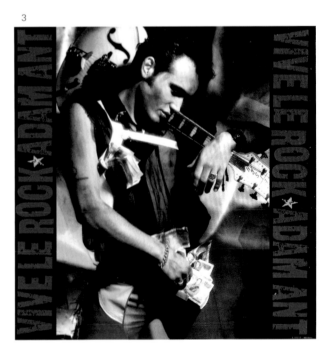

ALTERED IMAGES: **1** 'Happy Birthday' 45 poster (Epic Records, 1981); **David Band** artwork; **2** 'Dead Pop Stars' debut 45 (Epic Records, 1981); **David Band** artwork; **3** With A Flock of Seagulls at Sheffield University, 16 November 1981: poster signed by lead singer, Claire Grogan.

THE ART OF NOISE: **4** *In Visible Silence* LP poster (China Records, 1986); **John Pasche** artwork, **Peter Ashworth** photography; **5** *In No Sense? Nonsense!* LP poster (China Records, 1987).

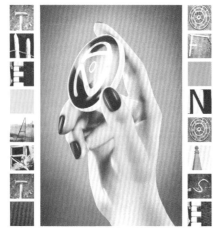

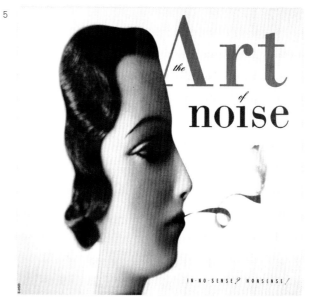

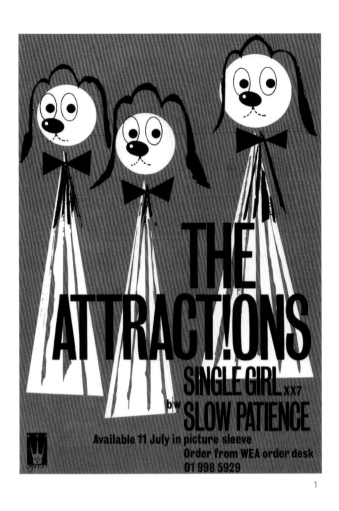

1

THE ATTRACTIONS (without Elvis Costello): **1** 45 sales sheet for 'Single Girl' (F-Beat Records, 1980).

BAD MANNERS: 2 This self-titled release poster includes highlights from their first two UK LPs (MCA, 1981).

BANANARAMA: 3 *Deep Sea Skiving* debut LP (London Records, 1983); **Peter Barrett** design, **Bay Hippisley** photography.

2

3

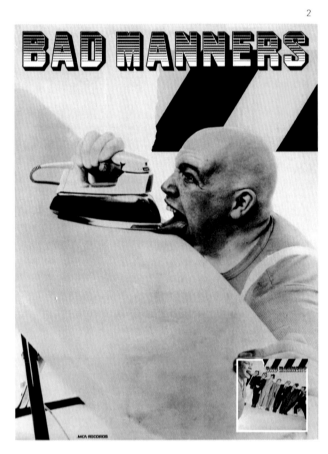

194

BE-BOP DELUXE: *Drastic Plastic* LP poster (Harvest Records, 1978); **Hipgnosis** design, **Geoff Halpin** lettering.

THE BEAT: **1** *The Noise In This World*, Beat 'zine back cover, May 1981; **2** Tour poster 'Tears of a Clown / Ranking Full Stop' 45 (2 Tone, 1979): the 'Beat Girl' was designed by **Hunt Emerson** from a 1960s photo of a woman dancing with Prince Buster; **3** *Wha'ppen?* LP poster (Go-Feet Records, 1981); **Hunt Emerson** and **The Beat** design; **4** 'Best Friend / Stand Down Margaret (Dub)' 45 poster (Go-Feet Records, 1980); **5** *Special Beat Service* LP flyer (I.R.S. Records, 1982). Note that The Beat had to be renamed The English Beat in the US as another band called The Beat already existed there.

1

2

4

5

THE BEATNIKS: (left) *The Beatniks* LP record slick (the cover of the LP printed on card for promotional purposes) with Yukihiro Takahashi and Keiichi Suzuki (Statik, 1982); **Ken Ansell** graphics, **Sheila Rock** photography.

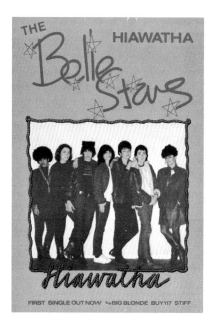

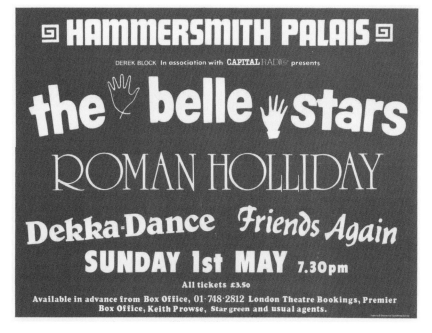

THE BELLE STARS: (left) Concert with Roman Holliday at Hammersmith Palais, poster, 1 May 1982; (above) Debut single 'Hiawatha' (Stiff Records, 1981); (below) 'Indian Summer' 45 poster (Stiff Records, 1983); **Jim Brogden** illustration.

BETTE BRIGHT AND THE ILLUMINATIONS: (opposite)
1 'Hello, I Am Your Heart / All Girls Lie' 45 front and back cover (Korova Records, 1980); **Colin Thomas** photography; **2** 'The Captain of Your Ship' unfolded 45 sleeve (Radar Records, 1979); **Malcolm Garrett** design.

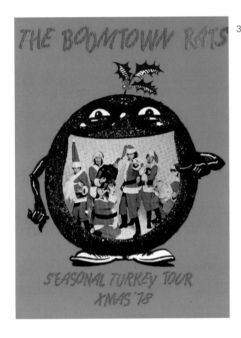

THE BOOMTOWN RATS: 3 Tour poster/program for Seasonal Turkey UK Xmas Tour, 1978; **4** Personality poster issued by the band's US label (Columbia Records, *c.* 1979); **5** *The Fine Art of Surfacing* LP poster (Columbia Records, 1979); **Fin Costello** photography.

THE BOOMTOWN RATS: (above) Invitation to a record industry showcase performance at Frederick's of Hollywood, Los Angeles, CA, 4 April 1979.

THE BOOMTOWN RATS: (above) *Mondo Bongo* LP sticker 104 FM WBCN Radio Boston, 17 March 1980; **Alan Schmidt**, **Andrew Prewett**, **Stuart Bailey** artwork, **Mike Owen** photography; (left) Poster for concert at the Duke Ellington Ballroom, DeKalb, IL, *c.* 1981.

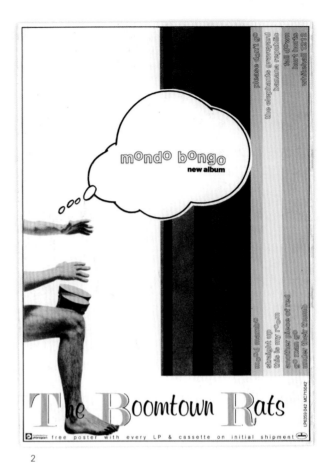

THE BOOMTOWN RATS: 1 'Bongos Over
Britain' tour programme with backstage
pass (Mercury Records, 1980); **Alan Schmidt,
Andrew Prewett, Stuart Bailey** artwork,
Mike Owen photography; **2** *Mondo Bongo*
LP, poster design in the style of the Soviet
Constructivist designers the **Stenberg
brothers** (CBS Records, 1981); **Alan Schmidt,
Andrew Prewett, Stuart Bailey** artwork,
Mike Owen photography.

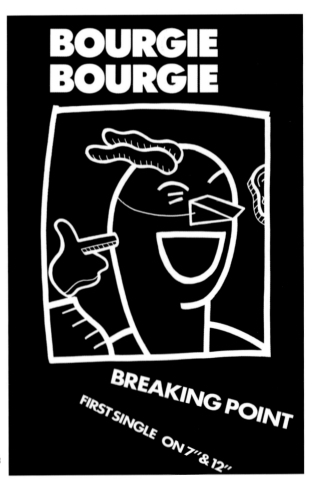

BOURGIE BOURGIE: 3 'Breaking Point' 45
poster (MCA Records, 1984); **David Band**
illustration.

3

BOW WOW WOW: 1 'W.O.R.K. (N.O. Nah No! My Daddy Don't)' 45 poster (EMI Records, 1981); **2** *See Jungle! See Jungle!* LP poster (RCA Records, 1981); **Nick Egan** design; **3** 'W.O.R.K. (N.O. Nah No! My Daddy Don't)' cassette single (EMI Records, 1981); **4** 'W.O.R.K. (N.O. Nah No! My Daddy Don't)' 45 tour poster for University of East Anglia, Norwich, 18 March 1981 (cancelled).

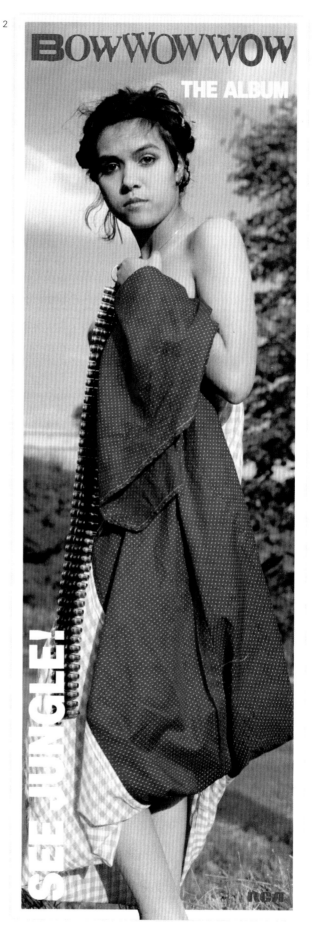

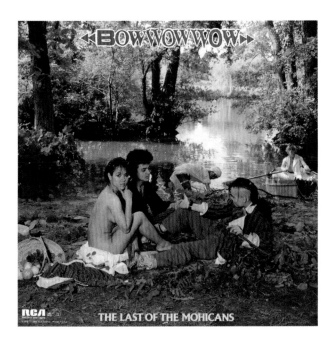

BOW WOW WOW: (left) 'Last of the Mohicans' EP (RCA Records, 1982); **Nick Egan** design, **Andy Earl** photography. For this photo shoot, the band was posed to recreate the painting *Le Déjeuner sur l'herbe* by **Edouard Manet**; (below) German concert poster with C30 cassette graphics, Bonn, 18 February 1981.

BOW WOW WOW: Poster for *See Jungle! See Jungle!* LP (RCA Records, 1981); **Nick Egan** design, **Andy Earl** photography. *See Jungle! See Jungle!* ranked No. 10 in *The 100 Best Album Covers* (Dorling Kindersley Publishing, 1999).

POSTERS GOING STEADY: MARTIN KAYE'S DESIGNS FOR THE PARADISO

Andrew Krivine

In the following section I have tried to shine a light on one vibrant corner of European music poster design. Martin Kaye was a prodigious and inventive talent — a one-man type foundry who produced a memorable series of concert posters during his eleven-year association with the Paradiso in Amsterdam. Martin may be a semi-notorious legend from the local music scene to Amsterdamers, but he is largely unknown in the wider design world.

While he produced a vast, eclectic range of types (complete alphabets, a rare achievement),[1] this alone would not justify dedicating an entire section to his work. Rather, Martin merits inclusion because he coupled his original types with an extraordinary eye for colours, and applied the colours in flat and split fountain silkscreens to often stunning effect. As can be seen in his poster for The Monochrome Set, the tonal transitions are exceptionally subtle.

THE MONOCHROME SET: With the Monomen, 20 September 1982; **Karen Kvernenes** printing.

[1] For those interested in seeing more of Martin's work — including several of his alphabets — I encourage them to track down this out-of-print title: *Façade alphabets etcetera*, Martin Kaye (De Buitenkant; 1st Edition, January 1985).

For me, this fusion of unique typefaces with unusual colourings produced some of the most beautiful concert posters of the 1970s and 1980s — and many new wave bands benefited from this treatment.

As you will probably infer after seeing these posters, Martin rarely bothered to look at the promotional materials sent by the record labels (at most he would include the main cover element), and it is quite likely that he didn't listen to their LPs before getting to work. The groups being promoted didn't cloud or inform his artistic vision. He worked from a clean slate every time — his posters were in no way an extension of the marketing campaigns devised in record label corporate HQs.

I don't think Martin had a close affinity with any particular genre of music or group. Rather, it was piece work, and every week he had to create posters for the upcoming stream of performers passing through Amsterdam. And yet the care and passion for his craft radiates from these posters. For the most part, there is an economy and elegance to his oeuvre, though at times he could be quite playful and whimsical (as in his posters for Toyah and Bow Wow Wow).

There is another reason why I felt compelled to include a section dedicated to his work: these posters serve as a graphical marker for the twilight of an era — a time when venues hired local artists to create posters for a single event. The following posters were all created between 1980 and 1984. By the mid-1980s, most venues had abandoned the practice of using local graphic designers: the box-office staff simply signed for drop-shipped boxes of posters from EMI, A&M, Universal, Warner, and so on, and then plastered them around town.

Martin's posters also evoke a live performance world that no longer exists. In many major cities, large concert venues were magnets for youth culture — a counterpoint to the traditional

BOW WOW WOW: With The Unknown Cats, 1 February 1981.

museums patronized by adults. In America during the 1960s and 1970s, concert halls such as the Avalon Ballroom and Fillmore West in San Francisco and the Grande Ballroom in Detroit took pride in creating their own distinct visual identities. The Paradiso is a European example. Rock music had not yet fallen completely under the jackboot of the record-label conglomerates.

Sadly, for the past three or more decades, most concert posters have been based on record-label-issued posters, with date and venue simply printed on the lower border. Such is production and distribution in a globalized, culturally homogenous world — end of story.

Just as Alton Kelley, Stanley Mouse, Gary Grimshaw and others dedicated much of their creative output to favourite local concert halls, Martin Kaye is inseparable from the Paradiso. However, unlike those artists, his legacy isn't limited to the few years of psychedelia. Countless punk, new wave, post-punk, no wave, reggae and even blues artists had the good fortune to be represented by Martin.

Finally, for those readers intrigued by these Paradiso posters, the following link is a useful resource: *https://paradisoposters.nl/paradiso-posters-by-martin-kaye/*

TOYAH: With Mistral, 11 December 1981.

1

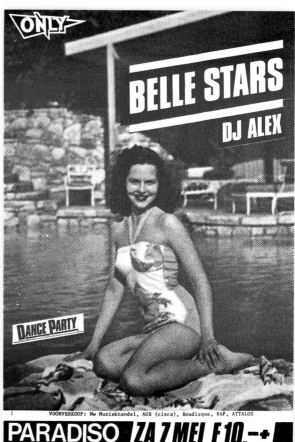

2

3

ALTERED IMAGES: **1** With Bamboo Monaco, 1 August 1981.

BELLE STARS: **2** With D.J. Alex, 7 May 1983.

BIRTHDAY PARTY: **3** With Exploiting the Profits, 21 January 1983 (and The Sound with Two Supply, 22 January 1983).

BRAM TCHAIKOVSKY: **4** With Uncle Rednose, 24 February 1980.

4

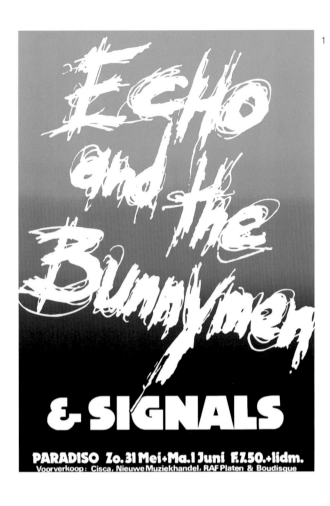

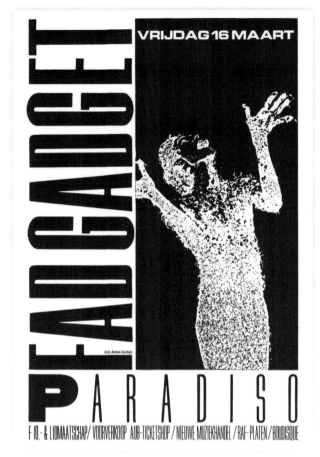

ECHO AND THE BUNNYMEN: **1** With the Signals,
31 May and 1 June 1983; **Karen Kvernenes** printing;
FAD GADGET: 2 16 March 1984; **3** With The Actor (and
A Certain Ratio with Quando Quango, Factory Records)
27 April 1983; **THE JAM: 4** With Dance in Armour, 24 and
25 April 1982; **Karen Kvernenes** printing.

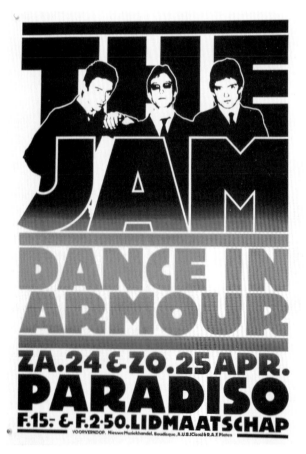

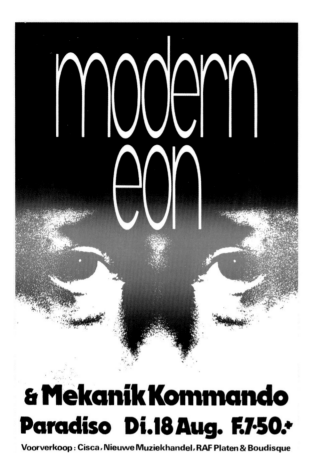

208

MODERN EON: (left) With Mekanik Kommando, 18 August 1981.

THE PASSIONS: (below) 10 November 1981.

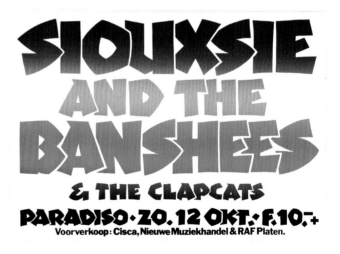

PRINCE CHARLES: (left) With The City Beat Band and D.J. Alex, 27 May 1984.

SIOUXSIE AND THE BANSHEES: (above) With The Clapcats, 12 October 1980; **Karen Kvernenes** printing.

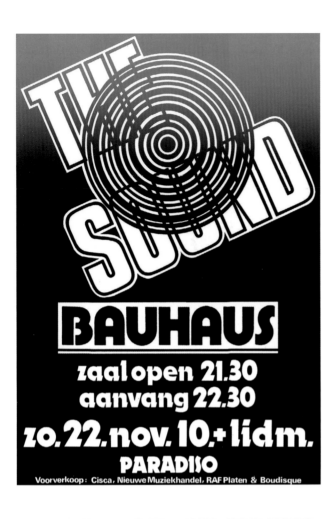

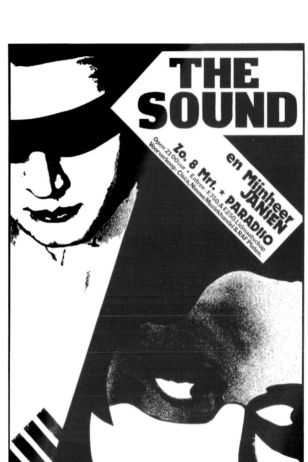

THE SOUND: (left) With Bauhaus, 22 November 1981; **Karen Kvernenes** printing.

THE SOUND: (below) With Mijnheer Jansen, 8 March 1981; **Karen Kvernenes** printing.

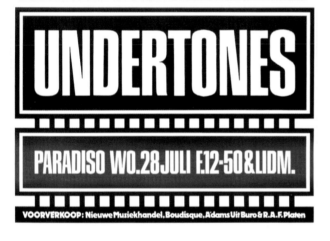

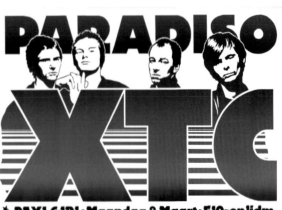

THE UNDERTONES: (above) 28 July 1980.

XTC: (right) With Paxi Girl, 8 March 1982; **Karen Kvernenes** printing.

BOY: 1 and **2** *Blackmail* catalogue, *c.* 1982. The
author's cousin, John Krivine, founded BOY in 1977;
3 Wristwatch, *c.* 1984.

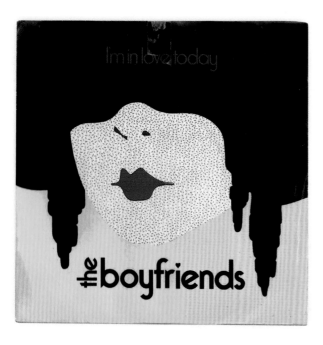

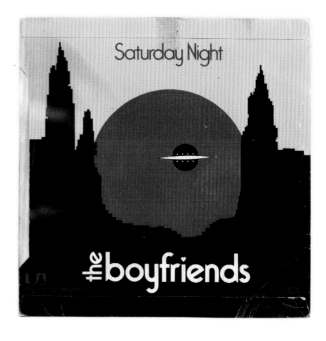

THE BOYFRIENDS: (above) 'I'm in Love Today / Saturday Night' 45 front and back cover (United Artists Records, 1978).

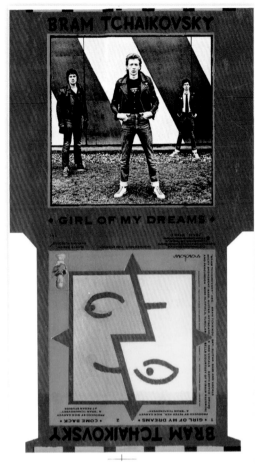

1

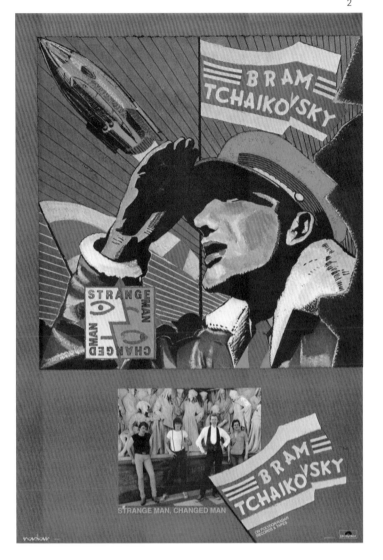

2

211

BRAM TCHAIKOVSKY: 1 'Girl of my Dreams'
unfolded 45 sleeve (Radar Records, 1979);
Rocking Russian design; **2** *Strange Man Changed
Man* debut LP poster (Radar/Polydor Records,
1979); **Rocking Russian** design.

BRONSKI BEAT: 3 'Hit That Perfect Beat' 45 poster
(London Records, 1985); **Peter Barrett** design.

BOY / THE BOYFRIENDS / BRAM TCHAIKOVSKY / BRONSKI BEAT

3

CLIVE LANGER & THE BOXES: 1 'It's All Over Now' 45 sales sheet (F-Beat Records, 1980); **Barney Bubbles** design; 2 'Splash (a Tear Goes Rolling Down)' 45 sales sheet (F-Beat Records, 1980); **Barney Bubbles** design.

CROWDED HOUSE: 3 *Temple of Low Men* LP poster (Capitol Records, 1988); **Margo Chase** lettering design, **Kelly Ray** artwork, **Dennis Keeley** photography.

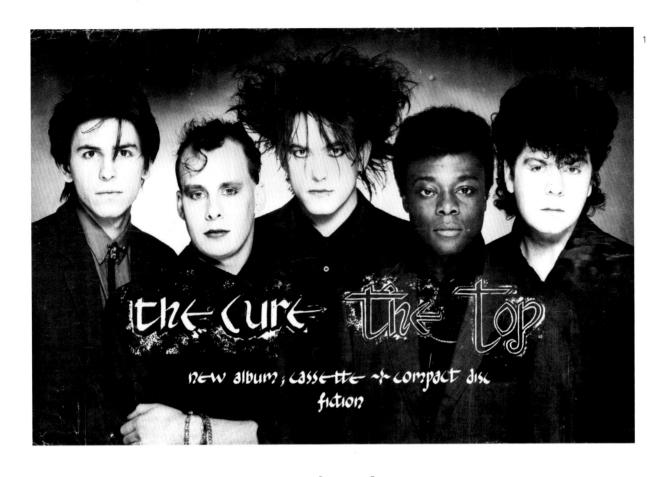

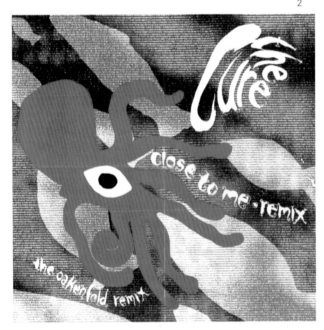

THE CURE: 1 *The Top* LP poster (Fiction Records, 1984);
2 'Close to Me' 45 record sleeve poster, Paul Oakenfold
remix (Fiction Records, 1990); **3** 'The Walk' 45 record sleeve
poster (Fiction Records, 1983); **Parched Art** design.

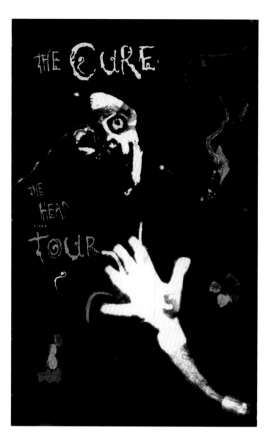

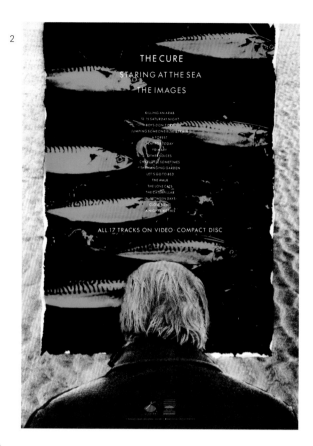

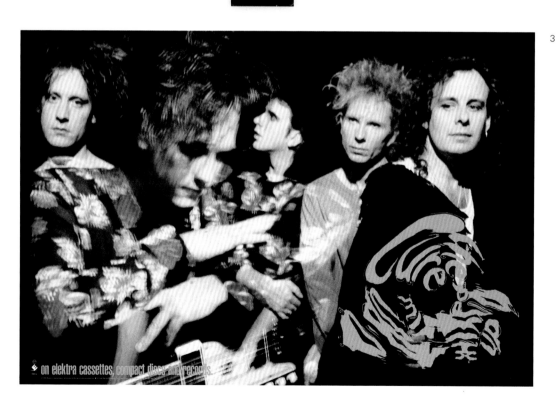

THE CURE: 1 *Head on the Door* LP tour programme, 1985; **Parched Art** artwork; **2** *Staring at the Sea* compilation LP video poster (Elektra Records, 1986); **3** *Mixed Up* compilation LP poster (Elektra Records, 1990).

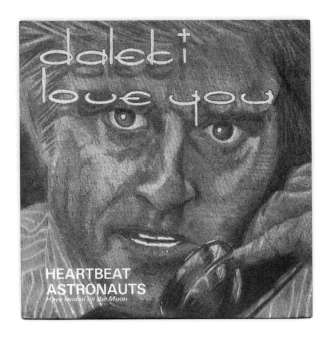

DALEK I LOVE YOU: (above left) 'Heartbeat' 45 (Back Door, 1981); (above right) 'Holiday in Disneyland' 45 (Korova Records, 1982); **Ian Wright** artwork.

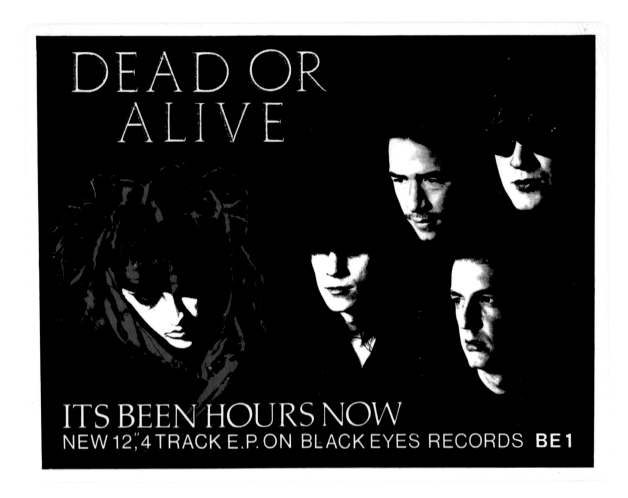

DEAD OR ALIVE: 'It's Been Hours Now' EP poster (Black Eyes Records, 1982); **Steve Hardstaff** artwork, **Francesco Mellina** photography.

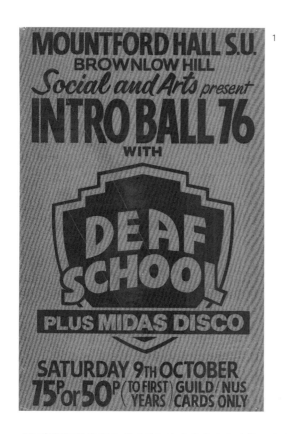

DEAF SCHOOL: 1 Mountford Hall Student Union, Liverpool, concert poster, 9 October 1976; **2** *English Boys/Working Girls* LP sticker (Warner Bros. Records, 1978); **Kevin Ward** artwork, **David Anthony** photography; **3** *Don't Stop the World* LP sticker (Warner Bros. Records, 1977).

216

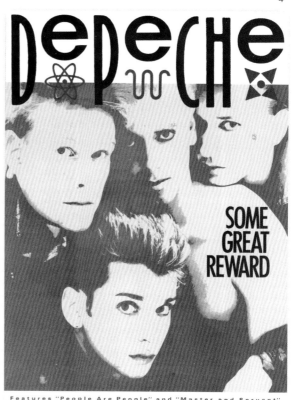

DEPECHE MODE: 4 *Some Great Reward* LP (Sire/Mute Records, 1984); **Mark Higenbottam**, **D.A. Jones**, **Martyn Atkins** design, **Brian Griffin** photography; **5** *Speak & Spell* LP (Mute Records, 1981); **Brian Griffin** photography.

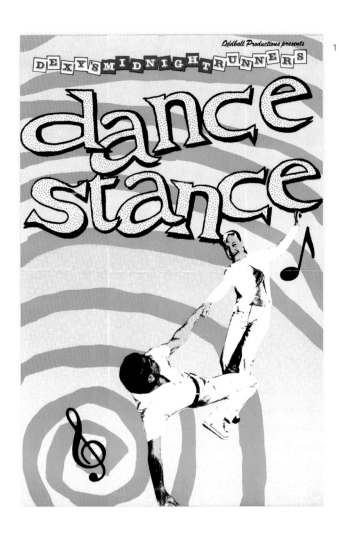

DEXYS MIDNIGHT RUNNERS: 1 'Dance Stance' debut 45 poster (Oddball Productions, 1979); **2** 'Geno' 45 sticker (Late Night Feelings, 1980); **3** *Searching for the Young Soul Rebels* LP poster (EMI America, 1980); **Nick Egan** design.

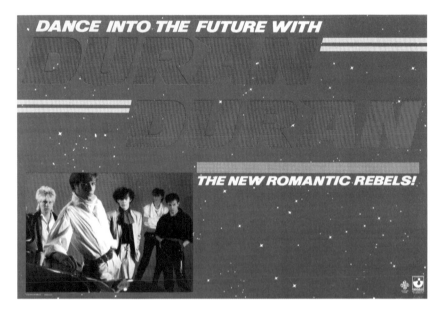

DURAN DURAN: (above) Self-titled debut LP poster (Harvest Records, June 1981); **Malcolm Garrett** (**Assorted iMaGes**) logo design, **Fin Costello** photography; (right) Large logo decal to promote *Arena* LP (Capitol Records, 1984); **Malcolm Garrett** (**Assorted iMaGes**) design.

1

2

3

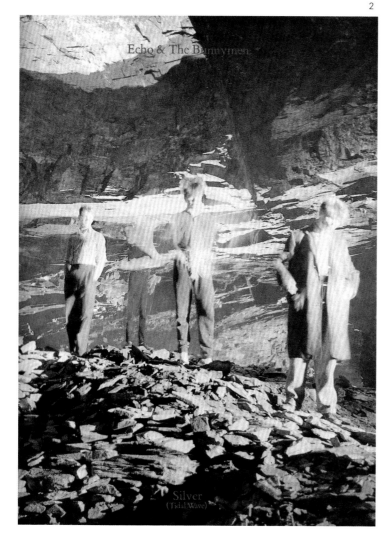

ECHO AND THE BUNNYMEN: 1 'Pictures on My Wall Read It in Books' 45 front and back covers (Zoo Records, 1979); **2** 'Silver' 45 sheet music (Korova Records, 1984); **Martyn Atkins** design, **Brian Griffin** photography; **3** The Lyceum concert poster, 7 September 1980.

ELVIS COSTELLO AND THE ATTRACTIONS:
(left) With The Revillos and Scars at
University of East Anglia Summer Ball,
June 1981; **Roy Lichtenstein** image
appropriation.

ELVIS COSTELLO: (below) Solo concert with
T. Bone Burnett, Chick Evans Fieldhouse,
DeKalb, IL, 26 April 1984; **Toulouse Lautrec**
homage design.

ERASURE: (above) 'The Circus' 45 flyer (Mute Records,
1987); **Me Company** (**Paul White**) design; (right) poster
for *The Circus* LP (Mute Records, 1987); **Me Company**
(**Paul White**) design.

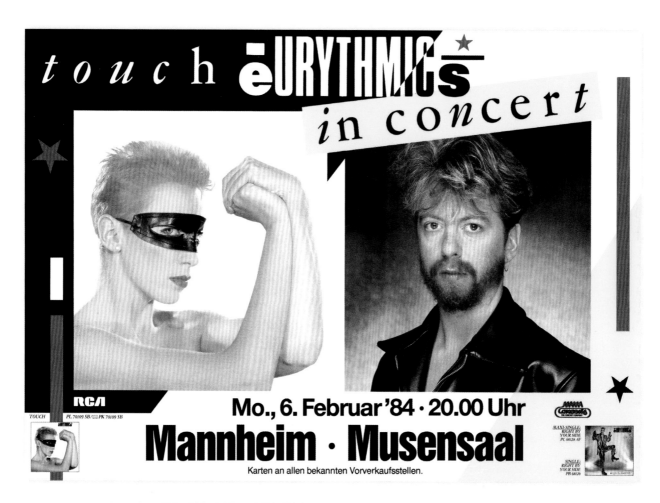

EURYTHMICS: (above) German tour poster for *Touch* LP (RCA Records) Mannheim, February 1984; **Laurence Stevens** artwork, **Peter Ashworth** photography.

FABULOUS POODLES: (left) *Think Pink* LP poster (Epic/Park Lane Records, 1979).

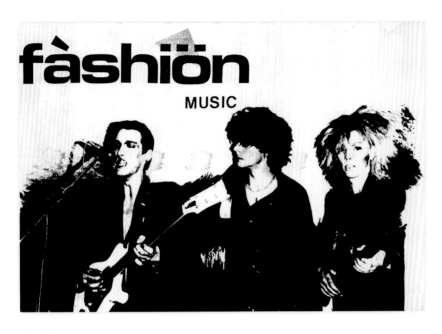

FÀSHIÖN MUSIC: (above) *Pröduct Perfect* LP poster (Fàshiön Music, 1979). After Fàshiön Music founded a label of the same name in 1978, they were often simply known as Fashion, and eventually changed their name to this. **Fàshiön Design** design, **Nigel van Beek** photography.

FINGERPRINTZ: (below) *Distinguishing Marks* LP poster (Virgin International, 1980).

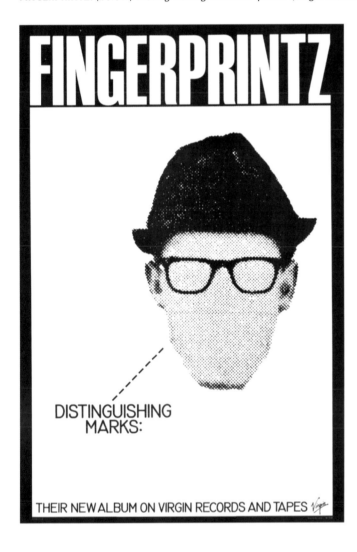

FISCHER-Z: 'Marliese / Right Hand Men' 45 front and back cover (Liberty Records, 1981).

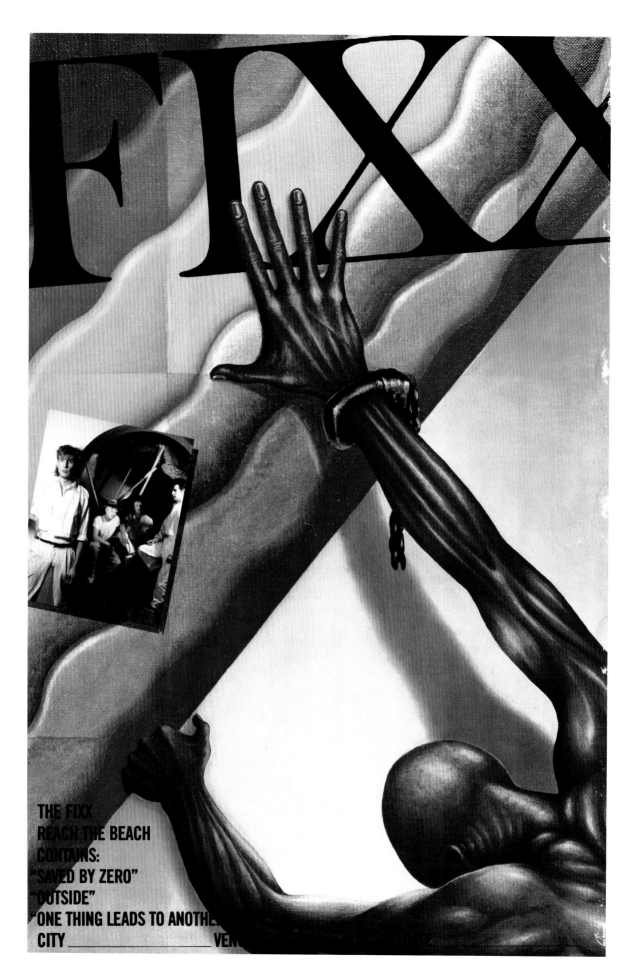

THE FIXX: *Reach the Beach* LP poster (MCA Records, 1983); **Cream** design, **George Underwood** painting.

FRANKIE GOES TO HOLLYWOOD: 1 and **2** *Welcome to the Pleasuredome* LP promotional mobile (ZTT Records, 1984); **Lo Cole** illustration; **3** *Welcome to the Pleasuredome* LP poster (ZTT Records, 1984); **Peter Ashworth** photography; **4** Promotional thought-bubbles sticker poster (ZTT Records, *c.* 1984); **5** 'Rage Hard' 7" and 12" 45 poster (ZTT Records, 1986); **Accident** design.

THE FUN BOY THREE

DEBUT SINGLE

THE LUNATICS HAVE TAKEN OVER THE ASYLUM.

FB3

Chrysalis

1

3

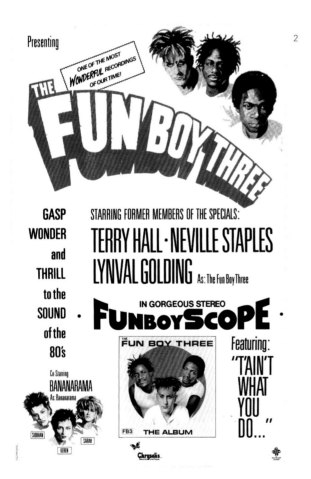

THE FRESHIES: (above) 'I Can't Get "Bouncing Babies" by the Teardrop Explodes /Tell Her I'm Ill' 45 (Razz Records, 1981).

FUN BOY THREE
GASP WONDER and THRILL to the SOUND of the 80's

Presenting
ONE OF THE MOST WONDERFUL RECORDINGS OF OUR TIME!

STARRING FORMER MEMBERS OF THE SPECIALS:
TERRY HALL · NEVILLE STAPLES LYNVAL GOLDING As: The Fun Boy Three

IN GORGEOUS STEREO **FUNBOYSCOPE**

Co-Starring **BANANARAMA** As: Bananarama
SIOBHAN KEREN SARAH

FUN BOY THREE
FB3 THE ALBUM

Featuring: "T'AIN'T WHAT YOU DO..."

Chrysalis

FUN BOY THREE
OUR LIPS ARE SEALED

FUN BOY THREE: 1 'The Lunatics Have Taken Over the Asylum' debut 45 poster (Chrysalis Records, 1981); **2** *The Fun Boy Three* LP movie-style poster with Bananarama (Chrysalis Records, 1982); **Jon 'Teflon' Sims** design; **3** 'Our Lips Are Sealed' 45 (Chrysalis Records, 1983); **David Storey** and **FB3** design, **Mike Owen** photography.

FREEEZ: (below) *Idle Vice* LP poster (Beggars Banquet, 1984); **Inhouse Outhouse** design.

GARY NUMAN: (right) *The Pleasure Principle* LP poster (ATCO Records, 1979); **Su Wathan** calligraphy, **Geoff Howes** photography.

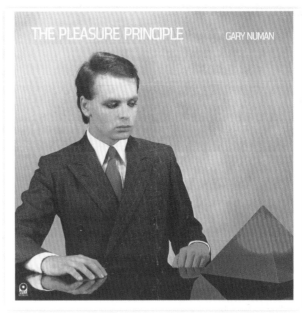

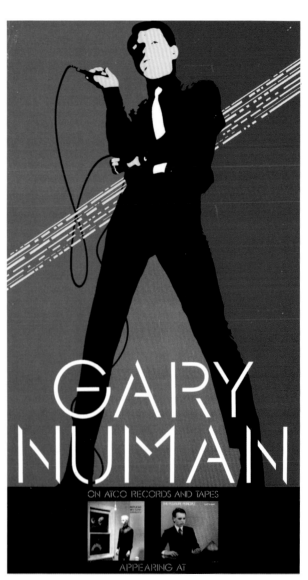

GARY NUMAN: (above) *Telekon* LP poster (ATCO Records, September 1980); **Geoff Howes** photography; (right) US tour blank (ATCO Records, 1979).

GENERATION X: 1 'Wild Youth' 45 banner poster (Chrysalis Records, 1977); **2** 'Wild Youth' 45 poster (Chrysalis Records, 1977); **Peter Kodick** photography; **3** 'Your Generation' debut 45 promotional T-shirt (Chrysalis Records, 1977); **Barney Bubbles** artwork; **4** Debut LP advertisement (Chrysalis Records, 1978).

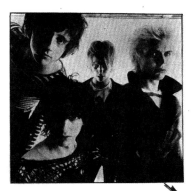

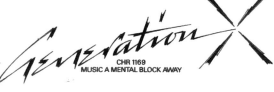

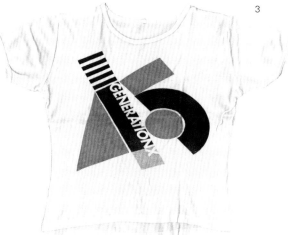

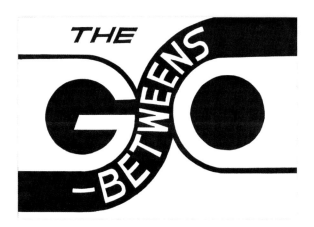

THE GO-BETWEENS: *Before Hollywood* LP, German tour poster (Rough Trade Records, 1983).

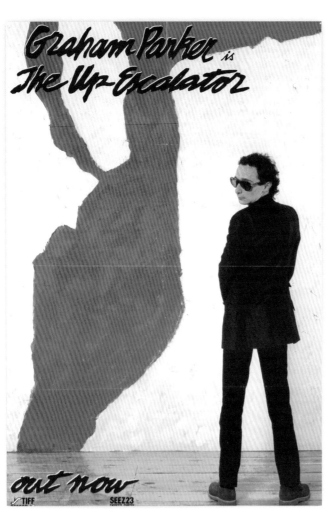

GRAHAM PARKER: (left) *The Up Escalator* LP poster (Stiff Records, May 1980); **Chris Morton** design, **Jolie Parker** artwork.

HEAVEN 17: **1** *Penthouse and Pavement* LP front and back cover (Virgin 1981); **Ray Smith** cover art; **B.E.F.** design; **2** '(We Don't Need This) Fascist Groove Thang' 45 (Virgin Records, 1981); **B.E.F.** in association with **Bob Last** artwork.

1

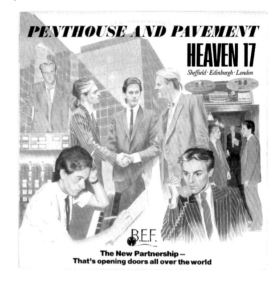

2

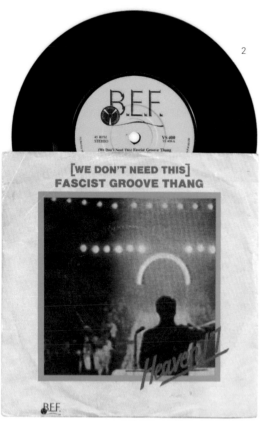

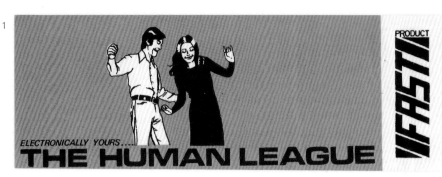

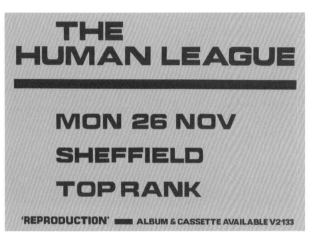

228

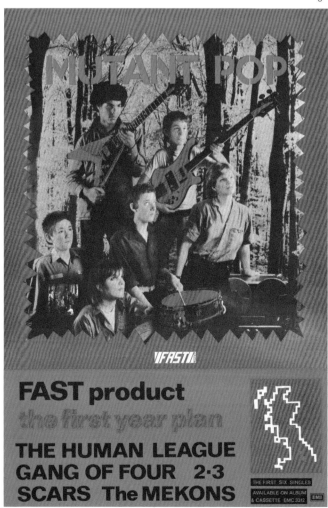

THE HUMAN LEAGUE: **1** 'Being
Boiled' 45 sticker (Fast Product,
1978); **Martyn Ware** and **Bob
Last** design; **2** *Reproduction* LP
and concert poster, Sheffield
University, 26 November 1979;
Malcolm Garrett design; **3** 'Mutant
Pop' *Fast Product — the First
Year Plan* compilation LP poster
with Scars and The Human
League (Fast Product, 1979);
Malcolm Garrett design, **Nick Price**
photography.

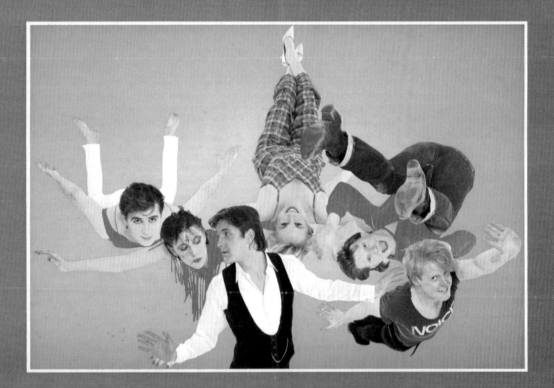

THE HUMAN LEAGUE: *Fascination!* mini-album poster (A&M Records, 1983).

IN SEARCH OF SPACE

Malcolm Garrett

No New Wave

Punk was pure, passionate and gritty, full of angst and revolt and rebellion. It sounded noisy — nasty even. In comparison, new wave was clean and sounded freshly laundered. There's clearly a difference.

Yet new wave was a term invented (no doubt by an opportunistic record company exec., or perhaps some journalist trying to make a name for themselves by coining a phrase to encapsulate the era) to make the very idea of 'punk' sound safe for ordinary listeners. I recall first coming across the term when one of the major record companies released a compilation album with it as the title. The record actually featured what were mainly punk bands (Ramones, The Damned, Richard Hell and the Voidoids) or relatively obscure acts, not all exactly new (Flamin' Groovies, The Runaways), who were perceived to vaguely fit the genre. None of them were really the kinds of bands that would later come to be referred to as new wave — not as it came to be understood. When the term was first introduced into the UK, it could almost be argued that no new wave bands actually existed. OK, The Boomtown Rats and Elvis Costello probably fitted the bill, but for the most part the bands featured in this book weren't those that were being introduced on this record. This marketing exercise was part of an attempt to skirt around the problems of media acceptance that punk presented. It was a way of sanitizing what was exciting, because it wasn't clean and radio-friendly. And thus 'new wave' started to be applied to anything that wasn't released before 1977, but didn't have the same street cachet as punk or its celebrated antecedents. It may well have been credible music in many respects — not least in its very musicality (punk was never about the music, *maaan!*) — but new wave acts by and large

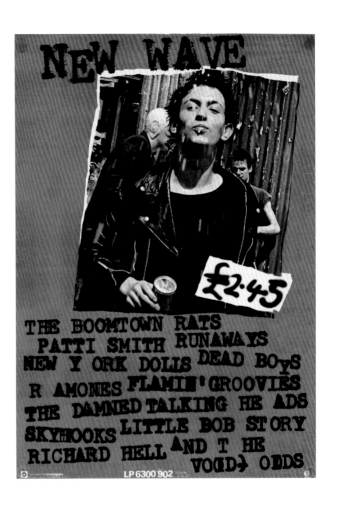

NEW WAVE: Compilation LP promotional poster (Vertigo Records, 1977).

lacked that aggressive bite. They simply wouldn't cut it on London's King's Road, or survive a Saturday night at Manchester's Electric Circus.

At the time, I really disliked the term. At best I was grudgingly receptive of much of the music 'new wave' was said to embrace. I liked punk rock, and this was neither 'punk' nor, in most cases, was it even 'rock'. I had never considered myself an ordinary listener, never aspired to being ordinary and shunned anything that suggested as much. But, and here's the irony, what new wave came to mean was that I now had a crucial role to play as a designer. More than simply being a mate of some guys with guitars, I was drafted into the front line. I was with the band.

Waving Not Drowning

What a wonderful thing hindsight is. You can't have hindsight before the future has happened. And here we were reversing into it. As it turned out, what we rebelled against as punks wasn't all bad, although what came after that certainly wasn't all good either.

Now, thankfully, we have a good forty years of hindsight to make sense of the seismic shift that happened between about 1976 and 1979. On reflection, I've come to realize that it was punk that was the wave — a tsunami, in fact — and new wave was another of those musical tides that ebb and flow across the decades. Its influence on design would continue in the years to come.

As we now know, but at its height were too immersed to anticipate, punk was very short-lived. It soaked us with its energy and then crashed dramatically onto the shore, its energy spent. It left us quite wet and gasping for air, but invigorated and refreshed. The new wave in its wake rolled in more calmly, lapping onto the shore in that timeless tidal way, depositing some driftwood and some notable castaways, along with a sizable flotilla of vessels that found their way into safe harbour. Most of these were only recently launched, others had been at sea for a while but now benefited from fresh wind in their sails; still others were to be dashed on the rocks.

But enough of the nautical metaphors.

Ultimately, what punk and new wave precipitated is clearly what's of interest to me: the integration of music and design. Rather than talk about the nuances of what is and isn't new wave, and the relative merits of genres, what I'd rather discuss is how, with this new focus on the style within music, graphic design became integral to the presentation and perception of music. Of course music has been packaged in nice cardboard wrappers carrying attractive photographs and evocative images for decades, but at some point in the 1970s it became increasingly apparent that ownership and maintenance of these spaces was more effective, not least by becoming more credible, when they were in the hands of musicians and not marketing departments. Yet it was designers who embraced this idea on the musicians' behalf. Musicians themselves were not necessarily best equipped to make the most of expressing themselves through design, even if they had been to art school, but the smarter ones knew someone who had, and creative relationships were established.

Say Hello, Wave Goodbye

Even though it had been the case before, it was not until new wave that the entire industry woke up and realized the importance of graphic design. All the visual aspects of music creation, performance and recording came to the fore and cohered. The visual media became part of the entire creative enterprise, and began to play its part, not just on the front of a record sleeve but within the very essence of the artist's identity. Following the effective dismantling of existing music industry norms during punk, graphic designers became much more pro-active partners and collaborators. They chose to work with the originators of the music, rather than the music corporations that had previously been in complete control of packaging and marketing.

Even the labels themselves were cognizant of this shift of emphasis, and of their unwanted interference in creative freedom. It was a short step from putting out your own record to establishing your own independent label. Hello Stiff. Hello Factory. Goodbye EMI.

From within punk (albeit drawing on other important influences and precedents from the counter-culture of the late 1960s, coupled with the passion, bordering on tribalism, of a music-led lifestyle, which was arguably most pertinent in the UK), the new wave gave a platform for design to shape the perception of music as a culture. With it, youth, identity and lifestyle evolved to the point where music culture is now an accepted part of the mainstream, where once it was shunned.

There were several important record releases which I found compelling and influential in advance of and in parallel to punk as it launched its attack on mainstream music.

Among the most notable were the renegade musicnauts Hawkwind. They brought us an entire alternative subculture, helped establish the idea of a free festival at Glastonbury, and would have a direct impact on new wave, most visibly by introducing us to the designer Barney Bubbles. His stunningly innovative work for Stiff Records and others figures heavily in this book.

Then there were the mysterious audio missives from the Cryptic Corporation, in the guise of weird-sounding and even weirder-looking LPs by The Residents. The first, *Meet The Residents*, parodies the sleeve for The Beatles' first album. Their second, *Not Available*, was, for reasons known only to the band (whose true identities have to this day never been revealed), not actually released. (Or not until several years later anyway, despite a promise that it would never appear.)

For me, it wasn't just Jamie Reid's explosive day-glo ransom-note lettering for Sex Pistols that was the 'ground zero' for music design (although that was a decidedly evocative intervention) but also the blank canvas of Throbbing Gristle's 1977 debut, *The Second Annual Report*. This independent release from Industrial Records came in an almost naked white sleeve, fresh from the pressing plant, and was adorned only by a small black and white label with information presented in a seemingly undesigned way, belying an inherent typographic sophistication. Although an economic solution to avoid expensive printing, its minimal design fundamentally questioned what a record sleeve could be.

In each of these examples, the story told through the bands' music and its presentation laid important foundations for graphic designers to build upon.

HAWKWIND: 1 *Doremi Fasol Latido* LP (United Artists Records, 1972); **Barney Bubbles** design.

THE RESIDENTS: 2 *The Third Reich 'N' Roll* LP (Ralph Records, 1976); **Pore No Graphics** artwork.

THROBBING GRISTLE: 3 *The Second Annual Report* LP (Industrial Records, 1977).

The visual components that celebrate music's identity — and what fans can both identify with and most importantly embrace and own for themselves — were brought from the sidelines and made central to the whole creative process. It was recognized as being about more than just music. More than sound and performance. Yes it was about personality, and stardom, if you like, but that personality demands consistent, coherent and credible visualization. This, then, is the central theme of this book. It is about what we can 'see' in music. It's not about marketing — it's about the language of music, which is something that the corporate music world has always struggled to capture and has so often emasculated.

My Wave

In the post-punk, new wave world, everything visual was to become a more complicit (and explicit) component of music and youth culture in a way that until now had been rather more peripheral, although no less important. The difference was that now (at their most influential) designers were invited to act as a fully integral part of the creative team, almost as if they were members of the band. Even if the bands didn't quite realize it yet. And if they did, they would no doubt defiantly resist any such suggestion, because what everybody wanted to believe — bands and fans alike — was that the musicians are the sole originators of all ideas, including packaging. They are seen as the beating heart of the creative process.

In truth though, if designers weren't exactly centre-stage, design was certainly on the bill. And the field was expanding, as multiple release formats proliferated, new media avenues opened up, and then — boom! — video welcomed us to a whole new visual era.

Obviously I take a graphic designer's perspective, but I was there and saw what was happening. I, too, was complicit and played an active part in helping shape the landscape and promote a fresh perspective. I considered myself to be part of that team. I played my part in working closely with musicians to translate what originated as an audio- and fashion-based presence into one that could be seen and touched in all its physical products. My approach to record sleeve design was not to produce standalone icons (iconic status could only

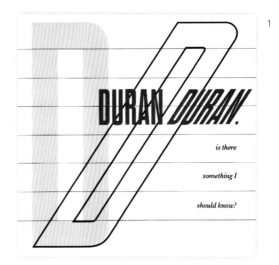

DURAN DURAN: 1 'Is There Something I Should Know?' 45 (EMI Records, 1983); **Malcolm Garrett (Assorted iMaGes)** design.

PET SHOP BOYS: 2 *Introspective* LP (Parlophone, 1988); **Mark Farrow** design.

POP WILL EAT ITSELF: 3 *The Pop Will Eat Itself Cure For Sanity* LP (RCA, 1990); **Designers Republic** design.

be granted later) but to create a space for music: where the sleeve is treated not as a picture gallery but as a flat box, a square package for a round object, and where the product itself is intangible — it is aural and it is human. It is whatever image is conjured up in audiences' minds when listening. It is a fluid not a fixed product. It is what the listeners choose it to be.

The challenge was thus to make tangible an indefinable idea of music and of the musicians who make it. Never strictly commercial in a base marketing sense, I tended to think a bit broader than simply declaring 'New Album Out Now!' in adverts, for instance. To my mind the commercial demands were best served with an intelligent, audience-focused approach, that understood both the need for fans to be part of the story — their story — and that music is a product of an elusive and ever-evolving brand. It cannot be marketed like any other comparable media, such as a film, a book, or a theatre play. It is especially not like a tin of paint, or a bank, or a soft drink — although the ways that these other products are marketed have inspired some of the most exciting and inventive music packaging.

I'm with the Band

In precipitating the growth of the indie labels, punk had also accelerated the demise of in-house art departments at all the major record labels. The designer had turned to working directly with the band, bypassing the label, or, as at Stiff Records and then with other newer independent labels such as Factory or 4AD, the 'in-house' designer set about building the entire house. Either way, designers seized the opportunity to create a dynamic environment, defining a shared visual connection between musician and audience perception.

Punk had shown that the most effective, most honest, most credible approach was when the designer for all intents and purposes had joined the band; when their experiences were the same and their objectives gelled. Think of Jamie Reid with Sex Pistols, or me with Buzzcocks.

Of course, the same was true when the designer actually *was* in the band. As a prime

example, designer-turned-musician John Foxx went as far as to create an entirely new persona as his final work to gain an MA at the Royal College of Art, in the form of the band Ultravox!

Peter Christopherson, a designer at Hipgnosis best known for his sleeves for Led Zeppelin and Pink Floyd, was also a founding member of Throbbing Gristle. From the outset he brought an astute graphic design sensibility to everything they did.

The Human League, a pioneering electronic band from Sheffield, produced their own artwork for their debut single 'Being Boiled'. Not only that but Adrian Wright, a non-musician who was responsible for programming the multiple slide projectors used during their set, actually appeared onstage, triggering the projections live with the band as they performed.

Following swiftly on from new wave came the fashion- and design-conscious New Romantics, fronted by Spandau Ballet, with their designer Graham Smith, and Duran Duran, whom I worked with for the first six years of their global success story.

It was clear by then that design and music had become indelibly interlinked. This has scarcely changed since the mid-1980s. In fact, it has become the norm.

Examples of band/designer relationships are now too numerous to list, save to cite some of the most notable.

Every release by Pet Shop Boys has been designed by Mark Farrow with a visual sensibility as refined as the songs. The musical mash-ups of Pop Will Eat Itself, as it layered disparate musical samples, were always perfectly complemented by the complex designs of Ian Anderson's Designers Republic, which in turn drew on cultural iconography from random sources.

Happy Mondays, on the other hand, was packaged with an almost primitive flourish of collages and paintings created by the band's childhood friends, the brothers Pat and Matt Carroll (Central Station), proving my point that the best and most distinctive design happens when you keep it in the family.

The Icicle Works 'Birds Fly (Whisper to A Scream) / Reverie Girl.

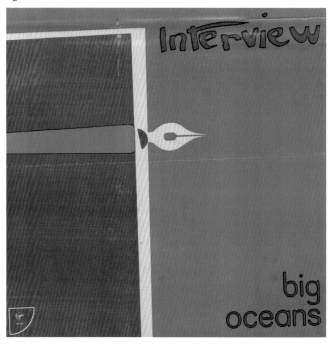

big
oceans

THE ICICLE WORKS: 1 'Birds Fly (Whisper to a Scream) / Reverie Girl' 45 poster (Situation Two Records, 1983); **Steve Hardstaff** artwork.

INTERVIEW: 2 *Big Oceans* LP poster (Virgin Records, 1979); **Ansell Sadgrove** artwork, **Brain** design.

THE JAGS: 3 *Evening Standards* LP poster and promotional enamelled badges (Island Records, 1980); **Nick Watkinson** sleeve concept, **Simon Fowler** photography.

3

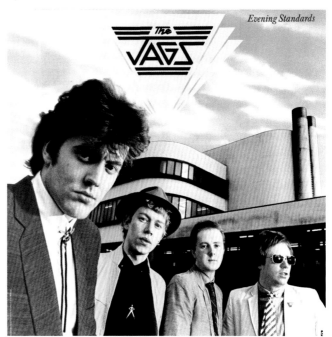

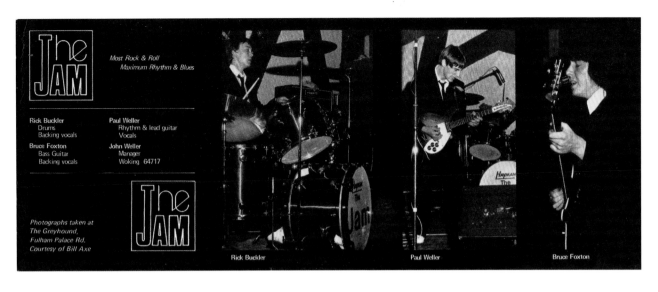

THE JAM: Booker card, front (1976); **Bill Axe** photographs (taken at The Greyhound, Fulham Palace Road).

The Jam

Sales

From Britain the headquarters of New Wave rock and roll, comes the premiere group of this genre--The Jam. Paul Weller on vocals and lead, Rick Buckler on drums and Bruce Foxton on bass are The Jam--the critics' choice as one of the brightest young groups in the punk rock vein. Their sound is bright, energized, hard and gritty and they'll win their audience over with solid musicianship. The group would not have looked out of place in the old Mods and Rockers riots on Britain's seafront. The title cut, "In The City" is the anthem for the seventies, like The Who's "My Generation" was for the sixties. Play this album at each account, and you'll see the sales. RECOMMENDED CUTS: "In The City;" "Slow Down;" "Away From The Numbers"

Publicity

"New Wave" is a new expression in the turbulent world of rock describing a new movement - a movement that is both visciously denegrated and patently misunderstood. It's a movement in music, attitude and lifestyle spawned mainly by the young and it's inexorably shaping up as a revolution in rock.

As New Wave grows, more and more bands are coming to light. The music and images grow and diversify accordingly, providing New Wave with even more emphasis and consequently broadening the very definition.

Already there is a band very rapidly breaking out of the narrow New Wave mold - The Jam.

The Jam are a 3 piece band who derive their influences both musically and visually from the early 60's mod. They dress in Mod black mohair suits and hold a strong and loyal conviction to Queen and country. Anarchy in the UK holds no sway with The Jam.

Paul Weller guitar and vocals is at 18, the youngest member and writes all of The Jam's songs. He hails from Woking, Surrey as do all three and started playing the guitar when he was 14. Paul was self taught and decided to play because in his own words, "I didn't want to go to school." A year later, while still at school, he formed The Jam initially a four piece band when Bruce Foxton joined. They have always played rock and roll and R&B influenced by the Tamla-Motown sounds and early 60s bands.

Their music originates from that renaissance period in British rock, but Paul's lyrics are contemporary inspired by the conditions of the environment, youth and the way in which they see the world. Two of his songs, "In The City" and

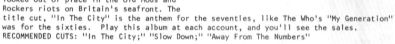
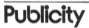

THE JAM: US publicity tear-sheet with text about first single, 'In the City' 45, referencing the 'new movement' that is new wave (Polydor, 1977); **Bill Smith** design, **Martyn Goddard** photo.

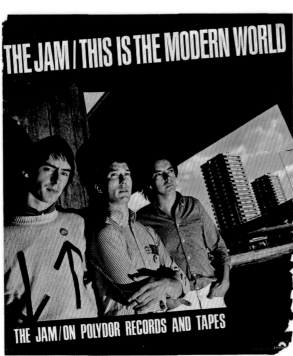

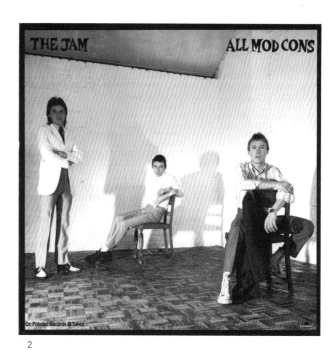

1

2

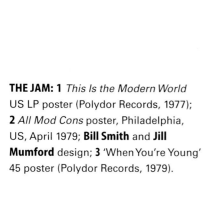

3

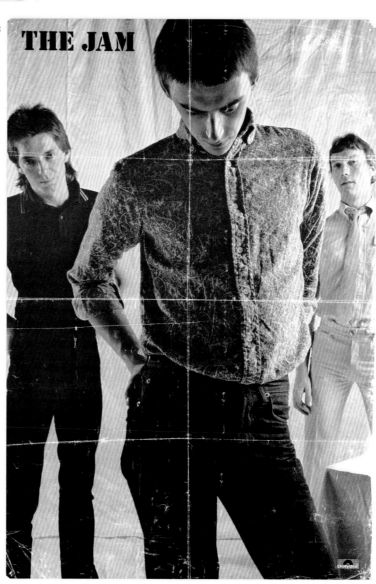

THE JAM: 1 *This Is the Modern World*
US LP poster (Polydor Records, 1977);
2 *All Mod Cons* poster, Philadelphia,
US, April 1979; **Bill Smith** and **Jill
Mumford** design; **3** 'When You're Young'
45 poster (Polydor Records, 1979).

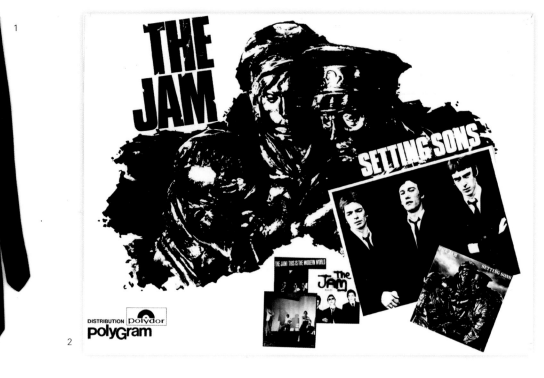

THE JAM: 1 Promotional skinny tie for *Setting Sons* LP (Polydor Records, 1979); **2** *Setting Sons* US LP promotional poster (PolyGram Records, 1979); **3** 'Beat Surrender' EP poster, the band's final studio release (Polydor Records, 1982); **Paul Weller**, **Peter Barrett** and **Simon Halfon** sleeve design; **Tony Latham** photography.

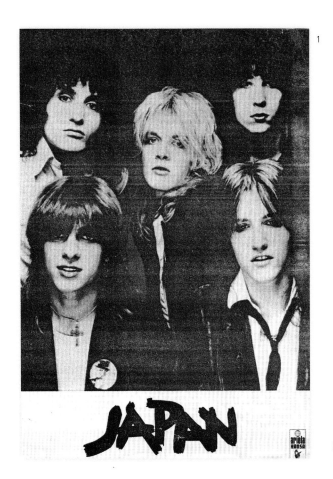

1

2

3

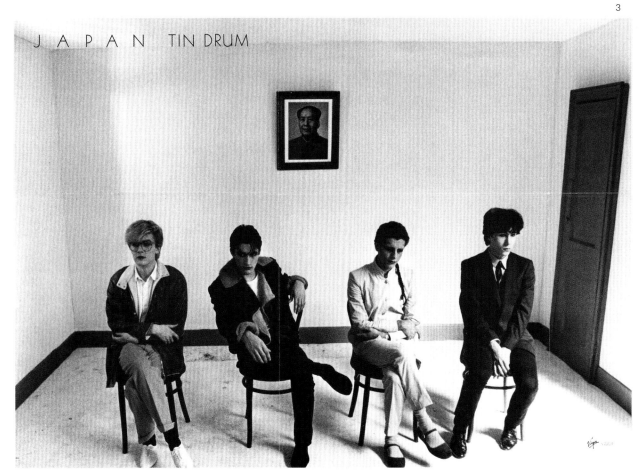

In 2005, on a bus from Guangzhou to Shenzhen in China, a Chinese man told me about his love of Japan's *Tin Drum* album. This surprised me. Sure, the album has tracks titled 'Visions of China', 'Canton' (the older name for Guangzhou), and 'Cantonese Boy', but it also has a picture of Chairman Mao on the cover, stuck to the wall behind lead singer David Sylvian, who is eating with chopsticks — this was his cover concept. How did that style-conscious shout-out to Mao by a bourgeois western rock group, which could know little or nothing about life under the Great Helmsman, strike Chinese music fans at a time when Mao (who died in 1976) and the sufferings of his era had become history? As I soon found out, my concerns were misplaced. At a big exhibition of applied art and design by young Chinese designers, the imagery of Mao's cultural revolution was raw material to quote playfully and to parody on T-shirts and skateboards. Mao is there again, presiding over Japan in a photograph by Fin Costello, taken for the poster included in early LP copies of *Tin Drum*. It's impossible to parse the dialectical relationship between the serene-looking leader and the four band members — Sylvian, Steve Jansen, Mick Karn and Richard Barbieri — who appear sullen, rather than ideologically inspired. Nor does the picture appear to be a piece of retro irony. The music effortlessly melds electronics with Chinese-sounding timbres and rhythms. *Tin Drum* comes across as a celebratory and idealized fantasy of 'China', and I suspect the man on the bus enjoyed its exoticism in the same way.

Rick Poynor

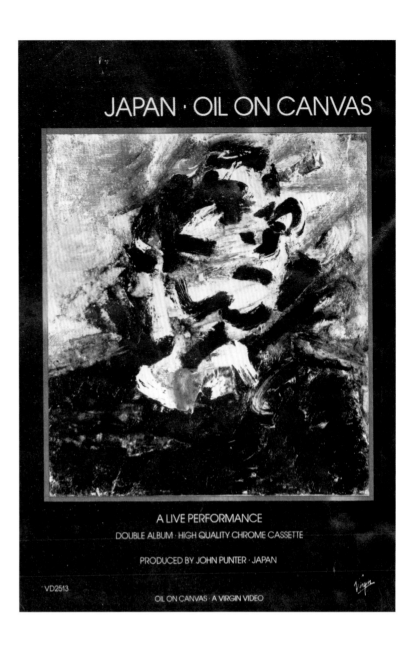

JAPAN: (above) *Oil On Canvas* LP advertisement (Virgin, 1983); **Frank Auerbach** painting; (opposite) **1** Promotional flyer (Ariola Hansa, 1978); **2** Sticker (Ariola Hansa, 1978–79); **3** *Tin Drum* LP poster (Virgin, November 1981); **Steve Joule** design, **Fin Costello** photography, **David Sylvian** concept.

J.J. BURNEL: 1 *Euroman Cometh* LP poster with JJ in the foreground of the Pompidou Centre, Paris (United Artists Records, 1979).

JOE CALLIS / S.H.A.K.E. PROJECT: 2 'Woah Yeah!' 7" 33⅓ rpm EP (Pop Aural Records, 1981).

JOE JACKSON: 3 Joe Jackson Band *Beat Crazy!* LP poster (A&M Records, 1980); **4** *I'm the Man* poster (A&M Records, 1979).

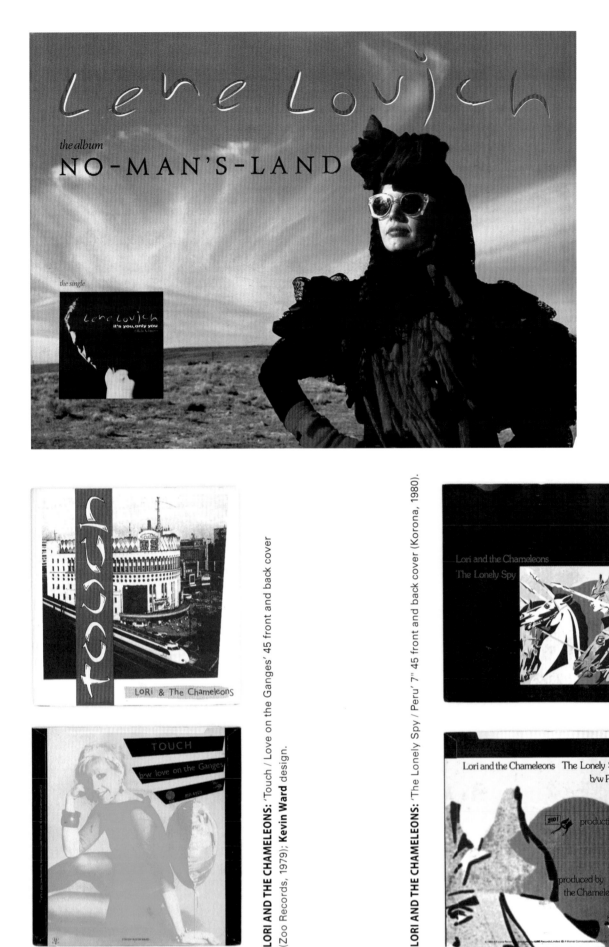

LENE LOVICH: *No Man's Land* LP poster (Stiff Records, 1982).

LORI AND THE CHAMELEONS: 'Touch / Love on the Ganges' 45 front and back cover (Zoo Records, 1979); **Kevin Ward** design.

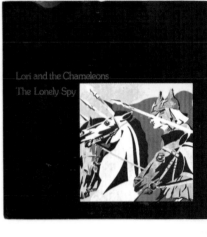

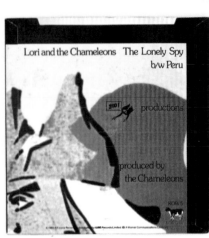

LORI AND THE CHAMELEONS: 'The Lonely Spy / Peru' 7" 45 front and back cover (Korona, 1980).

J.J. BURNEL / JOE CALLIS / JOE JACKSON / LENE LOVICH / LORI AND THE CHAMELEONS

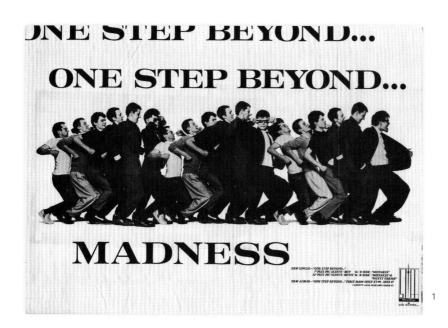

1

MADNESS: 1 *One Step Beyond* LP poster (Stiff Records, 1979): the cropping of the phrase at the top of the poster is deliberate, reflecting both message and bandname; **Eddie and Jules and Stiff** cover art, **Cameron McVey** photography; **2** 'That Nutty Sound' sticker (Stiff Records, *c*. 1980); **3** Promotional badges; **4** *Nutty Boys* Madness Comix #1, January 1981; **5** 'The Return of the Los Palmas 7' 45 small poster (Stiff Records, 1981).

2

THAT
NUTTY
SOUND

3

4

5

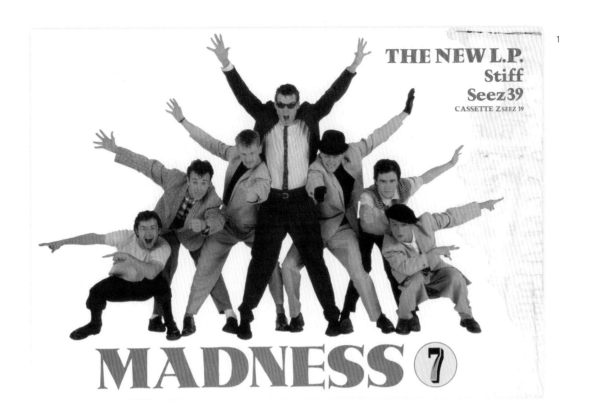

MADNESS: **1** *Madness 7* LP small poster (Stiff Records, 1981); **Chris Morton** design, **Stella** artwork, **Mike Putland** photograph; **2** 'Michael Caine' 45 poster (Stiff Records, 1984); **3** 'Our House' 45 poster (Geffen Records, 1983).

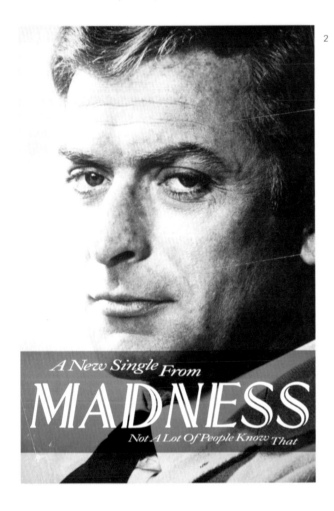

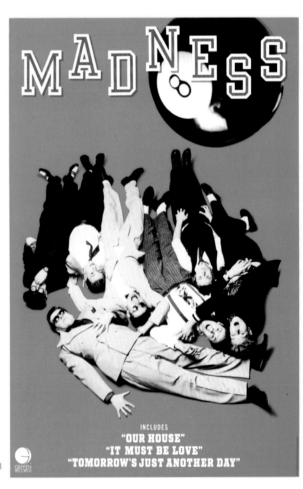

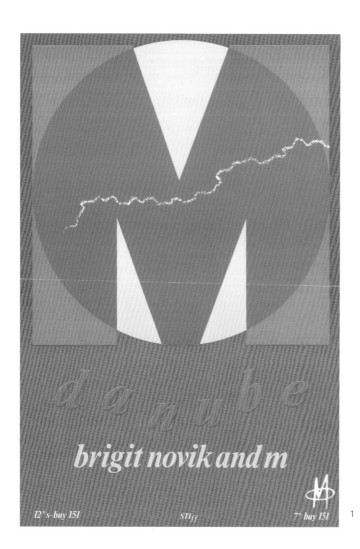

1

2

3

M: 1 'Danube' 45 poster (Stiff Records, 1982).

MASS: 2 With In Camera and screening of Otto Preminger's drug addiction movie starring Frank Sinatra, *The Man With the Golden Arm* (United Artists, 1955), at Scala Cinema, London, 18 July 1980.

THE MEMBERS: 3 *At the Chelsea Nightclub* debut LP poster (Virgin International Records, 1979); **Malcolm Garrett** design.

1

2

THE MEMBERS: 1 Banner poster promoting 'Working Girl' 45 (Albion Records, 1981); **Malcolm Garrett** design, **Barry Kay** photography.

MINNY POPS: 2 'Dolphin's Spurt' 45 Dutch front cover (Factory Records, 1981); **Martyn Atkins** design; **Minny Pops** photography.

3

4

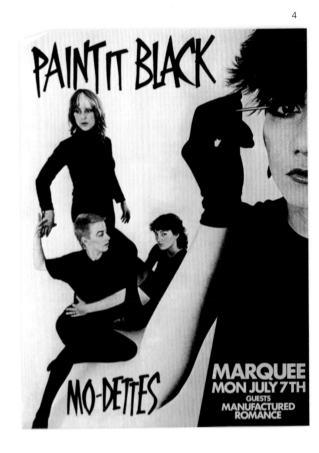

MO-DETTES: 3 'White Mice/Masochistic Opposite' 45 back cover (Mode Records, 1979); 4 Live at the Marquee Club, London, for 'Paint It Black' 45 poster (Deram Records, 1980).

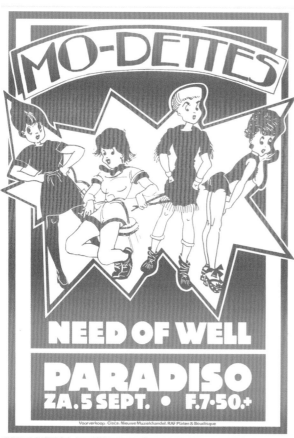

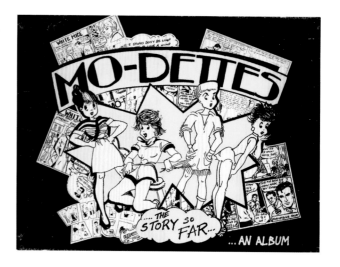

MO-DETTES: (above) *The Story So Far* LP poster (Deram Records, 1980); (below) Large sticker (Deram Records, 1980); (left) At Club Paradiso, Amsterdam, poster, 5 September *c.* 1982; **Martin Kaye** design.

248

The Motors Out Now
On Virgin Records & Tapes
Four moving parts that will drive you
into Rock 'n' Roll Ecstasy!

1

2

THE MOTORS: 1 *Tenement Steps* LP poster
(Virgin Records, 1980); **Pearce Marchbank**
design; **2** *The Motors* debut LP poster
(Virgin Records, 1977); **3** *Approved by the
Motors* LP poster (Virgin Records, 1978).

3

THE MOTORS: *Approved by the Motors* LP poster of an alternative sleeve image (Virgin Records, May 1978); **Hipgnosis, Cooke Key, George Hardie** design; **Aubrey Powell** photography.

NEW WEA WAVE '80: (left) Flyer promoting The Cars, Costello, Devo, Gary Numan in 1980, Japan (Warner/Pioneer 1980).

NO WAVE: (below) Sampler poster (A&M Records, 1978); **Chuck Beeson** design, **Katherine Walter** and **Lou Beach** illustration.

NINA HAGEN & THE NO PROBLEM ORCHESTRA: (below) Berlin concert poster, 25 November 1983 (CBS Records).

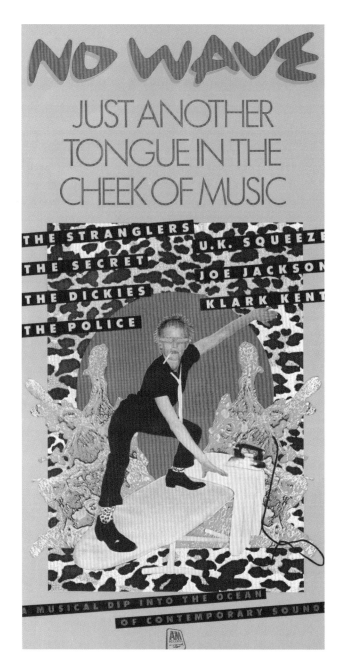

1

2

3

4

5

ORCHESTRAL MANOEUVRES IN THE DARK: 1 With Units, at Kabuki Nightclub, flyer, San Francisco, 27 March 1981; **2, 3** and **4** *Dazzle Ships* LP booklet (Virgin Records, 1983); **Peter Saville Associates** design; **5** *Dazzle Ships* poster (Virgin/PolyGram, 1983); **Peter Saville Associates** design.

ORCHESTRAL MANOEUVRES IN THE DARK: *Crush* LP poster (Virgin/A&M Records, 1985); **Paul Slater** painting, referencing **Edward Hopper**.

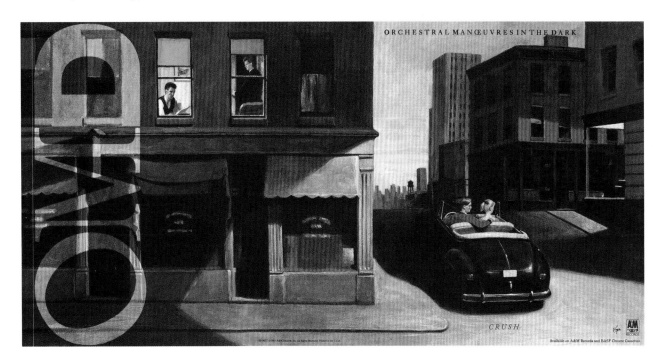

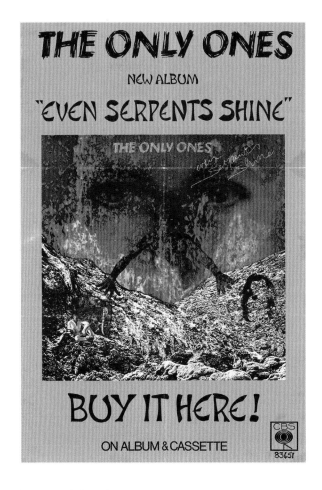

THE ONLY ONES: (left) *Even Serpents Shine* LP tour programme cover (CBS, 1979); (right) *Even Serpents Shine* LP poster (CBS, 1979); **Michael Beal** design.

1

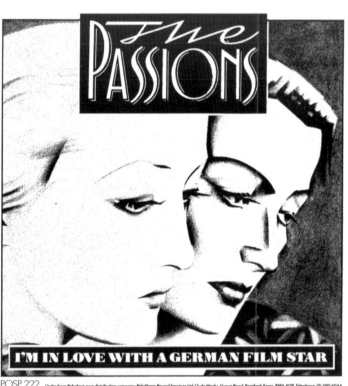

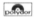

2

THE PASSIONS: 1 *Thirty Thousand Feet Over China* LP poster (Polydor Records, 1981); **Rob O'Connor** design, **Jeff Veitch** photography; **2** Tour with Roxy Music for 'I'm in Love with a German Film Star' 45 flyer (Polydor Records, 1981); Artwork inspired by **Tamara De Lempicka**.

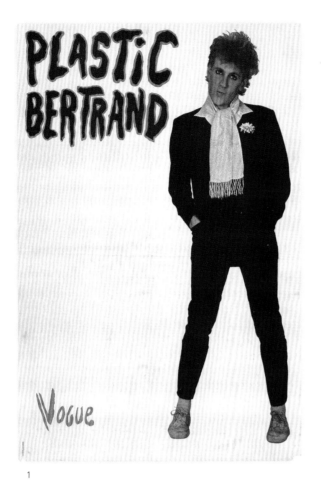

1

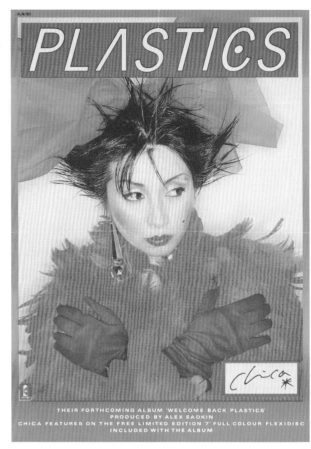

2

3

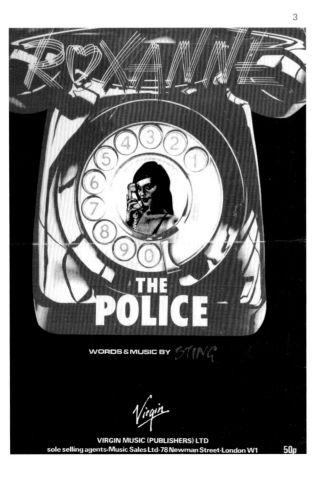

4

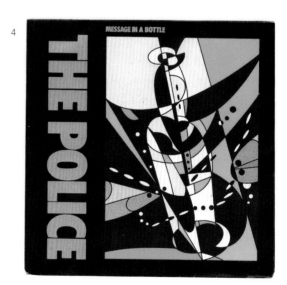

PLASTIC BERTRAND: 1 *An 1* LP debut poster (Vogue Records, 1977).

PLASTICS: 2 *Welcome Back* LP poster (Island Records 1981).

THE POLICE: 3 'Roxanne' 45 sheet music (Virgin Music Ltd, 1978); **4** 'Message in a Bottle' US 45 (A&M Records, 1979); **Artrouble** and **David Allen** cover illustration.

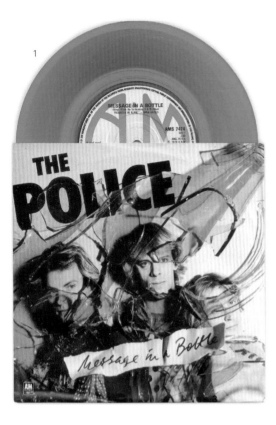

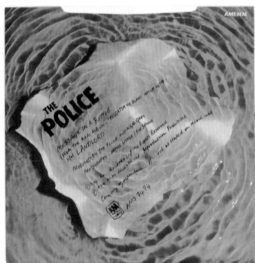

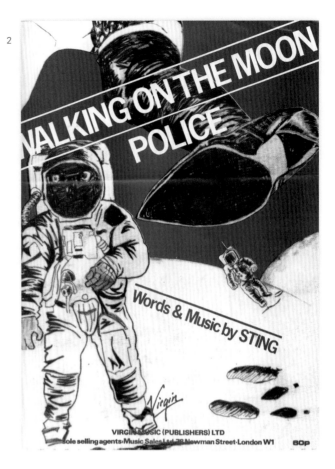

THE POLICE: 1 'Message in a Bottle' UK 45 front and back cover (A&M Records, 1979); **James Wedge**, **Rod Shone** photography; **2** 'Walking on the Moon' 45 sheet music (Virgin Music Ltd, 1979); **X3 Studios** design; **3** 'Tea in the Sahara' limited edition poster 20/500 (1983); signed by **Bob Linney** and **Ken Meharg** of **X3 Studios** design.

POSITIVE NOISE: (above) Banner poster for 'Positive Negative' 45 (Statik Records, 1981); (right) *Change of Heart* LP poster (Statik Records, 1982); **John Gordon** LP cover design.

THE PRETENDERS: (below) Self-titled debut LP poster (Sire Records, 1980); **Kevin Hughes** design, **Chalkie Davies** photography.

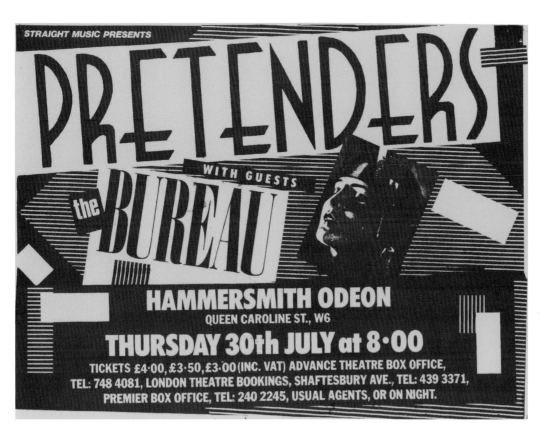

THE PRETENDERS: With The Bureau at Hammersmith Odeon, poster, 30 July 1981; image from the Fritz Lang movie *Metropolis* (1927).

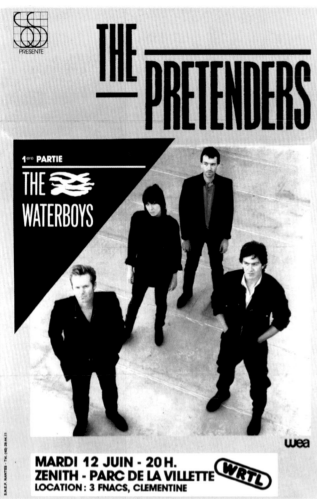

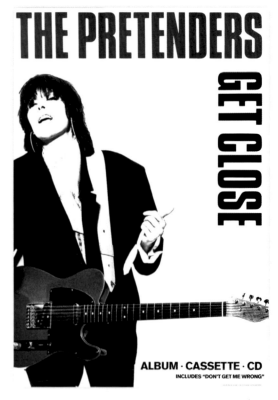

THE PRETENDERS: (left) With The Waterboys at Le Zénith, Paris, Île-de-France, poster, 12 June 1984; (above) *Get Close* LP poster (WEA / Real Records, 1986); **Helen Backhouse** design, **Richard Haughton** photography.

THE SOUND IS IN THE LABEL:
CHISWICK + STIFF + RADAR RECORDS

Andrew Krivine

I created sections dedicated to these labels because they were among the earliest and most artistically, if not commercially, successful British independent records labels, founded just as punk began to stir in London. Of note, the lead singer of the premier pub rock band (Lee Brilleaux of Dr. Feelgood) played a pivotal part in Stiff's creation. Lee was one of the coolest front men of the period. Although this story is difficult to verify, it burnishes the Stiff myth further: in 1976 Lee supposedly lent Jake Riviera and Dave Robinson (co-founders of Stiff) £400 of urgently needed seed capital to launch Stiff.

Despite a relatively brief period when their output was most prolific (1976 to 1978), Chiswick and Stiff are important in design terms because they created and embraced strong visual identities — promoting the bands *and* the labels in equal measure. Prior to 1976, I can't think of an example where a record label created such a distinct visual brand. Stiff Records was such an idiosyncratic, obsessive label — which is probably why I was attracted to their promotional materials from the get-go. The founders even devised their own (non-Dewey decimal) cataloguing system for record releases. Singles were coded by the prefix 'BUY'; LPs by 'SEEZ'; compilation records by either 'GET' or 'FIST'; EPs by 'LAST'; one-off 45s to showcase new talent by 'OFF'; and cassettes 'ZSEEZ'. Stiff also etched matrix messages into the run-off grooves of each single. Bert Muirhead correctly observed that Stiff elevated matrix messaging into an art form.[1]

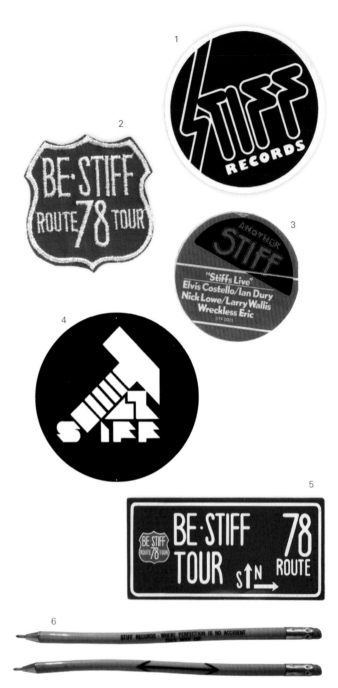

STIFF RECORDS: 1 Promotional logo disc (*c.* 1979); **Barney Bubbles** design; **2** Embroidered sew-on patch for the Be Stiff UK Tour, 1978; **Chris Morton** design; **3** *Stiffs Live* US LP cover sticker, 1978; **Chris Morton** design; **4** Promotional logo disc; **Barney Bubbles** design; **5** Be Stiff UK Tour map and programme card cover, 1978; **Chris Morton** design; **6** Promotional wavy pens, 1979.

[1] Bert was one of the largest dealers of second-hand records in Europe in the early 1980s, and in 1983 authored the first account of the label: *Stiff: The Story of a Record Label, 1976–1982* (UK: Blandford Press).

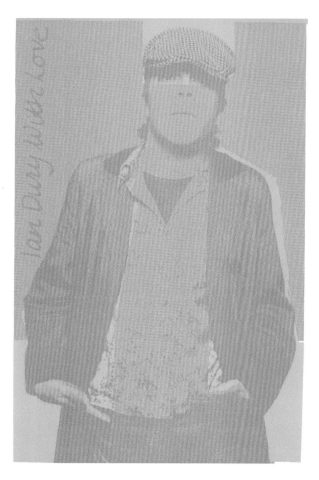

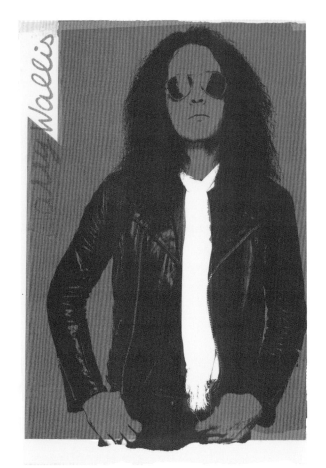

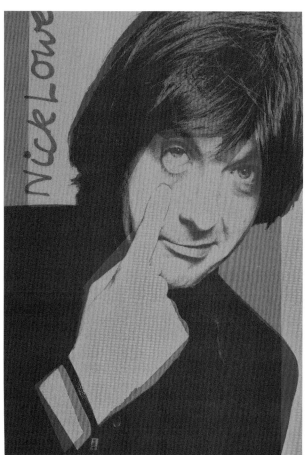

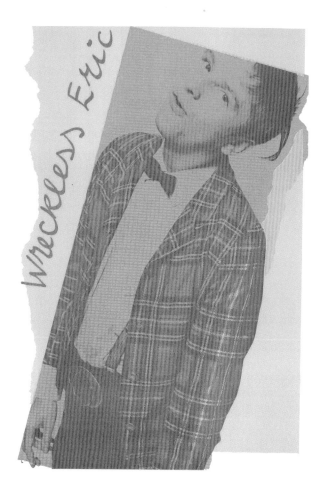

STIFF RECORDS: (opposite) The 5 Stiff Live posters (Elvis Costello appears in Chris Morton's 'Desert Island Designs' essay in this volume) were created by Barney Bubbles and Chris Gabrin, as merch to be sold during the first Live Stiffs tour in October 1977. Barney and Chris funded this venture on their own – they were not commissioned by Stiff Records; (below) Stiff Stiff Hurrah! Label showcase poster (Mo-dettes, The Feelies, etc.) in NYC, September 1980; **Chris Morton** design; (right) Very first Stiff Records promotional sheet, 1976; **Chris Morton** design.

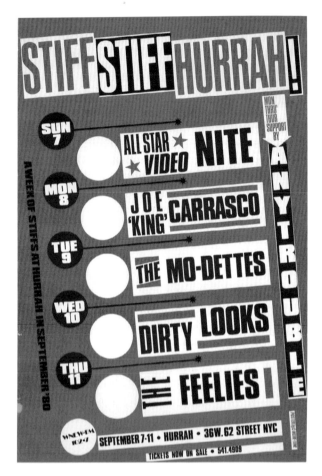

Stiff had the good fortune to hire two of the most gifted designers of the era: Barney Bubbles, a freelancer, and Chris Morton (dubbed 'c-more-tone' by Dave Robinson), art director. You will see several examples of their work in this chapter.

Stiff and Chiswick were closely affiliated, and even released a Wayne Kramer (ex-MC5 guitarist) single in 1978 on 'Stiffwick' records, to raise funds for Kramer's drugs-bust court case. Barney also accepted commissions from Chiswick — designing record sleeves for Johnny Moped and the Rings. Chiswick (founded by Ted Carroll and Roger Armstrong in 1975) and Stiff Records (started by Jake and Dave, along with in-house producer Nick 'Basher' Lowe) were soon emulated by such labels as Cherry Red, Rough Trade, 2 Tone, Beggars Banquet, New Hormones, Postcard, Zoo and Factory Records — a rich musical legacy.[2]

[2] Barney was surely inspired by Paul Rand's iconic portfolio of post-war corporate logo designs — though in all likelihood Paul never came across Barney's logo designs for the *New Musical Express*, or the Stiff, Radar and F-Beat labels.

THE AKRON COMPILATION PROMOTIONAL ITEMS:
1 Scratch'n'Sniff stickers, and **2** *The Akron Compilation* cover with a scratch-and-sniff logo that smells like a rubber tyre, 1978; **Chris Morton** design; **3** Aerosol with 'air from Akron as breathed by...' a list of meant-to-be but non-existent bands invented by Liam 'Mr Akron' Sternberg; **4** Luggage tag, 1978; **5** Ashtray, 1978; **6** Party hat, June 1978; **Chris Morton** design.

Following the demise of the Riviera–Robinson partnership at the end of 1977, Jake took over management of Elvis Costello and Nick Lowe. As part of the settlement, Stiff retained Ian Dury, whose success kept the label solvent until the label's next commercially successful act, Madness, came on the scene. Both Elvis and Nick moved to Radar Records, a subsidiary of WEA Records co-founded by Andrew Lauder (one of *the* A&R legends of the British music industry) and Martin Davis in early 1978 — which is why several Radar images (as well as the successor label, F-Beat Records) are included in this section.

Stiff Records spent lavishly and excessively on a (sometimes bizarre) range of promotional items — wall clocks, watches, scratch'n'sniff record sleeves, maps, luggage tags, darts, puzzles and a clay promotional brick for Wreckless Eric's *Big Smash* LP — with decidedly mixed results. However, I consider the brief collaboration of Jake Riviera and Dave

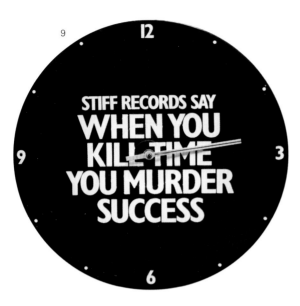

STIFF RECORDS SAY
**WHEN YOU
KILL TIME
YOU MURDER
SUCCESS**

THE DAMNED: (right) *Music for
Pleasure* LP poster (Stiff Records,
1977); **Barney Bubbles** LP cover
design, **Chris Gabrin** photography.

Robinson to be the greatest
pairing of label impresarios of
the early punk and new wave
years. As demonstrated in this
chapter, Jake was known for
his clever slogans and word
plays — such as the phrase on
Stiff's promotional wall clock:
'Stiff Records Say When You
Kill Time You Murder Success'.
Two of my personal favourites
can be found on The Damned
materials. The *Damned Damned
Damned* LP sleeve includes
'Made to be played loud at low
volume', and the poster for the
Music for Pleasure LP includes
this gem: 'Where every meal
is a memory'. While *Music
for Pleasure* is viewed as an
uneven musical achievement
by Damned fans, I am besotted
with the poster.

the damned
music for pleasure
album out now

THE BISHOPS: (left and right) 'Mr. Jones Human Bean/Route 66 (Live)' 45 front and back cover (Chiswick Records, May 1979); **Crunch** design, **Gary Ede** and **Zenon De Fleur** photos.

DEVO: 1 'Satisfaction' 45 poster (Stiff Records, 1978); **Chris Morton** design, **Brian Griffin** photography; **2** 'Jocko Homo' 45 poster (Stiff Records, 1978); **Barney Bubbles** design.

1

2

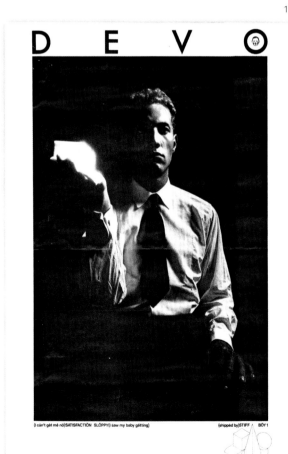

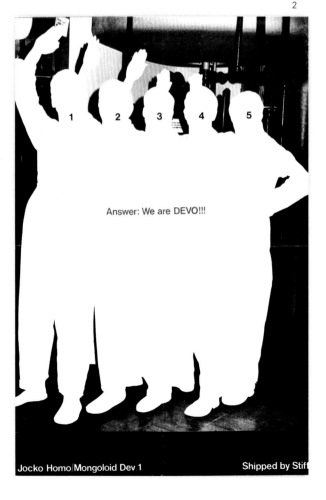

Warning: This is not This Year's Model.

ELVIS COSTELLO AND THE ATTRACTIONS: 1 Large yellow *This Year's Model* LP sticker (Radar Records, 1978); **2** *Billboard* magazine (US music industry trade publication) advertisement for *This Year's Model* LP, with reversed text (Radar Records, 1978); likely **Barney Bubbles** design, **Jake Riviera** text; **3** *This Year's Model* German LP poster (Radar Records, 1978); **4** 'Pump It Up' 45 poster (Radar Records, 1978).

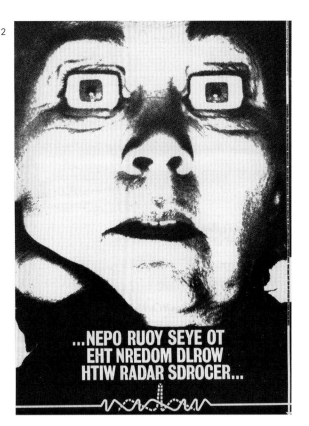

...NEPO RUOY SEYE OT EHT NREDOM DLROW HTIW RADAR SDROCER...

RADAR RECORDS Musik für Durchblicker

ELVIS COSTELLO

THIS YEAR'S MODEL

Elvis Costello »This Year's Model«
»Alles andere ist alt«

Radar Records

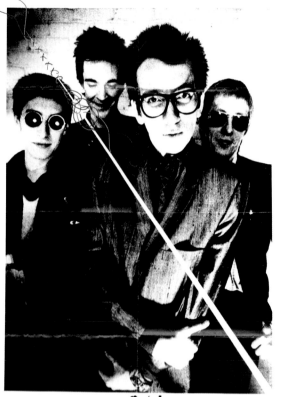

Pump It Up / Big Tears

Fads.

Maharishi Mahesh Yogi

JFK

Charles Manson

Patty Hearst

Arab oil

Elvis Presley

Elvis Costello unveils This Year's Model.

Drugs.

Love

Owsley acid

Lemmy's sulphate

Valium

Thalidomide

Keith Richard

Elvis Costello unveils This Year's Model.

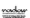

Cars.

THERE SHOULD HAVE BEEN AN ADVERTISEMENT
IN THIS WEEK'S ISSUE FOR
ELVIS COSTELLO — 'THIS YEAR'S MODEL'

Lotus Reliant

THERE SHOULD HAVE BEEN AN ADVERTISEMENT
IN THIS WEEK'S ISSUE FOR
ELVIS COSTELLO — 'THIS YEAR'S MODEL'

Nash Metropolitan

THERE SHOULD HAVE BEEN AN ADVERTISEMENT
IN THIS WEEK'S ISSUE FOR
ELVIS COSTELLO — 'THIS YEAR'S MODEL'

Dino Ferrari

THERE SHOULD HAVE BEEN AN ADVERTISEMENT
IN THIS WEEK'S ISSUE FOR
ELVIS COSTELLO — 'THIS YEAR'S MODEL'

Edsel Ferry

THERE SHOULD HAVE BEEN AN ADVERTISEMENT
IN THIS WEEK'S ISSUE FOR
ELVIS COSTELLO — 'THIS YEAR'S MODEL'

Morris Minor

THERE SHOULD HAVE BEEN AN ADVERTISEMENT
IN THIS WEEK'S ISSUE FOR
ELVIS COSTELLO — 'THIS YEAR'S MODEL'

Messerschmitt

Elvis Costello unveils This Year's Model.

Pop stars.

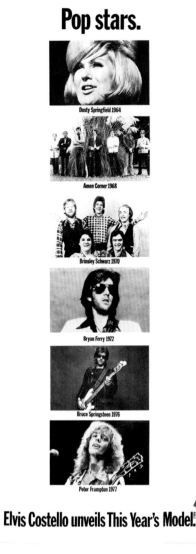

Dusty Springfield 1964

Amen Corner 1968

Brinsley Schwarz 1970

Bryan Ferry 1972

Bruce Springsteen 1976

Peter Frampton 1977

Elvis Costello unveils This Year's Model.

ELVIS COSTELLO AND THE ATTRACTIONS: For a brief period in the late 1970s Elvis Costello and the Attractions bestrode the globe, establishing a well deserved reputation as one of most electrifying live acts in new wave. The promotional recording *Elvis Costello — Live at the El Mocambo* (released in Canada in 1978) attests to the ferocity of their stage performances. *Live at the El Mocambo* is, for me, one of the two greatest live LPs of the decade (the other being The Who's *Live at Leeds*). The promotional materials issued by the three labels in support of releases during this period — Stiff, Radar and F-Beat (two of these co-founded by Jake Riviera) — played an essential role in burnishing the Elvis 'brand'. In my opinion, Jake was the Don Draper of his era. This set of four posters for *This Year's Model* — reprints of ad spreads for the musical weeklies *Sounds* and *Melody Maker* in March 1978 — are prime examples of Jake's marketing elan and panache. Pump It Up!

Andrew Krivine

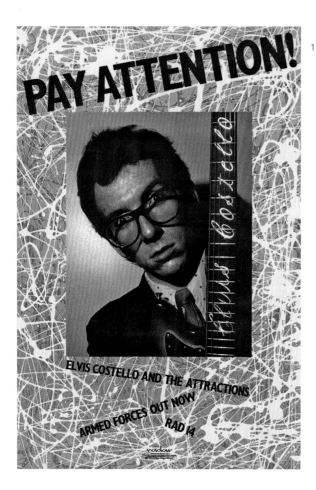

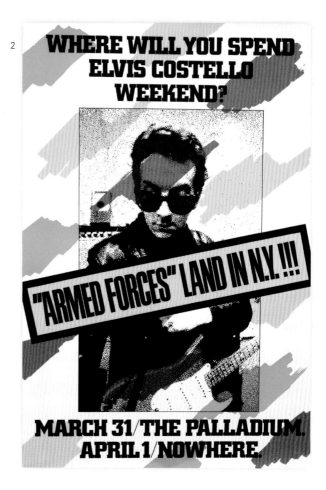

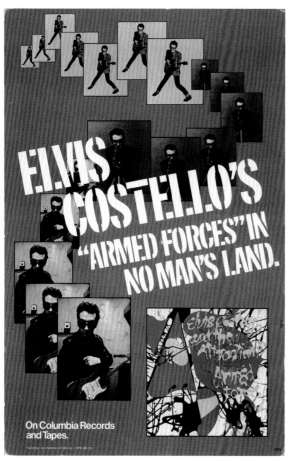

ELVIS COSTELLO AND THE ATTRACTIONS:
1 *Armed Forces* LP poster (Columbia
Records, 1979); **Barney Bubbles** design;
2 US *Armed Forces* tour, Palladium
NYC, March 1979; **3** *Armed Forces* LP
standee (Columbia Records, 1979);
4 *Armed Forces* LP UK tour, front of
T-shirt (1979); **Barney Bubbles** artwork.

**ELVIS COSTELLO AND THE ATTRACTIONS:
1** *Armed Forces* LP advance release promotional card (Columbia Records, December 1978).

RADAR RECORDS: 2 Advertisement in *Zig Zag* magazine, November 1978.

1

2

This poster (above), designed by Barney Bubbles, was used to promote the American release of *Armed Forces*, Elvis' third LP. This is one of Barney's most visually compelling designs — and no doubt a tribute to Robert Rauschenberg. It is estimated that fewer than 1,000 copies of this particular poster were printed.

Andrew Krivine

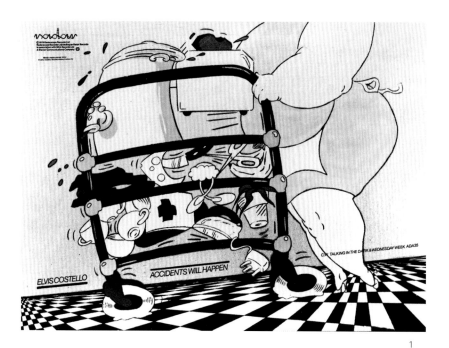

1

ELVIS COSTELLO AND THE ATTRACTIONS:
1 Flyer for 'Accidents Will Happen' 45
(Radar Records, June 1979); **Chaz and
Annabel Jankel** design; **2** 'Accidents
Will Happen' Japanese 45 front and
back cover (Radar Records, 1979); **3** UK
Armed Forces foldout tour programme
poster; **Barney Bubbles** design.

3

2

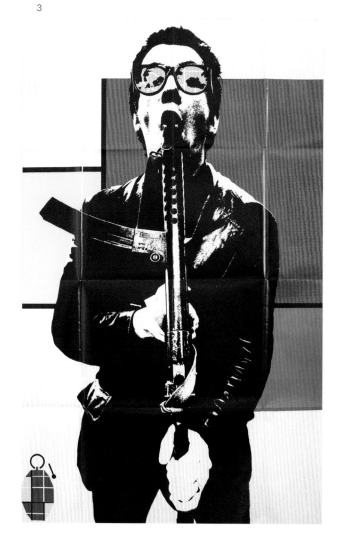

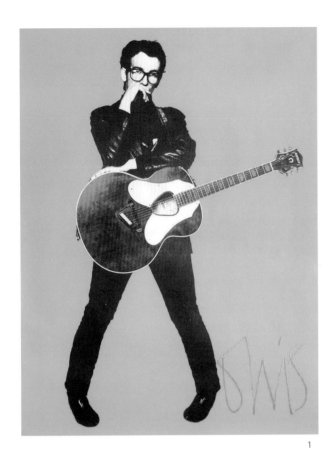

1

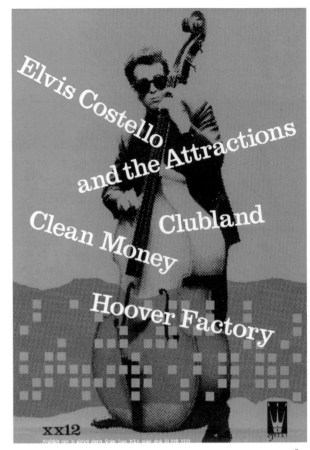

xx12

Available now in picture sleeve. Order from WEA order desk 01 998 3828

2

3

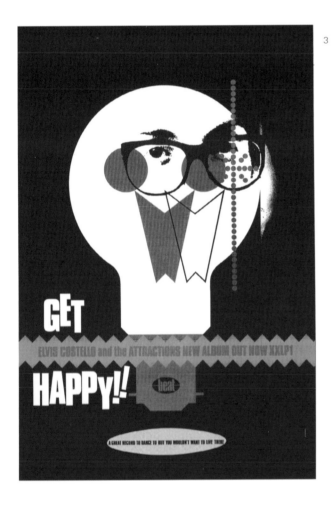

GET HAPPY!!

ELVIS COSTELLO and the ATTRACTIONS NEW ALBUM OUT NOW XXLP1

beat

A GREAT RECORD TO DANCE TO BUT YOU WOULDN'T WANT TO LIVE THERE!

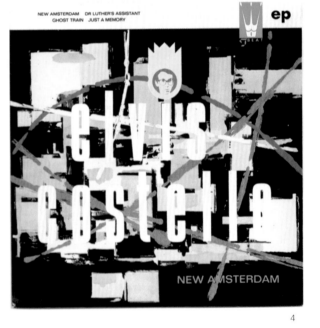

NEW AMSTERDAM DR LUTHER'S ASSISTANT
GHOST TRAIN JUST A MEMORY

ep

elvis costello

NEW AMSTERDAM

4

ELVIS COSTELLO AND THE ATTRACTIONS: 1 Personality poster (Radar Records, 1978) issued just prior to the release of the *Armed Forces* LP; **Barney Bubbles** design, **Chalkie Davies** photography; **2** 'Hoover Factory' 45 sales sheet (F-Beat Records, 1980); **3** *Get Happy!!* LP poster (F-Beat Records, February 1980); **Barney Bubbles** design; **4** 'New Amsterdam' EP cover (F-Beat Records 1980); **Barney Bubbles** design.

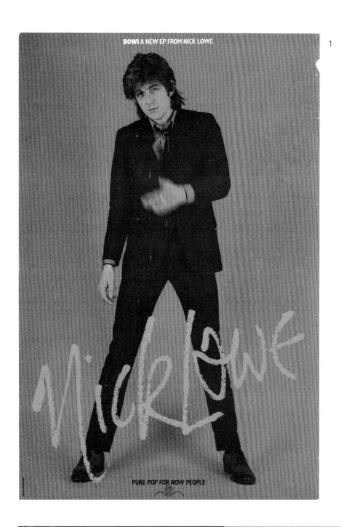

1

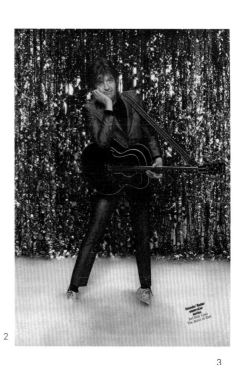

2

3

NICK LOWE: 1 'Bowi' EP poster (Stiff Records, 1979); **Barney Bubbles** design; **2** *Jesus of Cool* debut solo LP poster (Radar Records/*Sounds*, 1978); **3** *Jesus of Cool*, debut solo LP poster, best viewed through 3D glasses (Radar Records, April 1978).

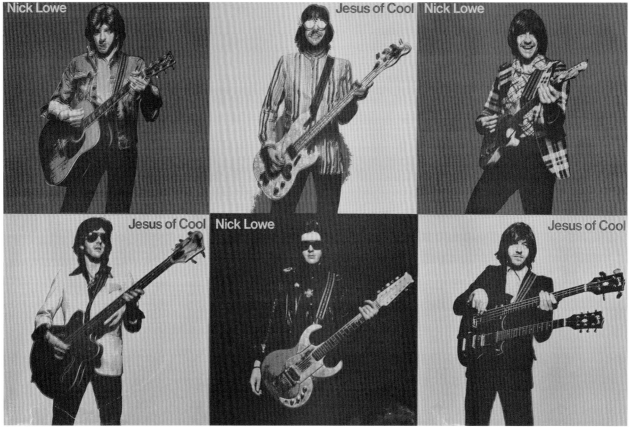

The Jesus of Cool is a testament to the Church of Aural Sects.

Prey for Nick Lowe.

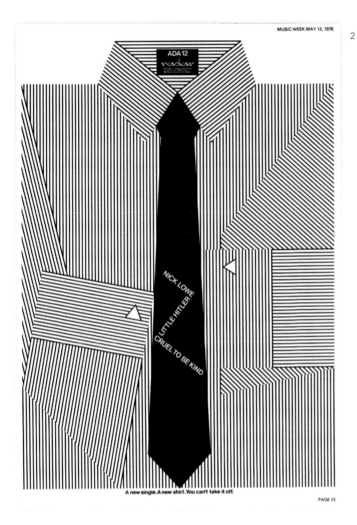

MUSIC WEEK MAY 13, 1978

ADA 12

NICK LOWE
LITTLE HITLER
CRUEL TO BE KIND

A new single. A new shirt. You can't take it off.

PAGE 13

3

On the fourth day, Lowe He came forth.

Side II Track V

NICK LOWE: 1 *Jesus of Cool* LP promotional sticker paired with promotional tie (Radar Records, 1978); **2** *Music Week* advertisement for 'Little Hitler/Cruel to be Kind' 45 (Radar Records, 1978); **Barney Bubbles** design; **3** Advance release poster (Radar Records, 1978); **Barney Bubbles** design.

IAN DURY: **1** 'Sex & Drugs & Rock & Roll' 45 promotional badges (Stiff Records, 1977); **2** *New Boots and Panties!!* LP back cover signed by Ian Dury (Stiff Records, 1977); **Barney Bubbles** design, **Chris Gabrin** photography; **3** Promotional matchbook (Stiff Records, 1978); **Barney Bubbles** design; **4** *Do It Yourself* LP poster (Stiff Records, 1979); **Barney Bubbles** design — one of twenty-four variant styles of the record cover produced and printed on wallpaper; **5** *Do It Yourself* LP poster (Stiff Records, 1979); **Barney Bubbles** design.

276

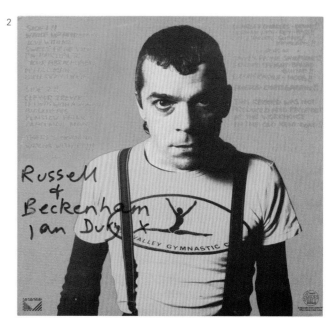

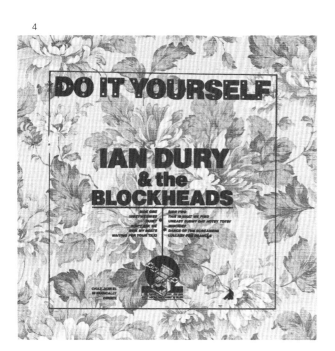
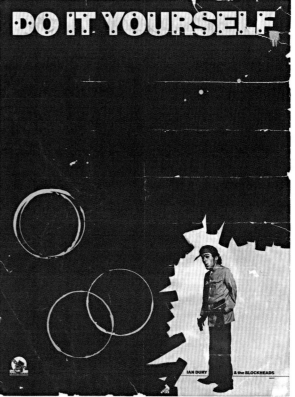

IAN DURY & THE BLOCKHEADS: 1 Hankie Pantie Christmas 1978 tour programme; **Barney Bubbles** design; **2** Ian Dury Songbook (Wise Publications, 1979); **Barney Bubbles** design; **3** *Do It Yourself* LP promotional badges with five band members (Norman, Davey, Ian, Charley, Johnny), 1979; **4** *Do It Yourself* LP promotion tour buttons (Stiff Records, 1979); **5** Paint can label (Stiff Records, 1979); **Barney Bubbles** design.

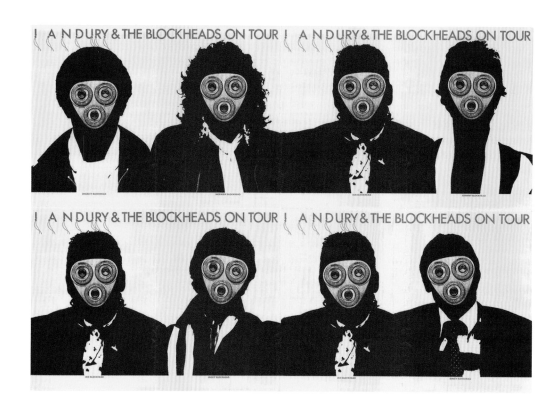

278 **IAN DURY & THE BLOCKHEADS:** (above and below) *Do It Yourself* front and back of LP tour poster, (Norelco shaver surrealism) (Stiff Records, 1979); **Barney Bubbles** design, **Chris Gabrin** photography.

IAN DURY & THE BLOCKHEADS: (top right) 'Tommy the Toolbox' 45 promotional badge (1979); **Barney Bubbles** design.

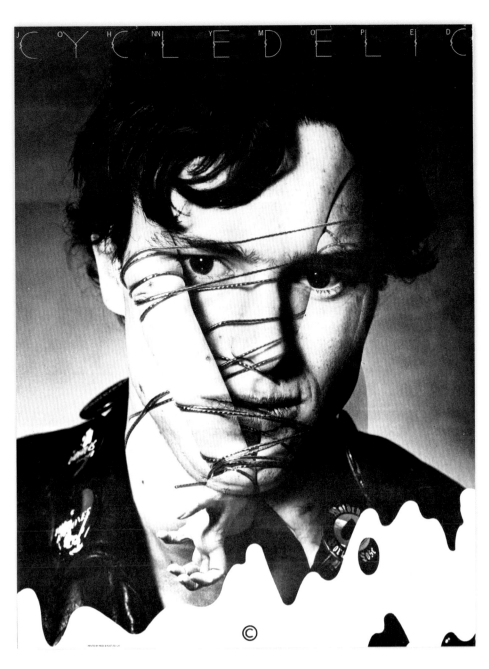

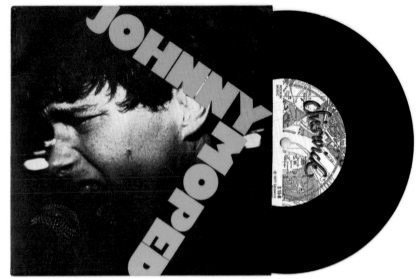

JOHNNY MOPED: (above) *Cycledelic*
LP poster (Chiswick Records, 1978);
Barney Bubbles design; (right) 'No
One/Incendiary Device' 45 cover
(Chiswick Records, 1977); **Pete Kodick**
photography, **Barney Bubbles** design.

JOHN OTWAY: (right) 'John Otway' US EP flyer (Stiff Records, 1980); **Chris Morton** design. Three copies were released without a vocal track, and Stiff offered the opportunity to win a personal Otway performance 'live in your living room'.

WOULD YOU LET THIS CRAZY SOIL YOUR CARPET?

You could be the lucky Stiff to have one of England's most prominent madmen, John Otway, perform "live in your living room." Sounds crazy? Well it is. All you do is go to your local record store and buy the new STIFF John Otway 7" single, "The Man Who Shot Liberty Valance." Go home and play it and if there are no vocals to the tune you are the lucky Stiff winner. Return with the single to the store where you bought it and they will make the arrangements for John Otway to sing the vocals to the tune in your living room. In addition, you will receive a John Otway single with the vocals (quite rare—only 500 pressed) and a pair of tickets to the John Otway show in your town. **JOHN OTWAY "LIVE IN YOUR LIVING ROOM" TOUR ON STAGE IN YOUR TOWN SOON, WATCH PAPERS FOR DETAILS.**

STIFF JOHN OTWAY 7" EP OWN-2, JOHN OTWAY 10" EP OWNIT-2 INCLUDES "THE MAN WHO SHOT LIBERTY VALANCE," "BIRTHDAY BOY" AND "RACING CARS." STIFF JOHN OTWAY ALBUM "DEEP THOUGHT" USE-5. BOTH AVAILABLE AT YOUR LOCAL RECORD STORE.

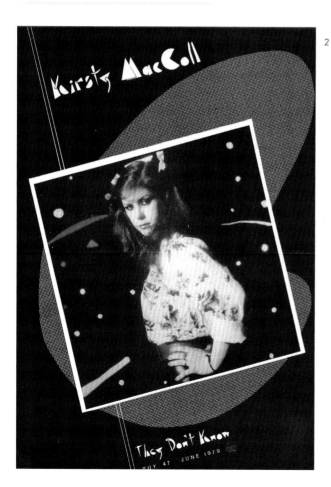

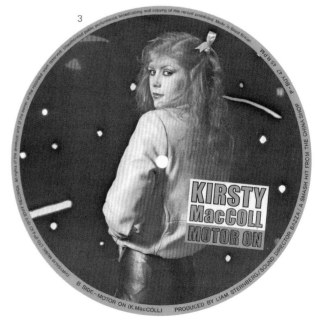

JANE AIRE & THE BELVEDERES: 1 'Yankee Wheels' 45 promotional postcard (Stiff Records (1978).

KIRSTY MACCOLL: 2 'They Don't Know' 45 flyer (Stiff Records, 1979); **3** 'Turn My Motor On' 45 B-side label (Stiff Records, 1979).

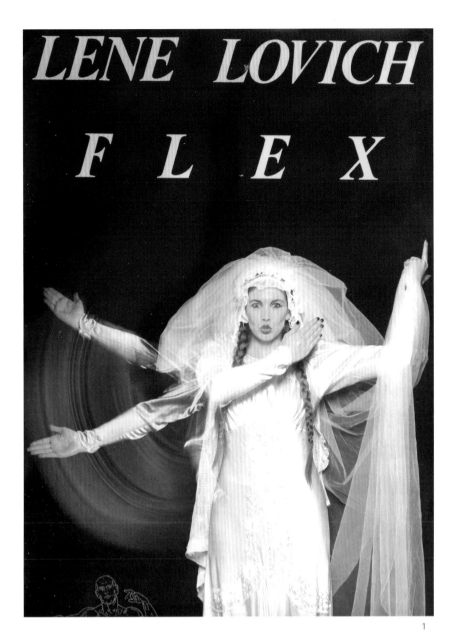

1

2

281

3

4

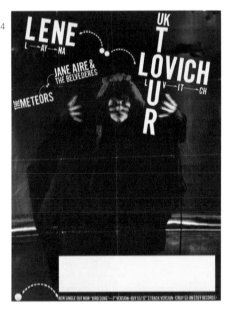

THE SOUND IS IN THE LABEL: CHISWICK + STIFF + RADAR RECORDS

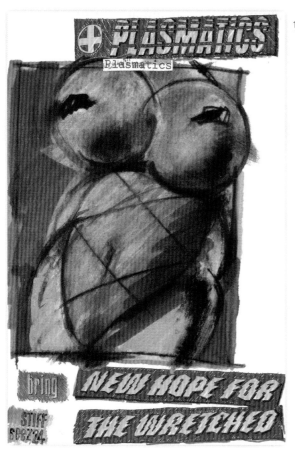

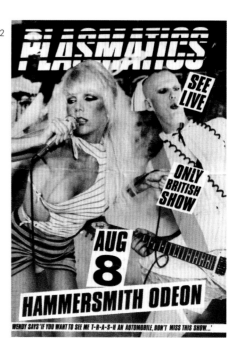

1

2

PLASMATICS: 1 *New Hope for the Wretched* LP poster issued with first pressing (Stiff Records, 1980); **Plasmatics** artwork; **2** Flyer for Hammersmith Odeon concert, 8 August 1980 (Stiff Records, 1980); **Chris Morton** design; **3** Flyer for Wendy's Legal Defense Fund (Stiff Records, 1981).

3

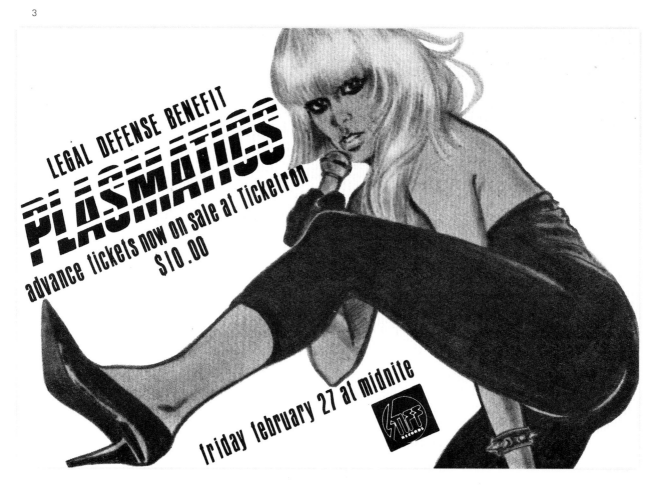

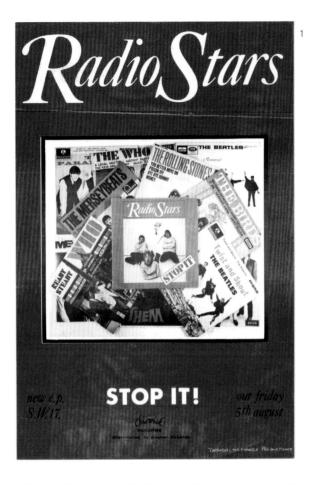

RADIO STARS: 1 'Stop It!' EP poster (Chiswick Records, 1977); **2** *Holiday Album* LP poster (Chiswick Records, September, 1978).

THE RADIATORS FROM SPACE: 3 'Enemies' 45 / tour blank (Chiswick Records, 1977); **4** *TV Tube Heart* debut LP poster (Chiswick Records, April 1977); **Art On My Sleeve** design; **5** Promotional one thousand dollar bill ('Ted Carroll cash') for 'Million Dollar Hero' 45 (Chiswick, 1978).

RED BEANS & RICE: 1 'That Driving Beat /
Throw into the Grass' 45 poster (Chiswick
Records, 1980).

**ALBERTOS Y LOS TRIOS PARANOIAS:
2** Flyer for 'Snuff' EP and concert at the
Roundhouse, London (Stiff Records, 1977).

STIFFS GREATEST STIFFS: 3 Poster for gig
in Liverpool with The Yachts as support,
11 October 1977.

STIFF RECORDS: 1 Promotional jigsaw puzzle, 100 pieces, *c.* 1980; **Chris Morton** design; **2** The first ever Stiff badge; hand-lettered in the typeface **Chris Morton** created for Stiff, 1976; **3** Dutch two-sided poster promoting several releases (1977); **4** *A Bunch of Stiffs* compilation LP (Stiff Records, 1977); **Barney Bubbles** design; **5** Sales sheet for early Damned, Elvis Costello and Nick Lowe releases (July 1977).

Shops stuffed with STIFFS

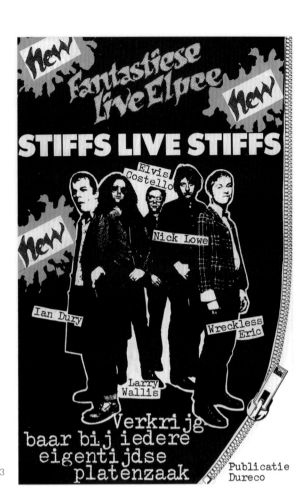

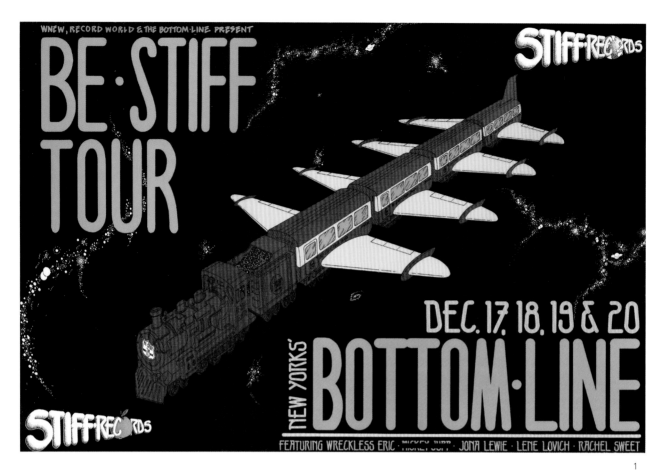

1

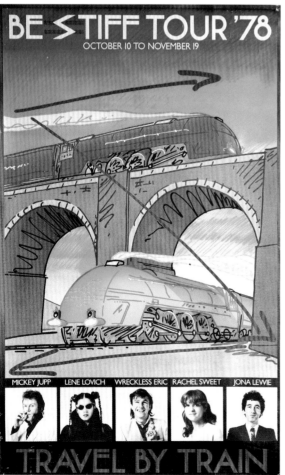

2

BE STIFF TOUR: 1 Bottom Line, NYC, residency poster (Stiff Records, December 1978); **Chris Morton** design. This poster promoted a four-day residency of several Stiff Record labelmates at the venerable New York club, The Bottom Line, in December 1978. This was an extension of the 1978 Be Stiff UK tour poster (**2**), a revue that crisscrossed Britain by train.

IAN DURY & THE BLOCKHEADS: 3 Window cling for their third and final studio LP for Stiff (Stiff Records, 1980).

3

STIFF RECORDS: *Record World* satirical magazine promoting the US leg of Be Stiff Tour, 1978.

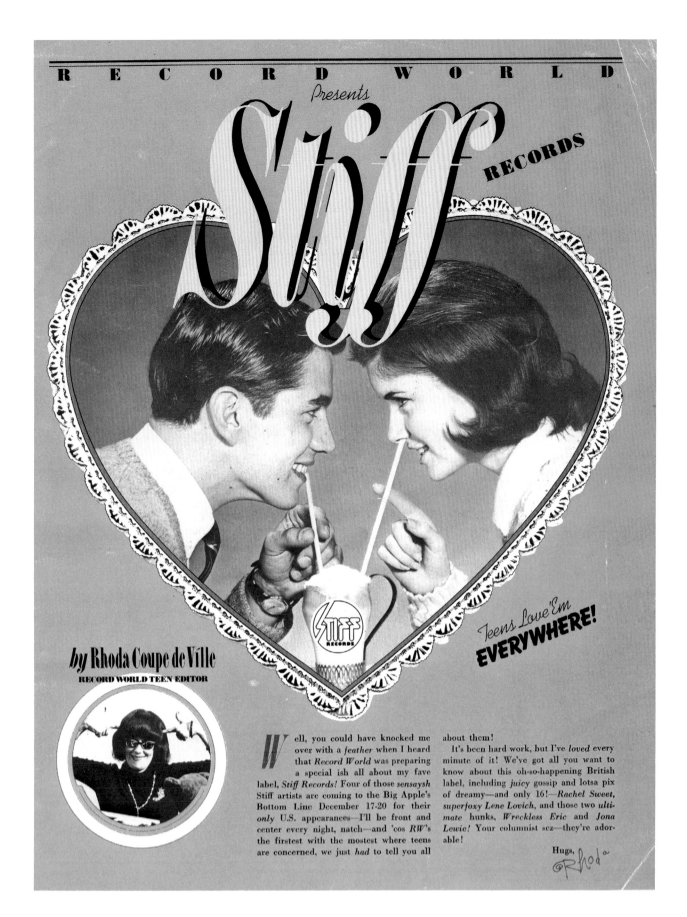

RECORD WORLD

Presents

Stiff RECORDS

Teens Love 'Em
EVERYWHERE!

by Rhoda Coupe de Ville
RECORD WORLD TEEN EDITOR

Well, you could have knocked me over with a *feather* when I heard that *Record World* was preparing a special ish all about my fave label, *Stiff Records*! Four of those *sensaysh* Stiff artists are coming to the Big Apple's Bottom Line December 17-20 for their *only* U.S. appearances—I'll be front and center every night, natch—and 'cos *RW*'s the firstest with the mostest where teens are concerned, we just *had* to tell you all about them!

It's been hard work, but I've *loved* every minute of it! We've got all you want to know about this oh-so-happening British label, including *juicy* gossip and lotsa pix of dreamy—and only 16!—*Rachel Sweet*, *superfoxy Lene Lovich*, and those two *ultimate* hunks, *Wreckless Eric* and *Jona Lewie*! Your columnist sez—they're adorable!

Hugs,
Rhoda

287

THE SOUND IS IN THE LABEL: CHISWICK + STIFF + RADAR RECORDS

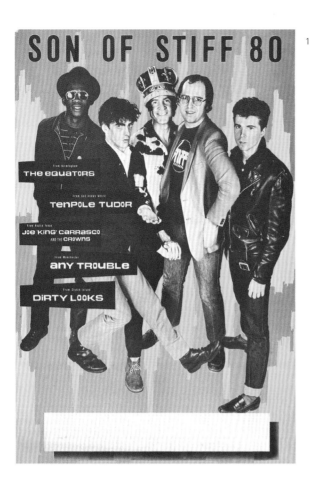

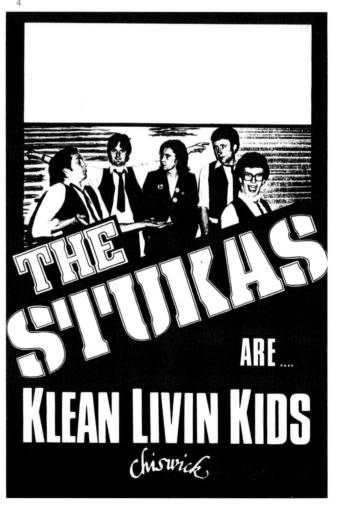

STIFF: **1** The Son of Stiff tour blank poster with photograph of all the acts (1980); **2** Stiff Records business card, *c.* 1979; **3** Ticket for the Son of Stiff tour at the University of East Anglia, Norwich, 3 October 1980.

THE STUKAS: **4** 'Klean Livin Kids / Oh Little Girl' 45/tour blank (Chiswick Records, 1977).

TENPOLE TUDOR: (top right) In analogue times, the marvellous rub-down transfer sheets were not just for letters — Letraset also made Letratone, a range of different-sized sheets of dots that came in nine shades of grey, from very light to almost black. They could give the same effect as the addition of tones, highlights and colour would to outline-drawn comic strips. I used them like that for the Wreckless Eric 'Big Smash' cover and campaign. However, their French counterpart, Mecanorma, also made a wide range of line effects and textures, which is what I used, in multiple overlaps, to make the illustration for this poster based on the LP cover I'd just done.

I developed that mix of mechanical and hand-drawn illustration style working on the early Theatre of Hate stuff, along with the technique for making Letraset type look scuzzy and battered. First you rub down the letters as normal onto white artboard, then carefully colour it all over with a thick black felt pen, then firmly stick masking tape over the lettering and quickly peel it off (like a sticking plaster on hairy legs). That would remove most of the Letraset type, but leave some little bits and a ragged edge — roughened white type on a black background — then you'd do a photographic reversal print to make it into black type on a white background.

That's how I did Tenpole Tudor's logo and the poster's lettering — and, incidentally, also the back cover title track lettering for The Clash's *Sandinista!* album, which was done by Julian Balme, who worked in the Stiff art department with me.

Paul Simonon, The Clash's de facto art director, who often frequented our office, paid me with a 12" white label promo copy of remixes of 'The Call Up/The Cool Out' b/w 'The Magnificent Dance/The Magnificent Seven' — which was sadly digitally unavailable until the recent-ish comprehensive Clash *Sound System* ghetto-blaster boxset. Those are wonderful dubby extended mixes that I still treasure to this day.

Chris Morton

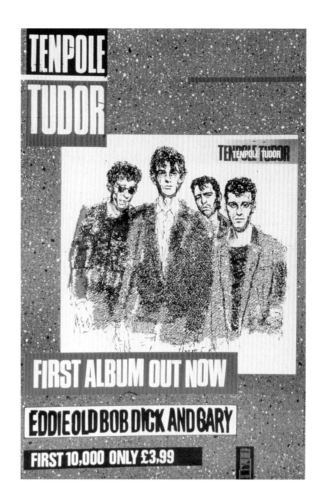

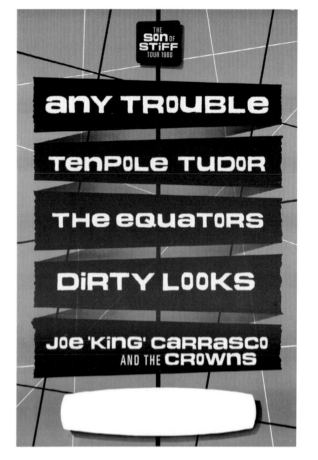

<div style="writing-mode: vertical">**TENPOLE TUDOR:** (bottom) *Eddie, Old Bob, Dick and Gary* debut LP poster original artwork (Stiff Records, 1980); **Chris Morton** design; Son of Stiff tour blank, 1980, large format poster, one of just fifty printed; **Eddie King** design.</div>

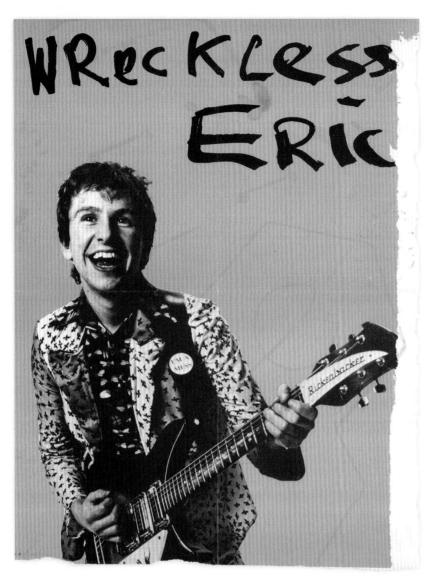

WRECKLESS ERIC: 1 'Big Smash' 45 promotional brick; **'Wreckless' Eric Goulden** handwriting, **Chris Morton** design; **2** Self-titled debut LP poster (Stiff Records, 1978); **Chris Morton** design; **3** 'Big Smash' Australian tour blank poster (Stiff Records, 1980); **Chris Morton** design. The labels on Wreckless Eric's records all featured the Stiff 'Wreckords' pun.

STIFF RECORDS PROMOTIONAL STICKERS AND BADGES: (opposite) **1** Bottle label sticker, 1978; **Chris Morton** design; **2** Sticker for The Damned *Music for Pleasure* LP (Stiff Records, 1977); **Barney Bubbles** design; **3** The Son of Stiff tour promotional sticker, 1980.

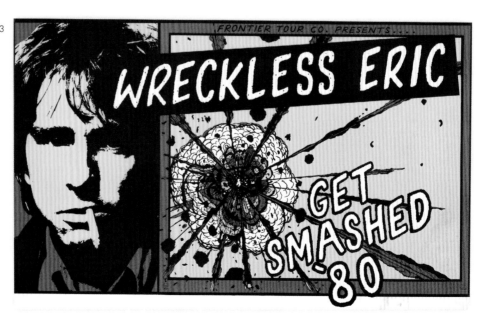

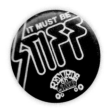

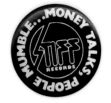
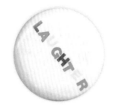
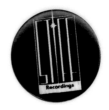

1

2

3

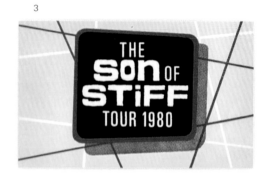

STIFF RECORDS: 1 Front of Stiff America mailer, Spring 1980; **2** Stiff Secret Service, shop flyer, 1977; **3** Flyer for upcoming releases, July 1978; **4** Flyer with directions to Stiff Records shop, 1976; **Chris Morton** design.

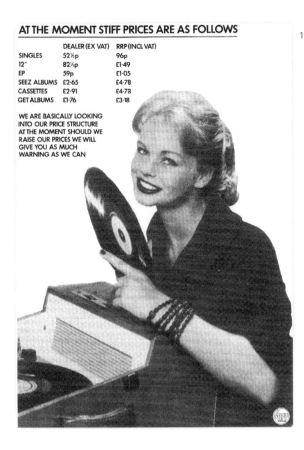

AT THE MOMENT STIFF PRICES ARE AS FOLLOWS

	DEALER (EX VAT)	RRP (INCL VAT)
SINGLES	52½p	96p
12"	82½p	£1·49
EP	59p	£1·05
SEEZ ALBUMS	£2·65	£4·78
CASSETTES	£2·91	£4·73
GET ALBUMS	£1·76	£3·18

WE ARE BASICALLY LOOKING
INTO OUR PRICE STRUCTURE
AT THE MOMENT SHOULD WE
RAISE OUR PRICES WE WILL
GIVE YOU AS MUCH
WARNING AS WE CAN

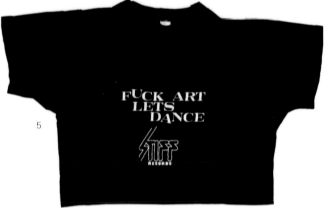

STIFF RECORDS: 1 UK price sheet, *c.* 1979; **2** Carrier bag most likely printed in London for the label's New York office, *c.* 1980; **Chris Morton** design; **3** Merchandising price sheet, 1978; **4** Shop flyer for Christmas 1982; **5** 'Fuck Art Let's Dance' T-shirt, 1980; **Chris Morton** design.

DESERT ISLAND DESIGNS — ONTO A DESERT ISLAND, A NEW WAVE ROLLS

Chris Morton &/or c-more-tone

Just as in the long-running and popular BBC Radio 4 show *Desert Island Discs*, I have been asked to choose eight items. In this case, we are talking posters from the new wave era, rather than recordings of songs, that I'd want to be cast away with. There are four of mine, and four by my then-contemporaries.

From the latter category, I have chosen designers I knew. They each influenced me and had a connection with Stiff Records, where I was the original art director. The posters have interesting backstories and also illustrate the chronological development of, and shift towards, digital designing. The new wave era was the high-water mark, and the end of a long craftsmanship tradition, of analogue design and production processes.

1. The first Stiff poster

This 50 x 75cm poster promoting Stiff's new roster of artistes was made and illustrated at life-size with hand-drawn type. This was not because I'd intended to make a punky DIY gesture, but because I didn't know about resizing, rescaling or making print-ready artwork using professional photographic processes — let alone posh photo-typesetting for the text.

All the dots are individually hand-placed using 'needle-point' Rapidograph pens. These varied in nib size from 0.1–0.3 mm for the 'misty cloud effect', and up to 2 and 3 mm for the lettering or outlines.

The title lettering at the bottom — as you can tell from the wonky spacing — was laid out and constructed in situ, using small compasses and tiny stencils. This was painstakingly recreated at different sizes from the first Stiff record label and 45-single 'house bag' designs that I'd just prepared in the same way. In contrast, the 'gravestones' text all around the undertaker MC character is simply drawn freehand. He was originally planned to feature in promotional work, such as for a Zippo lighter (which you can see in the Stiffs chapter), where his hat was 'doffed' when you flipped open the lid.

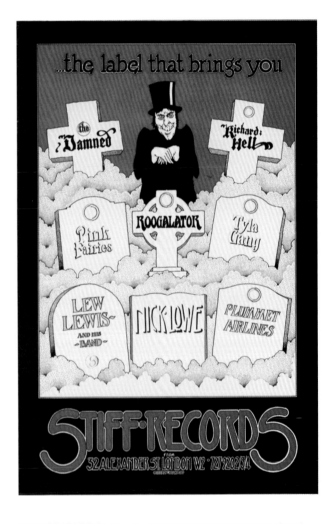

STIFF RECORDS: 'A Bunch of Stiffs' label roster promotional poster (1977); **Chris Morton** design. The ghoul is based on the Lon Chaney character from the lost silent film *London After Midnight* (MGM, 1927).

2. The 'Reasons to Be Cheerful' promo-poster

This poster was made in collaboration with the artist Peter Blake, who had taught Ian Dury at Walthamstow Art School. Ian had invited Peter into the Stiff art department to work on it, so as to help take his mind off a difficult breakup he was going through.

Luckily for me, by this time I had learned and was fascinated by the artwork processes for translating your ideas into print. Handy, as that's what Peter Blake wanted to learn about.

I've always treasured that extraordinary and insightful week constructing the poster, along with Peter's hand-written credit for me at the bottom.

IAN DURY & THE BLOCKHEADS: 'Reasons to be Cheerful' 45 poster (Stiff Records, 1979); Peter Blake/Chris Morton design.

3. Barney Bubbles' *New Boots and Panties!!* promo-poster

I believe that Barney Bubbles was one of the few people who was genuinely unique — a truly extraordinary artist and a designer whose influence cannot be exaggerated. Incredibly luckily for me, in the very early days of Stiff he was also a fascinating and mystifying mentor.

He had worked frequently with Jake Riviera pre-Stiff, and had already created some memorable work (including many underground comics, commissions for The Conran Group, the *Glastonbury Fayre* triple album (REV1–3, 1972), Chilli Willi and the Red Hot Peppers and Hawkwind designs and lightshows). I've chosen this poster as it links the last one to the next and highlights some of Barney's strength-in-depth qualities.

Barney usually planned his designs so they'd work well with attendant promotions and ads, which he also relished doing. He would start with a killer and/or leftfield idea that his contemporaries wouldn't have thought of. In this case, that initial idea was focusing on button badges with a twist. The badges on the poster promoting the album didn't yet exist, but he'd also just designed a real 'lapel set' for the pre-album single release. These were arguably the best ones he ever did for us: a set of four in differing bright colour combinations, all with bold white type, simply worded — sex &; drugs &; rock &; roll & — that you could arrange

IAN DURY: *New Boots and Panties!!* LP poster (Stiff Records, 1977); **Barney Bubbles** design.

and rearrange according to your moods and needs. Keeping to his (difficult to pull off) remits of making everything look deceptively simple as well as bold, and not making any unnecessary extra work for yourself (one of his top advice tips for me), this poster becomes an ad for Ian, the album, and for Stiff merchandising. It is a dramatic design, despite not achieving MD Dave Robinson's golden rule of punters having to be able to read it from a passing bus — a rule graciously and very unusually forgone, due to Barney's genius.

4. Barney Bubbles' Elvis Costello poster

This is from the privately produced iconic set of five that also included Wreckless Eric, Larry Wallis, Ian Dury and Nick Lowe, which were sold in the Stiff Shop and on live tours. I chose this one as it links Stiff and the later stuff Barney did for Elvis Costello — particularly the *Armed Forces* LP cover. (This also links me to the next poster, otherwise I couldn't have picked just one favourite from the set.)

These posters' visual style pays homage to Andy Warhol. Barney had a rare and enviable knack of appropriating art genres and artists' paintings without ripping them off. He did this by using (often dark) humour and, importantly, parody — where meaning is redeployed by imitating the 'myth of originality' through repetition — as opposed, crucially, to pastiche, which instead acts as a nostalgic form of borrowing, and is what the majority of designers seemed unwittingly to do.

Pastiche's mimicry homogenizes everything in an indiscriminate and seemingly value-free way, whereas parody can become politically invested. Pastiche is nostalgic retrieval without ideological motivation. That's philosopher and political theorist Fredric Jameson's definition, and it changed my whole approach to thinking about culture, never mind art and design.

ELVIS COSTELLO: 5 Live Stiffs Tour screenprinted poster (Stiff Records, October 1977); **Barney Bubbles** design, **Chris Gabrin** photography.

5. Loulou Picasso's Skydog poster for a Marc Zermati benefit gig

Loulou & Kiki Picasso (from the Paris-based Bazooka design collaboration) were internationally influential. So much so that Barney Bubbles invited them to work on the groundbreaking *Armed Forces* multi fold-out LP cover.

Bazooka's aims and output were truly revolutionary. Their initial and seminal work '*Un Regard Moderne*' was a series of newspaper-like publications that replaced text and photos with full-page hand-drawn, traced and collaged images that illustrated and 're-presented' (rather than simply represented) the original news story in less proscriptive ways.

I chose this particular poster not only for its striking and witty design, but also because of its link to Marc Zermati, aka the hippest man in Paris. Marc, among many rock'n'roll'n'punky firsts, founded the original indie record label Skydog, who influenced and prompted Stiff and Chiswick.

Incidentally, the ubiquitous punk blackmail-style lettering we saw in the UK was 'borrowed' from the radical Paris-based Situationists group. This was a hugely inspirational sociopolitical and creative arts/philosophy movement, and a key part of the legendary May 1968 student/worker uprising — the tail end of which influenced the nascent Bazooka group while still at art school.

THE DAMNED: Poster for concert with Tyla Gang at Electric Ballroom, Camden Town, London, 6 January 1979; **Loulou Picasso-Bazooka** design.

DESMOND DEKKER: 1 *Black and Dekker* LP poster (Stiff Records, 1980); **Neville Brody** design.

SIOUXSIE AND THE BANSHEES: 2 'Peek-a-Boo (Silver Dollar Mix)' 12" cover, black and silver duotone (Polydor/Wonderland, 1988); **Chris Morton** design.

PHILIP RAMBOW: 3 *Shooting Gallery* debut LP poster (EMI, 1979); **Chris Morton** design. See the text for the story of the pixelation.

SIOUXSIE AND THE BANSHEES: 4 *Peepshow* LP poster (Polydor/Wonderland, 1988); **Chris Morton** design.

6. Neville Brody's *Black and Dekker* promo-poster

Around 1982, a fresh-out-of-college Neville Brody worked with me in the Stiff art department. I've chosen him as he's a primary figure in the first art-school generation of would-be designers to move away from contemporary, traditionally taught graphic design norms and be influenced by punk and new wave ideas.

Like the Bazooka group — who I met via Neville — they both brought in a new approach to design thinking and innovative techniques. For instance, take this poster. He 'drew' Desmond Dekker's face on with the side of a scalpel blade — by first colouring in a whole sheet of tracing paper with a black magic marker, then scratching away the ink where there were facial highlights. It's no surprise that he went on to become such an iconic designer.

Bazooka's methodology also had a very energizing effect on me. I'm still extremely proud that they made me an honorary group member — they particularly inspired my approach to all the posters and covers I got to do for The Theatre of Hate. That's probably the band stuff I am most proud of — I could do a whole 'Desert Island Designs' just on those!

7. (One of) the Phil Rambow *Shooting Gallery* promo-posters (and ads)

This poster (and its attendant single bag, LP cover and music-paper ad campaign) was the first to use pixelated images, and heralds the dawn of the digital age.

After leaving Stiff and setting up as c-more-tone studios, I was fortunate to be invited by EMI Records to get involved in their early experimental digital image-generating set up. There was a sprawling, magnetic tape-based computer that filled a small room, and an extremely keen group of proto-geeks who couldn't have been more helpful. Not only did they provide the pixelated image for my poster (at the time unique within the record industry), but also a time-consuming set of pixelated portraits of famous historical figures for the ensuing 'guess the digitized faces' ad campaign. Looking back, this was probably the most creatively exciting and rewarding one I ever did — happy daze indeed!

8. The *Peepshow* poster for Siouxsie and the Banshees

The poster and that album's campaign (including the 'Peek-a-Boo' single) completes that transition — a digitized sun was peering over the horizon.

Peepshow's was the first album cover wholly produced using Photoshop, the earliest version of which was still only a printer's tool in the nascent digital-print production process. It was mainly used to digitally replicate the 'full-colour print' photo-mechanical colour separations needed to make the set of printing-press plates required for printing. Until then, these had been photographically derived from a designer's physical artwork.

Again, I was lucky, in that I got access to the 'non-designers stage' process at the printers. Though that was only because the album cover's artwork had suddenly had its deadline moved forward from a do-able London delivery two or three weeks away to being delivered in LA, via a courier to Heathrow, in twenty-four hours.

But first: my own analogue/digital transition that was the 'Peek-a-Boo' single bag.

Siouxsie was keen on a theme of masks. I had some Super8 footage of the Venice Carnival, with someone who I thought could look a bit like her, wearing a mask. I had this transferred onto video tape (then a hi-tech upgrade) and played that in slow motion on my 625-line cathode-tube TV (at the time the TV and video player were Sony's finest). Then I took a series of close-up photos with my trusty (and old, even then) Zenit 35 mm camera.

I then added a hand-drawn lettering logo design (it would turn out to be my last: the

302

circular flower-like one, which I'm very proud of), and a fun DIY cut-out mask to the back cover of the different 12" mixes' single bags. That was a string of, then, state-of-the-art 'electronic' processes — but not quite digital.

Originally, the *Peepshow* cover was going to be a fold-out pop-up toy theatre with Siouxsie and all the Banshees cut-out figures that could move about on the stage. However, the rush deadline changed all that — and also my design career.

The weird news was that the extreme rush obviated the need for making the usual physical artwork. The saving-grace news was that the printers were going to let me 'art direct' the design directly on/in their innovative and magical digital-print production computer. I say on/in as it was huge, and its various hardware components were housed in dust-free, double glazed, thermostatically-controlled booths — the main one of which you sat inside to operate Paintbrush, the proto-Photoshop program. They were not even called applications then, never mind apps.

I had brought some Siouxsie-approved 5 x 4-inch transparencies to be scanned, and we then spent most of an amazing — and literally and metaphorically eye-opening — night going through every colour, hue and saturation distortion and filter effect we could find or conjure, until I settled on the final image. Ironically, looking back, this looks like a glorified solarized photograph!

Nonetheless, the scale of this new print-production paradigm shift, and of what's also entailed when a key is simply clicked to digitally output all those complex required instructions for printing — the way we all now just touch 'print' on our screens — didn't hit home until a year or so later, when I was learning how to use an early Apple Macintosh.

Yes, it was (and is) amazing and incredibly time-saving to be able to design and 'make' your artwork on a screen. However, what was about to be lost forever was the designer's ability to be able to change, adjust and experiment with the physical artwork *after* you'd made it, but before you finally handed it to the printer. I often completely redesigned jobs: altering and redoing the physical artwork's different colour overlays to achieve very different visual outcomes. Now, once you're happy with your design on screen, one click also sends it all out of your hands.

Finally, and to keep in the spirit of things, at the end of the radio show you get asked what luxury item and book you'd also like to bring to your desert island, and which one of the discs you'd chosen would you keep if you had to be cast away with just one. Harsh, but fun (and remarkably and fortuitously there's already a record player on the island)!

I would like to ask if I can instead choose the 'poster that got away', as in a cherished design that unfortunately never got printed. If allowed, I'd explain — as of course it can't be seen on the radio — all about The Cramps, Madness and my 'fuck art, let's dance...' T-shirt.

When I originally designed that, while still at Stiff, it was meant for a poster and T-shirt for my all-time favourite band, The Cramps. I was doing an ad campaign for their first album, of which the cover, if I'd had my way, would have been just stark, faux-blue suede, with the title, text and photos on the inner/liner bag. (I've still got the tactile, flock-effect cover that our then sleeve printers mocked up for me.)

Lux and Ivy had given me a pre-release white label pressing of the album to play to Dave Robinson, with a view to hopefully releasing it on Stiff. Alas, it was not to be. However, Dave was so taken by the 'fuck art, let's dance...' concept that he politely 'convinced' me to use it for Madness. I couldn't really counter this, as he'd been employing me for over four years as well as letting me do freelance work in the evenings when we weren't all working late, or checking out new bands!

Mind, I still have fun redesigning that virtual poster to my heart's delight.

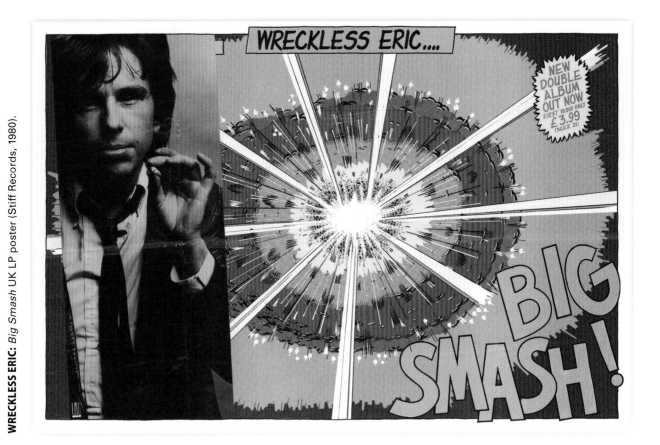

WRECKLESS ERIC: *Big Smash* UK LP poster (Stiff Records, 1980).

1

2

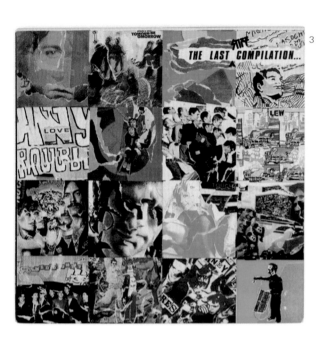

3

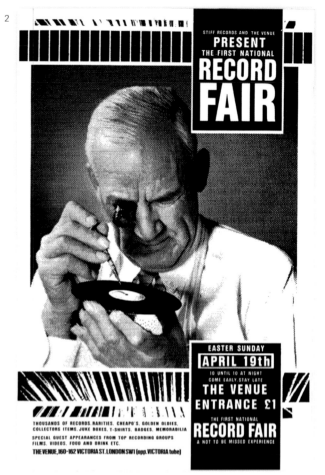

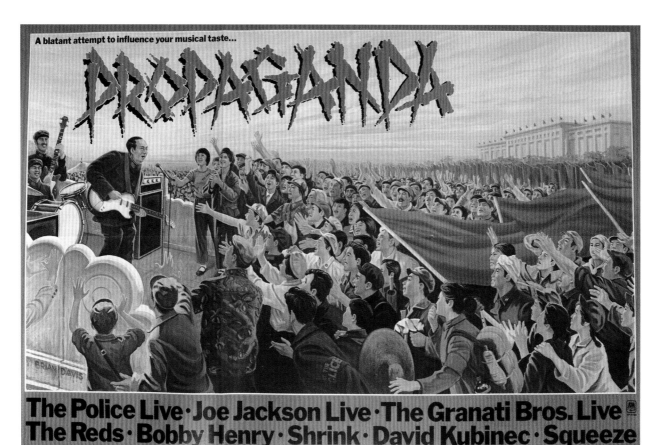

PROPAGANDA: (above) Compilation LP poster (A&M Records, 1979); **Brian Davis** artwork, **Jeff Ayeroff** cover concept, **Chuck Beeson** design.

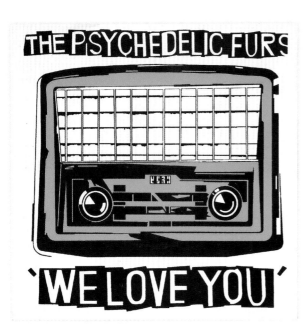

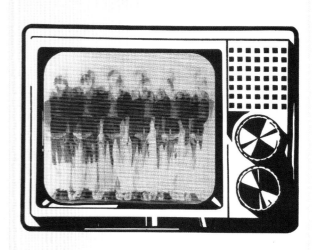

THE PSYCHEDELIC FURS: (above) 'We Love You / Pulse' 45 cover (Epic, 1979); (right) Self-titled debut LP UK press-kit folder (CBS Records, 1980).

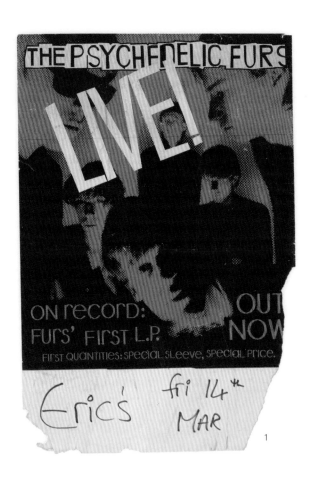

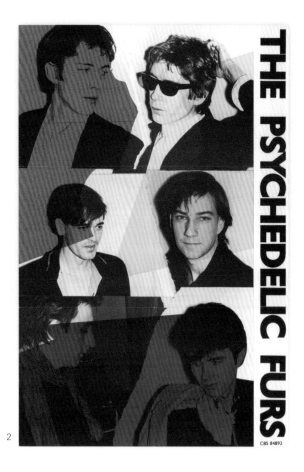

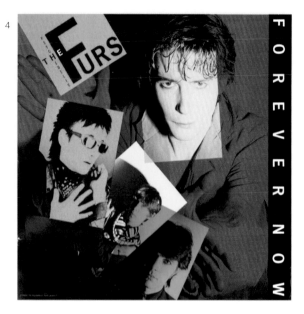

THE PSYCHEDELIC FURS: 1 Tour poster for debut LP, Eric's, Liverpool, UK (CBS Records, 14 March 1980); **2** *Talk Talk Talk* LP poster (Columbia Records, May 1981); **Julian Balme** and **Richard Butler** design (after **Andy Warhol**), **Andrew Douglas** photography; **3** Poster for concert at Tommy's Deep South Music Hall, Tallahassee, FL, 19 August 1981; **4** *Forever Now* LP poster (CBS Records, 1982); **Chris Austopchuk** design.

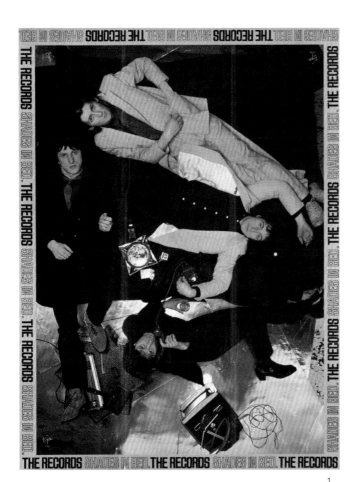

1

2

3

THE RECORDS: **1** *Shades in Bed* debut LP
poster (Virgin Records, 1979).

RE-FLEX: **2** *The Politics of Dancing* LP poster
(EMI Records, 1983); **Keith Breeden** design.

REMA REMA: **3** Flyer, at The Acklam Hall,
Notting Hill, London, 26 April 1979; **Gary
Asquith** design.

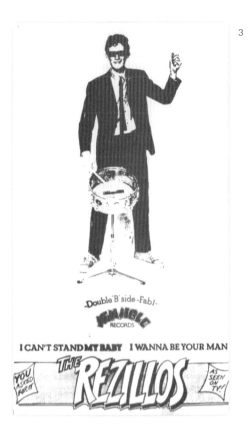

THE REVILLOS: 1 Poster for three-night residency at the Marquee, London, with DJ Jerry Floyd, July 1980; **2** *Rev Up* LP poster (Dindisc Records, 1980).

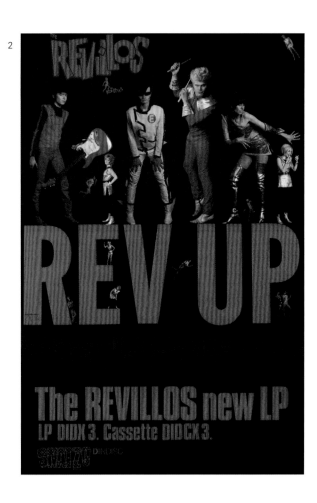

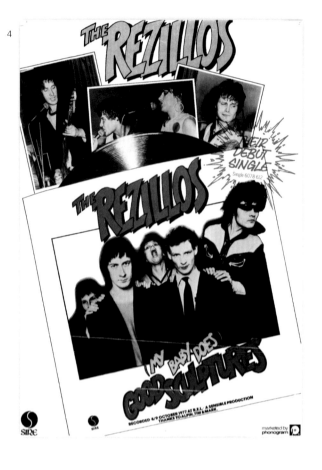

THE REZILLOS: 3 Small poster for 'Can't Stand My Baby' 45 (Sensible Records, 1977); **4** '(My Baby Does) Good Sculptures' debut 45 poster (Sire Records, 1977).

RICH KIDS: 1 'Marching Men' 45 banner poster (EMI Records, 1978); 2 *Rich Kids* fold-out LP poster (EMI Records, July 1978); **Rocking Russian** design, **Peter Kodick** photography; 3 Poster for concert at the Paradiso, Amsterdam, 7 April 1978; **Martin Kaye** design.

THE·PHENOMENAL·RISE·OF·RICHARD·STRANGE

A POLITICAL FANTASY

THE RECORD IS OUT NOW

1

THE RUMOUR

MAX
1st LP

marketed by phonogram Album 6360 149 Cassette 7138 088

2

AND

THE RUMOUR A EURO ALBUM FROGS SPROUTS CLOGS AND KRAUTS SEEZ 13

3

RICHARD STRANGE: 1 (ex-Doctors of Madness), *The Phenomenal Rise of Richard Strange* LP poster (Virgin Records, 1981); **Rene Eyre** artwork, **Marcus Wilson Smith** photography.

THE RUMOUR: 2 *Max* LP poster (Vertigo Records, 1977); **Keith Morris** photography; **3** *Frogs, Sprouts, Clogs and Krauts* LP poster (Stiff Records, 1979); **Barney Bubbles** design.

1

2

3

4

SCRITTI POLITTI: 1 'Asylums in Jerusalem/Jacques Derrida' 45 poster (Rough Trade Records, 1981); **2** 'The "Sweetest Girl"' 45 poster (Rough Trade Records, 1982); **3** *Songs to Remember* LP banner poster (Rough Trade Records, August 1982); **4** *Cupid & Psyche* 85 LP banner poster (Warner Bros. Records, 1985); **Keith Breeden** design.

SCRITTI POLITTI: 'Faithless' 45 poster (Rough Trade Records, 1982); **Bernard**, **Green** and **Tom** design, **Tom** artwork.

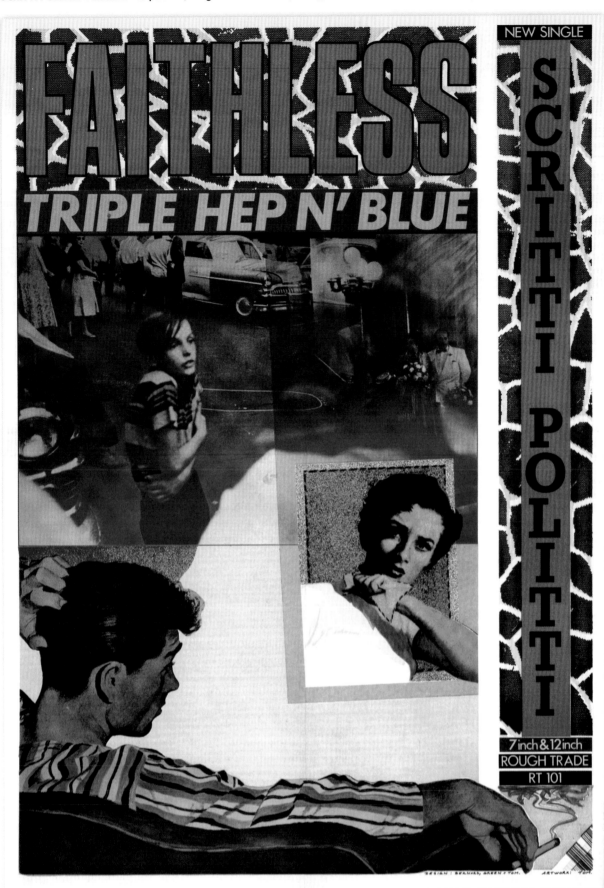

312

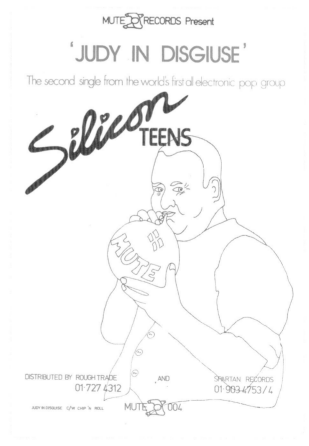

SEX BEATLES: 'Well You Never....' 45 poster (Charly Records, November 1979).

SILICON TEENS: 'Judy in Disguise' 45 sales sheet (Mute Records, 1980); **Simone Grant** design.

1

2

SIGUE SIGUE SPUTNIK: Formed in 1982 by former Generation X bassist Tony James, Sigue Sigue Sputnik were named by Fachtna O'Kelly, manager of The Boomtown Rats, after a Filipino street gang: 'sigue' from the Tagalog for 'go on' (or possibly the Russian for 'burn'), and Sputnik referencing the first man-made satellite launched by the Soviet Union in 1957. **1** *Flaunt It* debut LP, banner format poster (Parlophone Records, 1986); **2** *Flaunt It* debut LP, cassette format packaged like a toy for a hanging display (Parlophone Records, 1986); **Bill Smith Studio** cover, **Image Manipulation** design, **Syd Brak** illustration; **3** 'Love Missile F1-11' 45 poster (Manhattan Records, 1986); **4** Poster for concert in Spain, 27 March 1987.

3

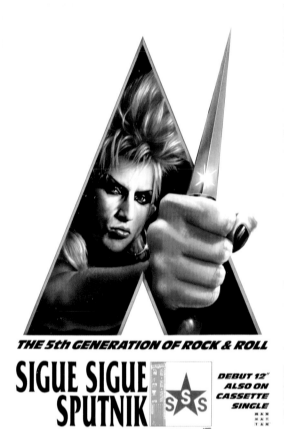

4

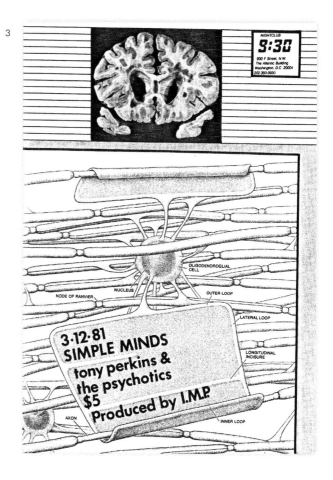

SIMPLE MINDS: 1 *Life In A Day* LP poster
(Zoom Records, 1979); **2** *Sparkle in the
Rain* LP poster (A&M Records, 1984);
Malcolm Garrett inset cover design; **3**
Flyer for Nightclub 9:30, Washington DC,
12 March 1981.

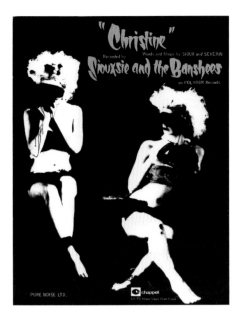

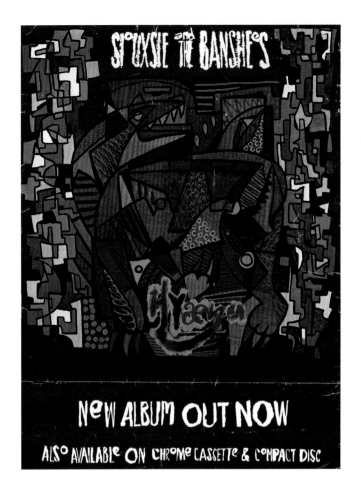

SIOUXSIE AND THE BANSHEES: (above)
'Christine' 45 sheet music (Chappell, 1980);
Rob O'Connor design, **Paddy Eckersley**
photography; (right) *Hyaena* LP poster
(Geffen Records, 1984); **Maria Penn**
painting, **Da Gama** and **Siouxsie and
the Banshees** design.

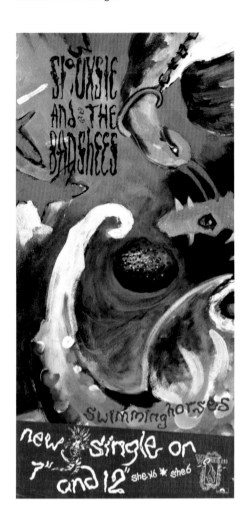

SIOUXSIE AND THE BANSHEES: (below) With The Scientists,
concert at the Bristol Hippodrome, 10 November 1985; (left)
'Swimming Horses' 45 poster (Polydor, 1984); **Alex McDowell**
painting, **Da Gama** design.

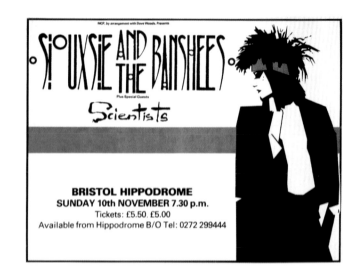

THE SKIDS: (left) *Scared to Dance* debut LP poster (Virgin Records, 1979); **Russell Mills** artwork and design; (above) *Scared to Dance* LP banner poster (Virgin International Records, 1979).

316

1

2

3

SOFT CELL: 1 *Non-Stop Erotic Cabaret* LP, Canadian release poster (Vertigo Records, 1981); **Huw Feather** artwork, **Peter Ashworth** photography. Poster courtesy of Lawrence Demellier; **2** 'Numbers / Barriers' double A-side single flyer (Some Bizzare Records, 1983); **Huw Feather** illustration; **3** 'Down in the Subway' 45 flyer (Some Bizzare Records, 1984); **Raoul Revere** design.

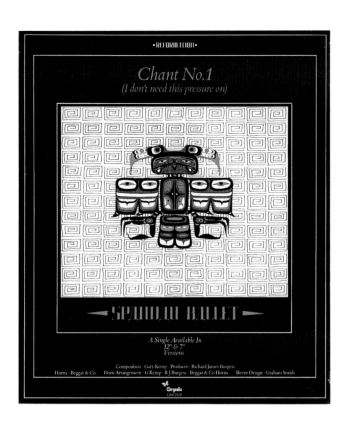

SPANDAU BALLET: 'Chant No. 1 (I Don't Need This Pressure On) / Feel the Chant' 45 poster (Chrysalis Records, 1982); **Graham Smith** design.

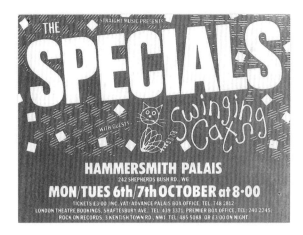

2

3

"Just because you're a black boy
Just because you're a white
It doesn't mean you've got to hate him
It doesn't mean you've got to fight
It doesn't make it alright
It doesn't make it alright

It's the worst excuse in the world
And it, it doesn't make it alright
Just because you're nobody"

THE SPECIALS: **1** Flyer for Hammersmith Palais concert, October 1980; **2** Poster in support of the charity Oxfam, with lyrics from the song 'Doesn't Make It All Right' c. 1980; **3** *More Specials* LP poster included in early record pressings (Two-Tone Records, 1981); **Chalkie Davies** photography.

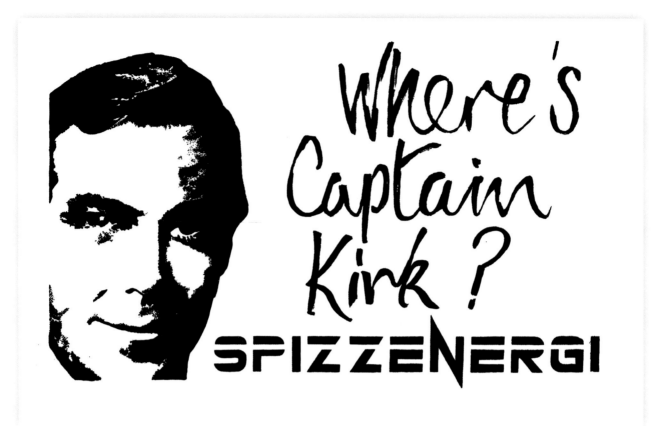

SPIZZENERGI: 'Where's Captain Kirk?' 45 poster (Rough Trade Records, December 1979); (below) Flyer for a gig at the Venue in London, 30 December 1981; **Spizz** design.

THE SPIZZLES: (right) With Mo-dettes, flyer for Squatters Benefit gig at City University, 29 January 1981.

SPLIT ENZ: *Mental Notes* debut LP poster (Chrysalis Records, 1976).

1

2

3

SPLIT ENZ: 1 *Waiata* LP poster (A&M
Records, 1981); **2** *True Colours* LP poster
(A&M Records, 1980); **Graeme Webber**
artwork; **3** *Time and Tide* LP poster
(A&M Records, 1982).

SQUEEZE: **1** CBGB's residency poster, June 1978 (A&M Records); **2** *Sweets from a Stranger* LP poster (A&M Records, 1982); **Simon Ryan** and **Squeeze** design, **Mike Putland** photography; **3** *Cosi Fan Tutti Frutti* LP poster (A&M Records, 1985); **Rob O'Connor** design, **Simon Fell** illustration.

SQUIRE: **4** *Get Smart!* LP poster (Hi-Lo Records, 1983).

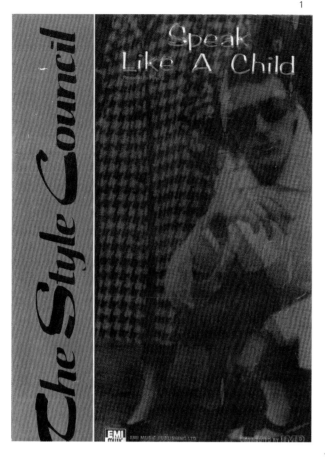

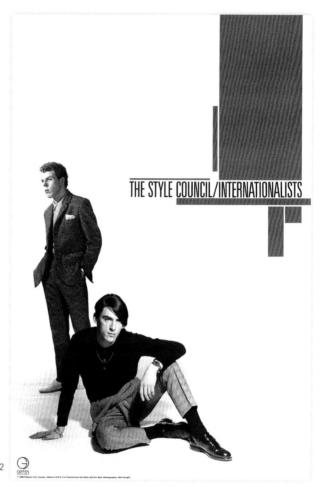

2

3

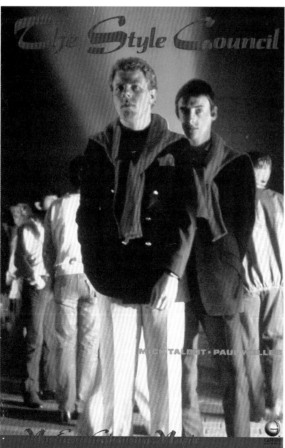

THE STYLE COUNCIL: **1** 'Speak Like a Child' sheet music (Polydor Records, 1983); **2** *Internationalists* (released as *Our Favourite Shop* in the UK) LP poster, with postcard (Geffen Records, 1985); **Paul Weller** and **Simon Halfon** design, **Nick Knight** photography; **3** *My Ever Changing Moods* (released as *Café Bleu* in the UK) LP poster (Geffen Records, 1984); **Paul Weller** and **Simon Halfon** design, **Peter Anderson** photography; **4** Plastic 'Mood Meter' promotional item for *My Ever Changing Moods* LP (Geffen Records, 1984).

4

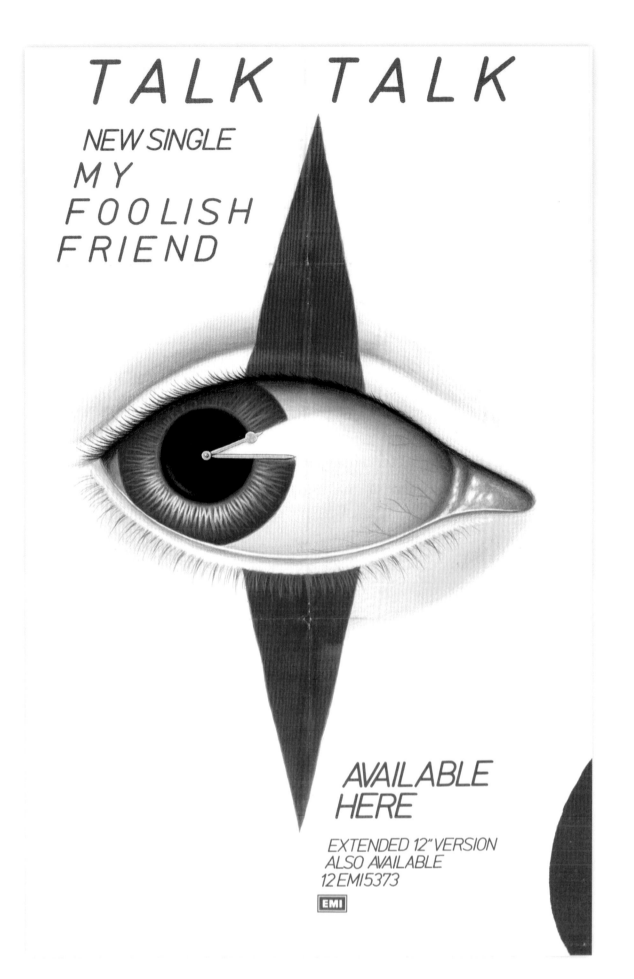

THE STYLE COUNCIL / TALK TALK

TALK TALK: 'My Foolish Friend' 45 poster (EMI Records, 1983); **James Marsh** illustration.



324

THE TEARDROP EXPLODES: 1 *Kilimanjaro* debut LP poster (Mercury Records, 1980); **Rocking Russian** design, **Brian Griffin** photography; **2** Poster with The dB's and Pylon, The Ritz, NYC, 21 and 22 April 1981; **3** Culture Bunker tour poster (Mercury Records, 1981); photograph by **Peter Ashworth**; **4** 'Reward' Concert ticket, University of East Anglia, England, 13 June 1981; **5** Poster for concert at Paradiso, Amsterdam, 14 February 1982; **Martin Kaye** design; **6** 'Treason (It's Just a Story)' 45 cover (Zoo Records, 1980).

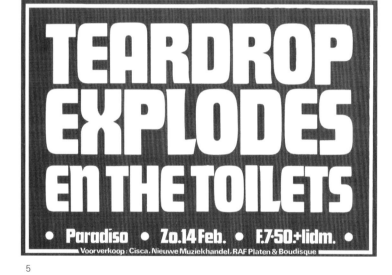

TEARS FOR FEARS: (above) *The Hurting* debut LP poster (Mercury Records, 1983); **Peter Ashworth** photography.

THOMAS DOLBY: (below) *The Flat Earth* LP poster (Capitol Records, 1984); **Malcolm Garrett**, **Matthew Seligman**, **Thomas Dolby** design; **Richard Haughton** photography.

THE THE: (above) *Mind Bomb* LP (Epic Records, 1989); **Fiona Skinner** logo, **Andrew MacPherson** photography; (below) *Infected* LP poster (CBS/Epic Records, 1986); **Andy Dog** artwork.

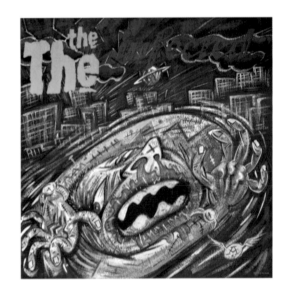

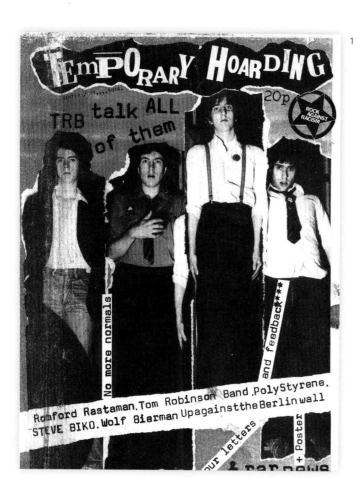

TEMPORARY HOARDING: 1 Rock Against Racism 'zine, Issue 3, 1977.

TOM ROBINSON BAND: 2 Band logo poster (Harvest Records, 1977); **Roger Huddle** design.

TOM ROBINSON'S SECTOR 27: 3 *Sector 27* first LP poster (I.R.S. Records, 1980).

U2: 1 In-store cardboard standee for *BOY* LP (Island Records, 1981); **Phil Sheehy** photography; **2** Debut *BOY* LP poster (Island Records, 1980); **3** Pre-Island Records signing badge, *c.* 1979; **Phil Sheehy** photography.

ULTRAVOX!: 4 (The first three albums with John Foxx featured an exclamation mark in the band's name) *Ha!-Ha!-Ha!* second LP/ tour blank poster (Island Records, 1977); **Bloomfield/Travis** design; **5** *In the City* fanzine no. 11, back cover, June 1979.

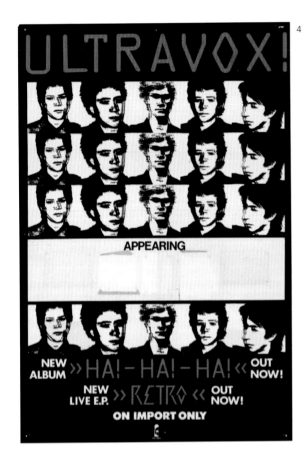

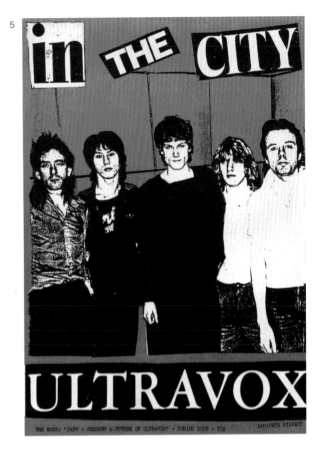

ULTRAVOX: (below) *Vienna* LP press kit cover (Chrysalis, 1981); **Glenn Travis** design, **Brian Griffin** photography.

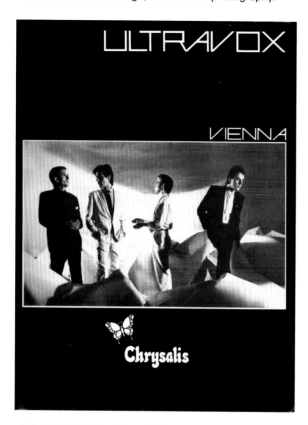

328

THE UNDERTONES: **1** Poster torn off a building site wall by the author for gig at the Diplomat Hotel, NYC, 15 July 1980; **2** *Positive Touch* LP poster (Capitol Records, 1981); **Bush Hollyhead** design.

VIC GODARD AND THE SUBWAY SECT: **3** 'Stamp Of A Vamp' 45 poster (Club Left Records, 1981); **Pete Barrett** design.

VISAGE: (below) Self-titled US-only mini-LP poster (Polydor, 1981); **Alwyn Clayden** *Visage* design, **Robyn Beeche** photography.

WASTED YOUTH: (above) 'Rebecca's Room' 45 poster (Bridge House Records Ltd, 1981); **Wasted Youth** cover concept, **Alison Turner** photography.

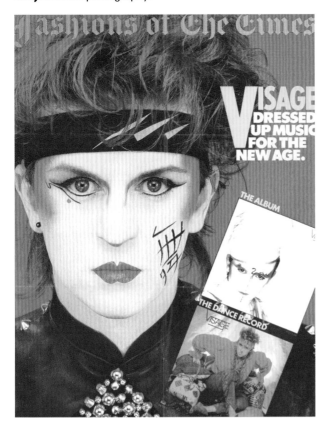

XTC: (above) 'This Is Pop?' 45 cover (Virgin Records, 1978); (left) 'Making Plans for Nigel' 45 cover (Virgin, 1979); **Steve Shotter** illustration, **Cooke Key** design.

XTC
Are you receiving me
Virgin VS23I

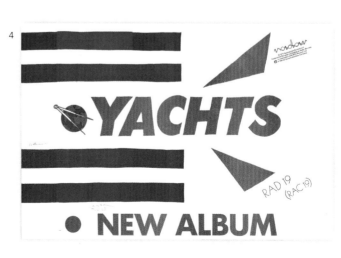

XTC: 1 *'Are You Receiving Me?'* 45 poster (Virgin Records, 1978); **Cooke Key** design; **2** With Fingerprintz, poster for concert at Gaston Hall, Georgetown, Washington DC, 24 January 1980.

YACHTS: 3 'Look Back in Love (Not in Anger)' 45 (Radar Records, 1978); **Malcolm Garrett (Assorted iMaGes)** design; **4** *Yachts* LP poster (Radar Records, 1979); **Malcolm Garrett (Assorted IMaGes)** design.

Andrew Blauvelt is director of Cranbrook Art Museum, which focuses on modern and contemporary art, architecture, design and craft, and is located in metropolitan Detroit, Michigan. He is a curator of modern and contemporary design and has organized a wide range of travelling exhibitions and related publications, including *Too Fast to Live, Too Young to Die; Punk Graphics, 1976–1986* (Pavilion, 2020); *Hippie Modernism: The Struggle for Utopia* (Distributed Art Publishers, 2016); and the upcoming *With Eyes Opened: Cranbrook Academy of Art since 1932*. Prior to Cranbrook, Blauvelt had served in various senior curatorial and administrative roles at the Walker Art Center in Minneapolis.

Philip Brophy formed the experimental band tsk-tsk-tsk in 1977 in Melbourne, Australia, and released numerous records between 1979 and 1982, in another life. Across this period he also designed the artwork for many Australian new wave venues (such as the Crystal Ballroom), record labels (from Au Go Go to Mushroom) and punk and new wave bands. These interests much later culminated in his article on punk and post-punk record graphics, published in one of the magazines he edited through the 1980s, *Stuffing*. He has since worked as a filmmaker, musician and writer.

Malcolm Garrett MBE RDI is one of the UK's leading authorities on design and branding in music, with a career that spans four decades from punk to digital download. He is creative director of the design consultancy Images&Co and a founder and artistic director of the annual *Design Manchester* festival. He has a collaborative, multi-disciplinary and user-focused approach to design. At art school in Manchester in 1977 he founded the graphic design group Assorted iMaGes, and in 1994 the pioneering digital agency AMX. Working at the interface of digital, virtual and real-world experience, he has gone on to lead numerous design projects, both local and international, for artists, musicians, businesses large and small, community groups and for the public sector. He became the first Royal Designer (RDI) in the field of New Media in 2000, and in 2020 he was awarded an MBE in the Queen's Birthday Honours for 'services to design'.

Pete Groff is associate professor of philosophy at Bucknell University. He normally writes on Nietzsche, Arabic philosophy and comparative issues. But he has played in bands all his life and occasionally writes on music too. He teaches a class on punk and has curated an exhibit for the Samek Art Museum called *Damaged Goods: The Punk Aesthetic* from Andrew Krivine's collection.

Chip Kidd is best recognized as a graphic designer for book covers. He grew up to be associate art director at Knopf, and freelanced for Farrar Straus & Giroux, Amazon, HarperCollins, Scribner, Penguin/Putnam and many others. At Pantheon Books he designed graphic novels, and he also wrote for and designed DC Comics. In 2003, he collaborated with an American cartoonist and editor, Art Spiegelman, on *Jack Cole and Plastic Man: Forms Stretched to Their Limits*. The film adaptation of Michael Crichton's *Jurassic Park* novel featured Kidd's concept art for the novel. In 2001, he released his debut novel, *The Cheese Monkeys*, which narrates the coming-of-age tale about state college art students who were bullied by their graphic designing instructor. Its sequel, *The Learners*, appeared in 2008. Kidd also wrote the story for the original graphic novel *Batman: Death By Design* (2012). In 2014, he received an AIGA medal for his contribution to the graphic design industry.

Chris Morton (aka c-more-tone studios) was the original art director for Stiff Records and designed the first ever punk single label logo and sleeve for The Damned's 'New Rose' — as well as the illustrated EP cover of Richard Hell's *Blank Generation*, the iconic and much-copied 'Fuck Art, Let's Dance…' T-shirt for Madness and the 'Home Taping is Killing the Industry' cassette and crossbones logo. From 1982 to 1994, he was 'c-more-tone studios', an award-winning album cover designer exhibited at London's ICA and internationally. Following a fine art MA in 2001, he began 'Artgoes –The Catalogue Art Superstore' (and publishing imprint) — an anti-elitist twist on Argos (a popular UK chain of catalogue-style 'click & collect' stores). He teaches and lectures on DIY book arts and autonomous publishing, and created the *Pleasant History of Chapbooks* series. In 2008, he set up artPods, showing creative groups and older artists how to promote and re-present themselves digitally. In 2013, he created 'artPodjects' — a socio-political Public Art practice. Chris is currently focused on preliminary PhD research: showing the transition from analogue to digital via the twist of 'Fuck Dance, Let's Art…'

Rick Poynor writes about design, photography and the visual arts. He is professor of design and visual culture at the University of Reading. In 1986, he contributed to the cult book *More Dark Than Shark* (Faber) about Brian Eno. Other books include *Vaughan Oliver: Visceral Pleasures* (Booth-Clibborn Editions, 2000); *No More Rules: Graphic Design and Postmodernism* (Laurence King, 2003); and *David King: Designer, Activist, Visual Historian* (Yale University Press, 2020).

Matthew Worley is the author of *No Future: Punk, Politics and British Youth Culture* (CUP, 2017) and professor of history at the University of Reading. He has written widely on punk-related culture in journals such as *History Workshop* and *Twentieth Century British History*. As a co-founder of the Subcultures Network, he edited *Ripped, Torn & Cut: Pop, Politics and Punk Fanzines from 1976* (Manchester University Press, 2018) and is currently writing a book-length study of punk's alternative press.